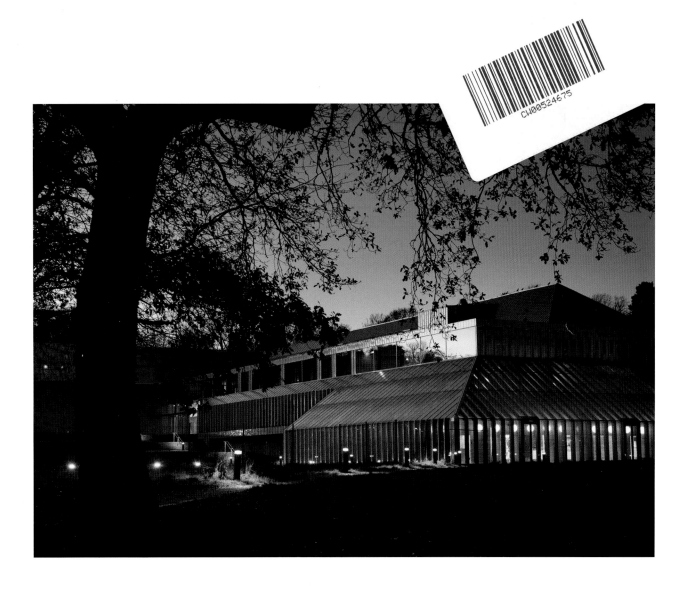

# Souvenir Guide

**The Burrell**
Collection

First published in 2022 by Glasgow Museums Publishing, part of Glasgow Life.
Text © Culture and Sport Glasgow (Museums) 2022.
Images © CSG CIC Glasgow Museums Collection, unless otherwise acknowledged.

ISBN 978 1 908638 34 2

## Acknowledgements

Image of Lilian Shelley p. 34 © The estate of Sir Jacob Epstein/Tate
Front cover image: Sir William and Constance, Lady Burrell, 2022, by Alexander Stoddart (S.494). © Alexander Stoddart
Back cover image: the Burrell Collection, 24 November 2021.

Edited by Fiona MacLeod.
Designed by John Westwell and Jacqui Duffus.
Photography by Iona Shepherd, Maureen Kinnear and Enzo di Cosmo.
Reprographic scanning by Alan Broadfoot.

Images supplied by Glasgow Museums' Photo Library.
**www.csgimages.org.uk**
**www.glasgowmuseums.com**
**www.burrellcollection.com**

## Authors

Noorah Al-Gailani, Laura Bauld, Martin Bellamy, Claire Blakey, Yupin Chung, Jane Flint, Alan Greenlees, Edward Johnson, Rachel King, Anthony Lewis, Joanna Meacock, John Messner, Ralph Moffat, Rebecca Quinton, Pippa Stephenson-Sit, Brian Weightman

Printed in Scotland by J Thomson Colour Printers, Glasgow
Cover printed on Galerie Art Satin. Interior spreads printed on Clara Silk.

MIX
Paper from responsible sources
FSC® C023105

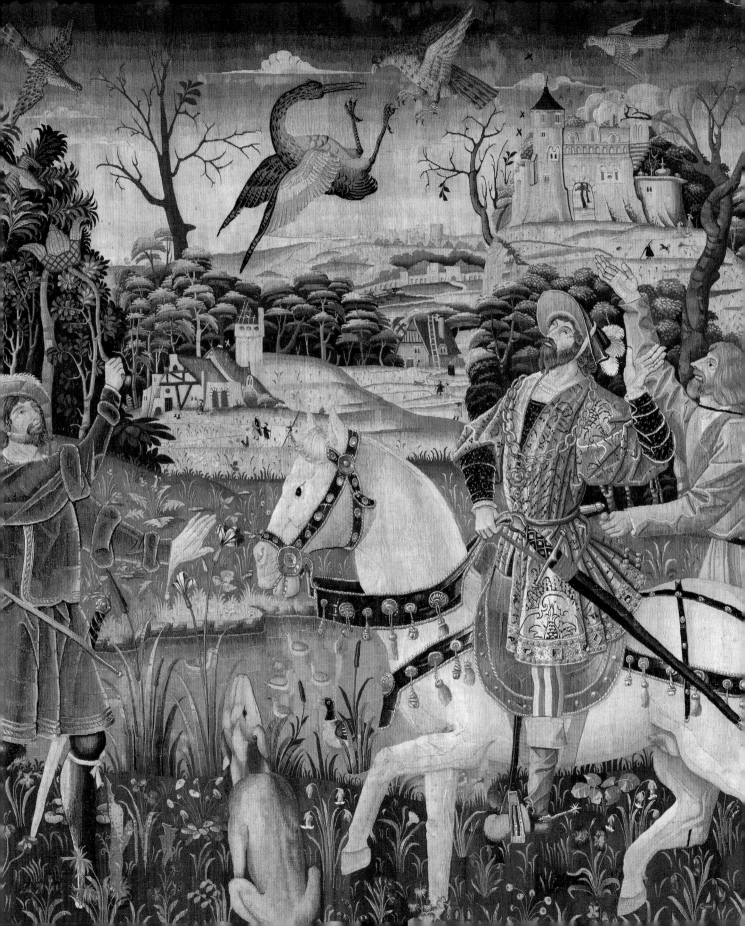

# Foreword

Lyon & Turnbull is delighted to sponsor this new guidebook to the Burrell Collection. We are Scotland's oldest and largest firm of fine art auctioneers, established in 1826, and I like to imagine that Sir William Burrell, or the dealers that often bought on his behalf, may have picked up some of the treasures in this wonderful collection from our salerooms in the late nineteenth and early twentieth centuries.

As a boy growing up on the outskirts of Glasgow, I remember clearly my first visit to the Burrell Collection when it opened in 1983. Wandering through the rooms of amazing treasures, beautifully laid out in the award-winning A-listed building designed by Gasson, Meunier and Andresen, I found it incredibly inspiring and have no doubt it fuelled a passion for art and antiques which set me on my journey to becoming an auctioneer. I hope that your visit to the Collection today is equally inspiring and that this guidebook adds insight and depth to your appreciation of the artworks.

Working closely with private collectors to help them both grow, through the acquisition of new works, and refine their collections as personal tastes and space require, is one of the great joys of being part of the ever-changing world of fine art and antiques auctions. It is wonderful therefore to be associated with this top-class collection, amassed by a private individual and then gifted to the City of Glasgow for the world to enjoy.

Gavin Strang
Managing Director | Lyon & Turnbull Fine Art Auctioneers

# Welcome to the Burrell Collection

In spring 2022, emerging from the COVID-19 pandemic to see the re-opening of the Burrell Collection after a closure of more than five years, there seems no more appropriate time to reaffirm the importance of art and culture, philanthropy, beauty and heritage in determining and shaping the future health, wealth and wellbeing of our communities and our planet.

The re-opening of the Burrell Collection aims to ensure that Glasgow continues, in the words of its city motto, to flourish for generations to come, demonstrating the significance and value of culturally rich cities in re-growing economies, finding new ways of living together, and celebrating the very best of human achievements.

It was before the pandemic that the renowned Artificial Intelligence supremo Kai-Fu Lee predicted that the human qualities of kindness, compassion and love would come to the fore as prime currency in the continuation of our global society. All of these attributes, and more, can be found in this remarkable collection of 9,000 precious objects and works of art, the stories which sit behind them, the lives of their creators, collectors, supporters and audiences, as well as the architecture and building design of this reimagined, state-of-the-art, sustainable museum.

Sir William Burrell spent his whole adult life collecting beauty and quality, knowing the works he surrounded his family with would bring them enlightenment and pleasure throughout their lives.

The act of extraordinary philanthropy of Sir William, and Constance, Lady Burrell, in giving the Collection to Glasgow so that millions more could enjoy their art, shows just how much joy it brought them.

Thanks are due to the far-sighted public, private and voluntary sector agencies, individuals and institutions whose generosity, hard work and collective efforts have ensured this national and international treasure is once again able to inspire a more profound understanding, as well as new connections crossing time and cultural borders, encouraging innovation and the very best in human achievement.

The Burrell Collection deserves to be globally acknowledged. It is one of the greatest ever assembled by a collector. Many of its treasures are unique and all of them tell us about the times they were made in, the people who made them, and their culture.

Having a place to appreciate 6,000 years of human endeavour and accomplishment reminds us all that when future generations search for meaning, hope and education, we will find it in our museums in the precious history they hold for us all.

Thank you for taking the time to come and visit this wonderful museum. I hope you find inspiration here too.

Bridget McConnell
Chief Executive, Glasgow Life

# A Gift to Glasgow

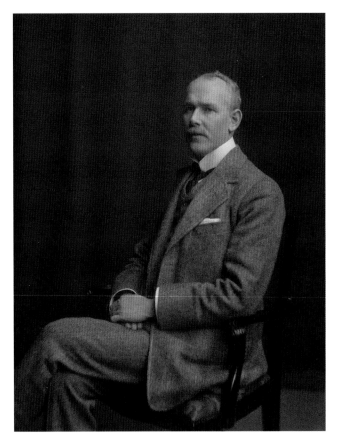

William (above) and Constance (opposite), photographed by T. & R. Annan and Sons, Glasgow, 1916.

William Burrell (1861–1958) was born and raised in Glasgow. He joined his father in the family business as a ship owner and shipping agent. When his father died in 1885, he and his brother George took over the business while still in their twenties, and transformed it into one of the leading cargo shipping companies in Britain. William had a natural flair for business and earned himself a sizeable fortune. The bulk of his wealth came during World War I when he sold most of his ships for many times more than what he bought them for.

He had developed an interest in art as a boy and he used his wealth to steadily build his collection, quickly surpassing his local contemporaries in terms of the quantity and quality of his artworks and firmly established an international reputation as a collector of good taste and judgement. Burrell had an innate talent for art collecting. He understood what he was buying, and his refined taste led him to areas that other collectors dared not touch. His primary passion was for Gothic art and he built an outstanding collection of medieval and Renaissance tapestries, stained glass and furniture. His collection of Chinese bronzes and ceramics is one of the most comprehensive in the country, and his collection of French Impressionists contains numerous masterpieces by Manet, Cézanne and especially Degas.

Burrell used his wealth to advance himself in society and to purchase Hutton Castle in Berwickshire, where his Gothic collections were displayed to great effect. But his wealth and art collection were not simply for personal gain. Burrell had a deep sense of public duty, serving for long periods as a local councillor in Glasgow and Berwickshire, and as a trustee of the National Galleries of Scotland and the Tate Gallery in London. He wished to use his art collection for public good and lent large parts of it to galleries around the country so that as many people as possible could enjoy it. In 1927 he was knighted for his public and political work and services to art in Scotland.

Unlike most collectors, his collection was not sold or bequeathed for personal or family gain. He donated the majority of his collection to Glasgow in 1944, which at the time amounted to 6,000 items. He continued to add to the Collection so that today it amounts to a staggering 9,000 artworks. He also donated smaller parts of his collection to Berwick-upon-Tweed and several other provincial galleries, with the aim of enhancing the cultural standing of these places.

At the time of his gift to Glasgow the Collection was valued at well in excess of £1 million, and it came with an additional £450,000 in cash to build a dedicated museum for it. This was a major act of philanthropy, with very few strings attached other than stipulating where and how it was to be displayed.

Burrell simply wanted people to gain as much pleasure from art as he had, and to improve their lives through a better understanding and appreciation of beauty.

Burrell's collecting passions were shared with his wife Constance (1875–1961), who played an active role in developing the Collection. In his will Burrell was very particular in stating: 'I have had the benefit of my wife's help in many ways including financial help and have received from her the greatest assistance and most wholehearted support in forming the collection ... it is my desire that it be distinctly understood that the entire gift is from my wife and myself and that her name shall always be associated with mine and shall receive full acknowledgement in all official literature relating to the collection'. William and Constance were faithful and loving companions throughout their married lives, and operated very much in partnership in their business, collecting and philanthropic endeavours.

The opening of the Burrell Collection museum in 1983 was the culmination of William and Constance's ambitions. It gave each and every citizen of Glasgow free access to their art collection in beautiful surroundings in a way that fostered enjoyment, contemplation and understanding.

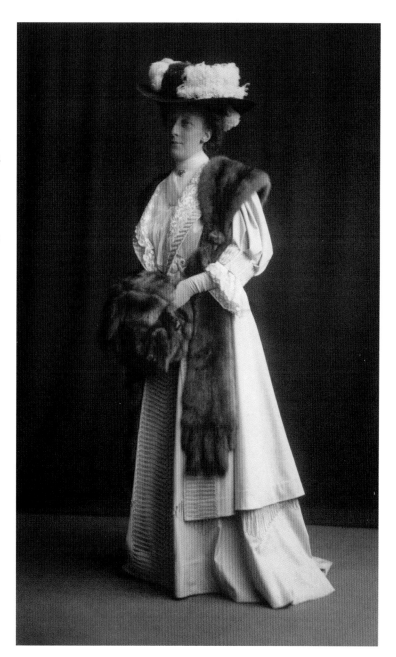

# Building the Burrell Collection

Throughout his entire collecting career Sir William Burrell had been generous with his collection, lending many of his works to special exhibitions and for displays in museums. For example, most of his Chinese bronzes and ceramics were displayed in Kelvingrove Art Gallery and Museum and hundreds of his paintings were on long-term loan to the Tate Gallery in London. Then, sometime around 1930, Burrell decided that he was going to donate his entire collection to the public.

He had already gifted 48 paintings and 30 prints to Kelvingrove Art Gallery and Museum in 1925, but he was unsettled about where the rest of his collection would go. His first thought was that the Gothic art would go to the Victoria and Albert Museum in London. They would gladly take the tapestries and a few other choice pickings, but they were unwilling to take the whole collection. The idea that the Collection as a whole should be kept together then developed into one of his overriding considerations. Concerned for the Collection's safety with the onset of World War II, Burrell reassessed what was on loan to dozens of museums and galleries across the country. He donated many of his artworks that he did not see as part of the central 'Burrell Collection' to places like Dundee, Kirkcaldy, Torquay, and Ipswich. He then began the process of finding a home for the remaining 6,000 items.

His initial focus was on London, which he saw as the centre of the art world and where his collection would be seen by a large and appreciative audience. He approached the Westminster government with the idea that he would leave his collection to the nation as a separate government institution like the Wallace Collection. Although the government took the offer seriously it had other priorities, with the war still raging. Burrell then approached London County Council with a similar offer. Negotiations got to an advanced stage, but in the end the cost of maintaining the Collection proved too much and the offer was declined.

Only a matter of days later Burrell brought his offer to Dr T. J. Honeyman, the director of Kelvingrove Art Gallery and Museum, who later recalled: 'One December evening in 1943 he got me on the telephone. [...] When he told me that Lady Burrell and he had finally determined to present the entire

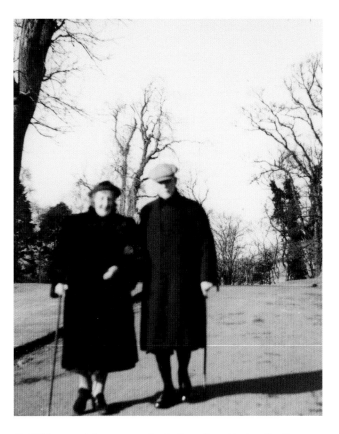

Sir William and Constance, Lady Burrell, at Hutton Castle, about 1955.

collection to the City of Glasgow [...] I was too excited to be coherent.' Glasgow welcomed the gift with open arms and the memorandum of agreement between William and Constance and the Corporation of Glasgow was signed in April 1944. Burrell had clear intentions regarding the Collection's location, contents and display, and the agreement stated that the Collection was to be housed by Glasgow Corporation 'in a suitable distinct and separated building' that was to be 'within four miles of Killearn, Stirlingshire, and not less than sixteen miles from Glasgow Royal Exchange'. He also stipulated that the Collection be 'shewn as it would be if in a private house [...] so as to insure that the building has as little of the semblance of a Museum as possible'. Although it took several years for everything to arrive in Glasgow, the 1944 gift saw the Collection brought together for the first time in its history. To celebrate,

a modest exhibition of highlights was held in Kelvingrove in 1946. At the opening, the principal of the University of Glasgow, Sir Hector Hetherington, stated that the collection was 'among the greatest gifts ever made to any city in the world'. Burrell donated £450,000 (about £20 million in 2022 prices) for the construction of a museum for his collection but finding a suitable site for it was not easy. The city had immediately started making investigations and by the late 1940s at least eight different sites were thought of as possibilities. Sir William would occasionally come through to inspect potential properties, but none was quite right. Mugdock Castle Estate, near Milngavie was seriously considered, even though it was much closer to Glasgow than the stipulated 16 miles. Then in 1951 the Dougalston estate, also near Milngavie, was gifted to Glasgow by the widow of a Glasgow shipbuilder on the condition that the Burrell Collection be constructed on the site. Preparations got to an advanced stage but in 1955 the National Coal Board announced plans to sink a coal mine nearby and all plans for the Burrell Collection were abandoned and the Collection remained in storage for many years.

The ideal solution finally arrived with the offer of Pollok House and its estate to the city. This was the ancestral home of the Stirling Maxwells on the south side of Glasgow. It was only three miles from the city centre, but its 360-acre parkland made it an ideal rural setting that was within the spirit of Sir William's ambitions for his museum. After long and protracted negotiations, the government stepped in with financial support of £250,000 for the museum. In 1967 the Pollok estate was transferred to the city, and preparations to build the Burrell Collection finally got underway.

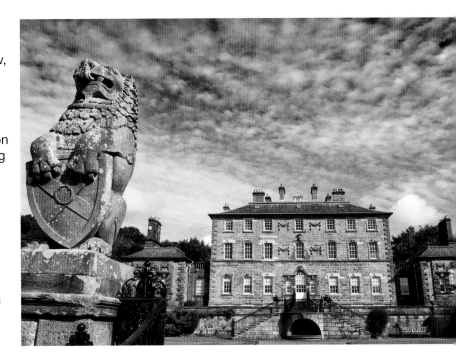

Pollok House.

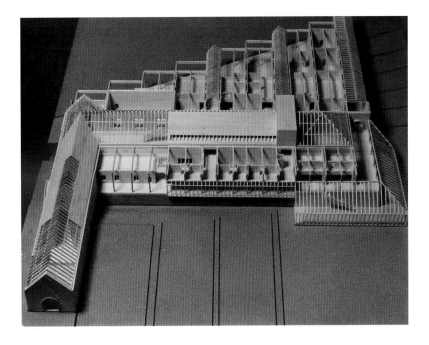

A model of the Burrell Collection building, 1973.

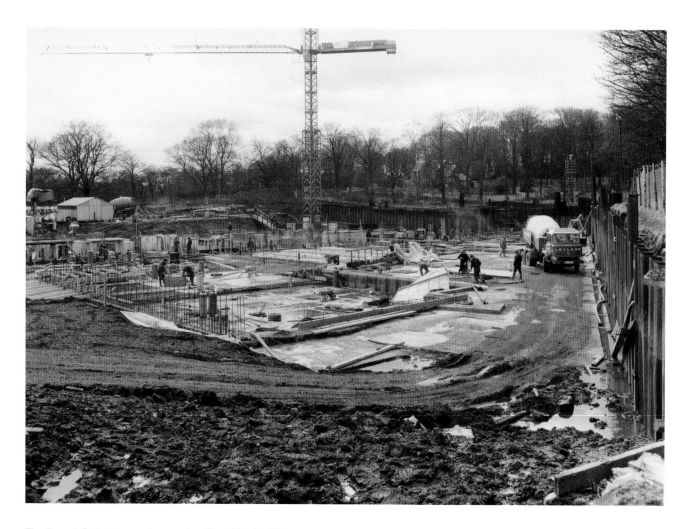

The Burrell Collection under construction, March 1979.

In 1970 an architectural competition was launched to identify a suitable architect for the museum. The competition brief made it clear that whilst the competitors were to comply with Burrell's exacting conditions, they were at liberty to design 'a fine modern building' which would make the most out of both the Collection and the site. In March 1972 Barry Gasson, John Meunier and Brit Andresen, all tutors at Cambridge University's School of Architecture, were announced as the winners.

Inevitably, as the project progressed the costs increased, and this again put the museum in jeopardy. The Corporation had no option but to approach the government for additional support and eventually the Secretary of State for Scotland promised to meet 50 per cent of the estimated £9.6 million cost in recognition that the Burrell Collection was not just important for Glasgow but was a national treasure that would benefit the country as a whole.

With the funding finally secured it was possible to proceed with construction work, and on 3 May 1978 the first sod was cut. Over the next five years the complex and beautiful building emerged. The building was influenced by Scandinavian design and the understated exterior harmonized effortlessly with its woodland surroundings. The architects created a clever way of using the orientation of the building to bring in as much natural light as possible while still protecting the vulnerable parts of the Collection. The integration of the building, its rural setting, and the Collection was central to the architects' thinking, and the way in which the objects were sensitively built into the structure ensured that the museum became

a part of the Collection rather than simply being a space in which Burrell's objects were housed.

The museum was finally opened on 21 October 1983 by Queen Elizabeth II. For the first time the public could view William and Constance's gift that had, for the most part, lain in storage for the past 39 years. In her speech the Queen stated: 'Glaswegians can be proud, not only of Sir William Burrell and his astute and unflagging pursuit of excellence, but also of the way in which they have responded to his generosity. He himself could not have visualised a finer setting for the museum than Pollok Park'. She then went on to comment on the long wait to achieve the museum: 'Difficulties which would have daunted people of lesser mettle have been overcome, and the collection is now permanently housed in a building worthy of it.' Burrell may have baulked at the final cost of the building, but the end result certainly resonates with his feelings that the museum should be 'as simple as possible': 'To put up an extravagant building is quite opposed to what we have stipulated. What it needs is fine contents.'

The opening of the Burrell Collection was the culmination of William and Constance's ambitions. It gave each citizen of Glasgow free access to their art collection in beautiful surroundings in a way that fostered enjoyment, contemplation and understanding. It immediately captured the imagination of the public, placing Glasgow firmly on the cultural map. More than one million visitors passed through its doors in the first year and the Burrell Collection quickly established itself as one of Glasgow's most-loved buildings and one of the jewels in its cultural landscape. Although it opened much later than originally anticipated, and long after the deaths of both William and Constance, its opening occurred at just the right time to play a major role in the transformation of Glasgow from a state of depressed post-industrial gloom into an internationally renowned city of culture.

Miss Silvia (previously Marion) Burrell, daughter of William and Constance, with architect Barry Gasson, May 1978.

After 30 years as one of Glasgow's leading attractions, the innovative museum building needed a significant upgrade to meet twenty-first century standards of access and environmental sustainability. The Burrell Renaissance Project was born to secure the future of the building and to revitalize the displays to meet the demands and expectations of contemporary audiences. This major investment has ensured that the Burrells' wish of enriching the lives of Glasgow's citizens and visitors through 'becoming more closely acquainted with what is beautiful' will continue for many generations to come.

Duncan Dornan
Head of Glasgow Museums

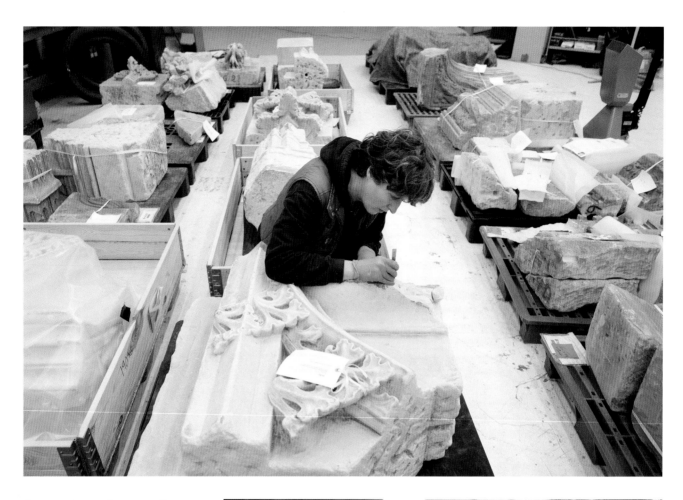

Conservators and conservation
contractors working on objects during
the Burrell Renaissance Project.

# About this book

With more than 9,000 objects in the Burrell Collection, this book contains just some of the highlights from the galleries. Written by our specialist curators, we hope it gives you a flavour of the wonderful variety of items that you might see on a visit to the Collection in Pollok Country Park.

Objects are sometimes lent to other museums or on display in our other venues, and occasionally they are taken off display so that we can conserve them for future generations. As a result, we cannot guarantee that everything you see in these pages will be on display when you visit. However, to find out more about a specific object you can always search our Collections Navigator online at collections.glasgowmuseums.com

Research on the Collection is an ongoing process, and for that reason information about objects is constantly evolving, so if you do spot any discrepancies between the displays, guidebook and Collections Navigator, that is why.

We look forward to welcoming you to the revitalized Burrell Collection.

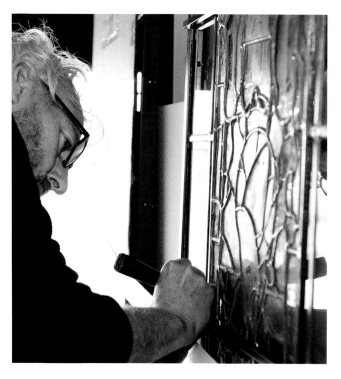

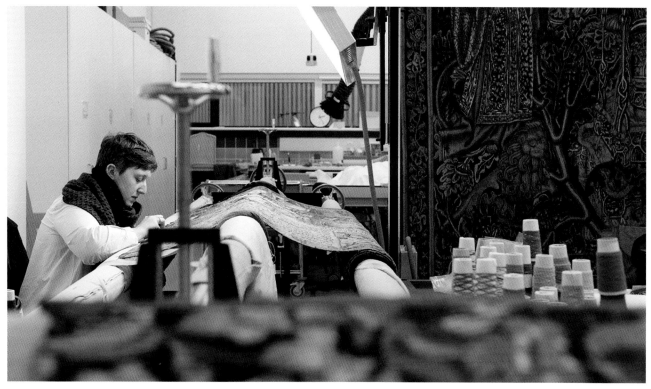

# The Galleries

**Vase, known as
the Warwick Vase,
100–200, restored 1770–80**
Marble
Made in Italy
294 cm x 195 cm x 195 cm
42.20

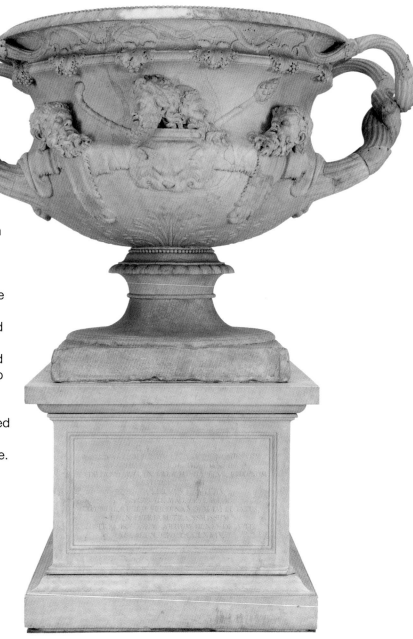

Fragments of the Warwick Vase were
excavated in 1771 in the grounds of the
villa at Tivoli, Italy, belonging to the Roman
Emperor Hadrian (76–138). Antoine-
Guillaume Grandjacquet (1731–1801)
restored the vase after designs created by
Giovanni Battista Piranesi (1720–78) for the
famous antiquarian Sir William Hamilton
(1730–1803). Hamilton gave the completed
vase to his nephew, George Greville, 2nd
Earl of Warwick (1746–1816). It was placed
in Warwick Castle courtyard for almost two
centuries, before being purchased in 1979
for the Burrell Collection.

The vase takes the shape of a two-handled
drinking cup, decorated with motifs and
figures of Bacchus, the Roman god of wine.

**Hornby Castle portal, 1500–1600**
Sandstone
Made in Yorkshire, England
685.3 cm x 228.6 cm
44.100

This sandstone doorway was once part of Hornby Castle, near Richmond, Yorkshire. It was the main entrance to the castle's great hall. William Conyers, 1st Baron Conyers (1468–1524), refurbished the castle in the late 1400s. The family name is displayed over the arch and the coats of arms displayed all belong to families related by marriage to the Conyers.

Sir William Burrell bought the portal in 1953 from the collection of American newspaper owner William Randolph Hearst (1863–1951). Burrell acquired several architectural features from the Hearst collection to incorporate into the future Burrell museum building.

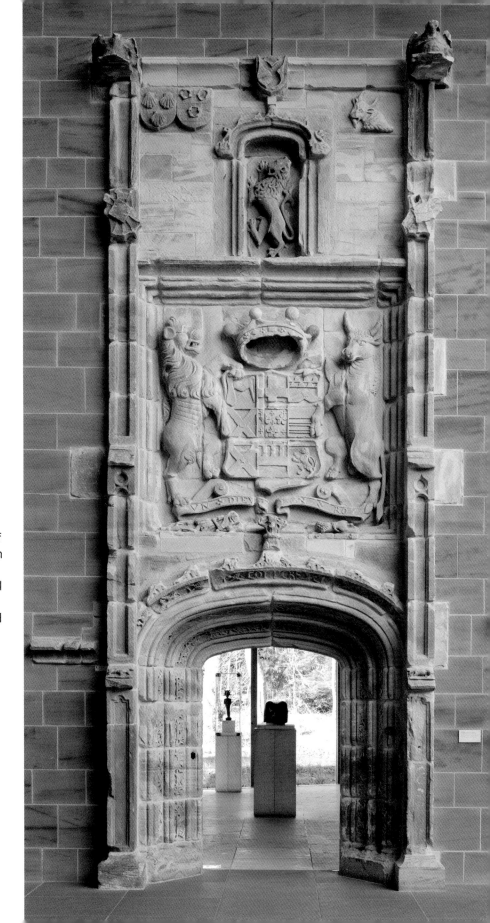

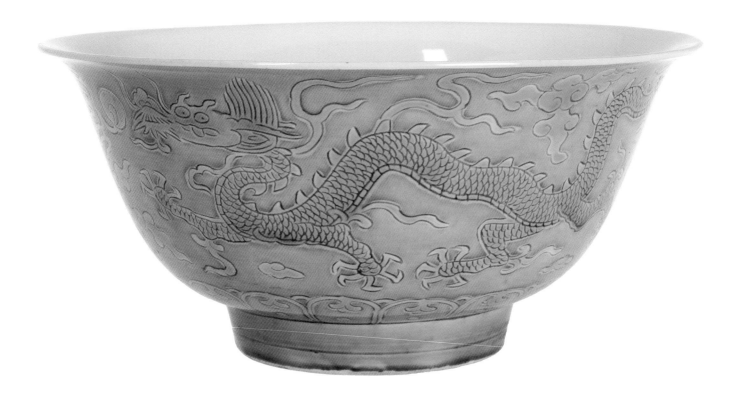

**Bowl, 1506–21**
Porcelain
Ming Dynasty, Zhengde Period
Made in Jingdezhen, China
21.4 cm x 21.4 cm x 10 cm
38.655

During the reign of the Zhengde Emperor (1506–21) porcelain objects decorated with lavish dragon patterns in green and yellow were much coveted. This bowl is incised with five-clawed dragons chasing pearls among scrolling clouds. It was fired twice, first at a high temperature (1280°C–1400°C) and then again at a lower temperature, at which point artisans carefully applied yellow and green enamels onto it. A four-character mark signifying the Zhengde reign is inscribed on the base.

This bowl previously belonged to Leonard Gow (1859–1936), a Glasgow-born ship-owner. Gow lent his important collection of Chinese porcelain to Kelvingrove in 1936, for an exhibition Sir William Burrell would have seen.

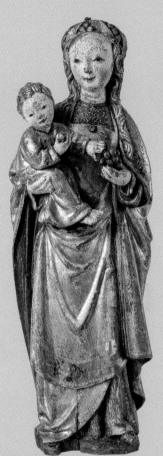

### Virgin and Child, about 1510
Wood, polychromy, gold, gem stones, metal
Made in Mechelen/Malines, Brabant, Southern
Netherlands, now Belgium
37 cm x 14 cm x 6.5 cm
50.5

The Virgin Mary stands holding Christ in her arm. The apple in his hand refers to the temptation of Eve and the fall of man. His left hand reaches towards a bunch of grapes symbolizing his later sacrifice and the wine that represents his blood that is drunk in Christian religious services.
　These small figures, known as *Poupées de Malines* (Dolls of Mechelen), were made in large numbers for small cabinet altarpieces for domestic homes. Either used as single figures or with others, they were often surrounded by flowers and fruit to create a heavenly garden.

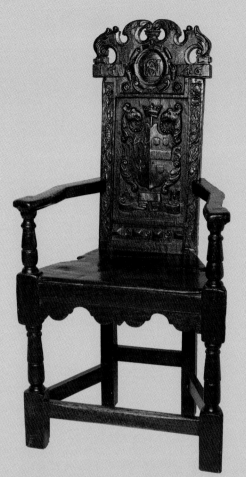

### Vase, 1662–1722
Porcelain, underglaze blue
Qing Dynasty, Kangxi Period
Made in Jingdezhen, China
77.4 cm x 27.5 cm x 27.5 cm
38.1028

The shape of this vase is known in Chinese as *bangchuiping*, meaning 'wooden club' vase. It is named after a tool with a handle used for laundry. It was a popular shape for porcelain vases in the Kangxi Period (1662–1722).The central scene is the Battle of the Riverlands, from the Chinese classic fourteenth-century novel attributed to Luo Guanzhong, *Romance of the Three Kingdoms*. Burrell saw this fine vase on display in *The Chinese Exhibition* at the Royal Academy, London, in 1935–36, before purchasing it on 13 May 1943.

### Armchair, 1646
Oak
Made in Aberdeen, Scotland
128.1 cm x 66.1 cm x 41.8 cm
14.50

Sir William Burrell purchased objects relating to Scottish history, such as this chair for himself and for Provand's Lordship in Glasgow.
　This marriage chair carries the carved initials IS and AM, and its heraldic arms also record the marriage. Burrell may have been attracted by the crown on the crest of the chair indicating rank and royal favour, and the date 1646. Burrell was interested in British Stuart monarchs. In 1646 King Charles I (1600–49) surrendered to the Scots.

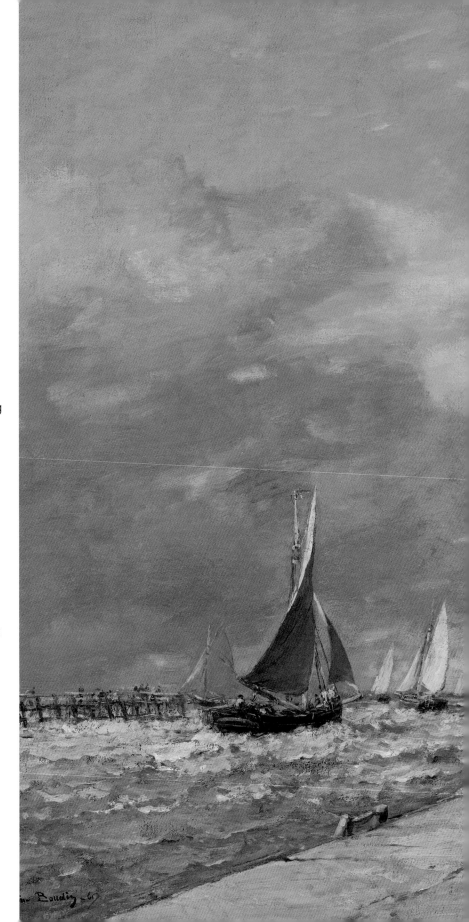

### The Jetty at Trouville, 1869
Eugène Boudin
Oil on canvas
65 cm x 93 cm
35.43

French artist Eugène Boudin (1824–98) painted outside, drawing scenes of everyday life. He was an influential figure for the French Impressionist painter Claude Monet (1840–1926), and acted as his mentor, encouraging him to take his sketchbooks outdoors. Against a vast expanse of cloudy sky, fashionably dressed figures are seen here chatting, holding onto their hats as they walk against the wind, or watching the fishing boats head out to sea. Boudin often painted the jetties of Trouville and Deauville, on the coast of Normandy, France. The jetties were built to shorten and deepen the narrow channel leading into the port but they soon became a popular place for visitors to promenade.

Burrell bought this painting from Glasgow art dealer Alexander Reid (1854–1928) on 28 April 1919 for £730. It is one of several Boudins that Burrell purchased from him. Burrell considered that Reid had done 'more than any other man has ever done to introduce fine pictures to Scotland and to create a love of art.'

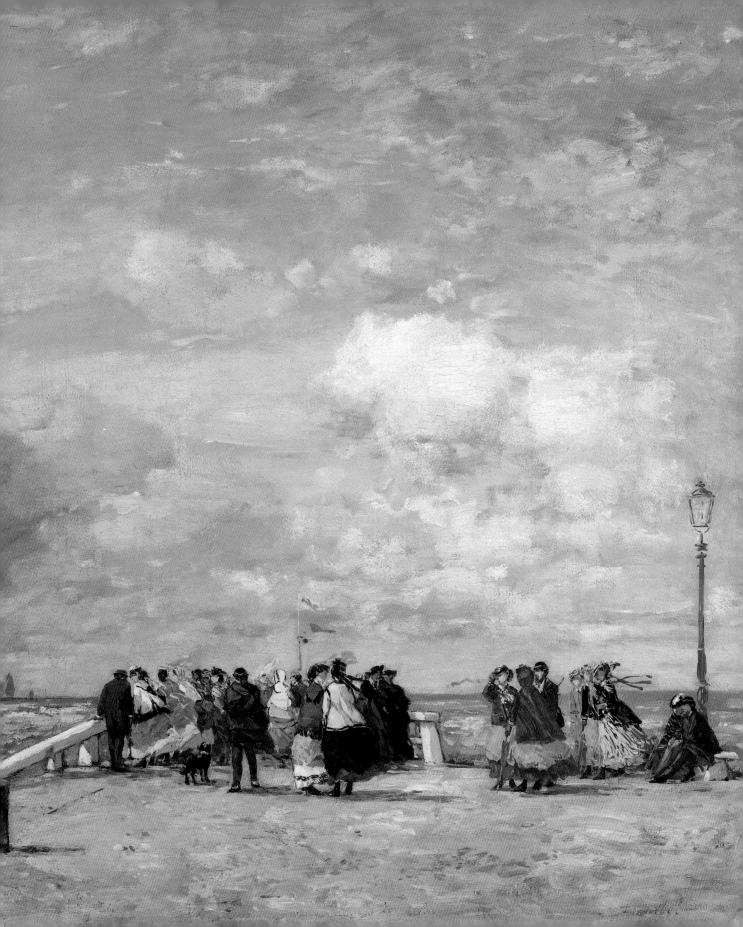

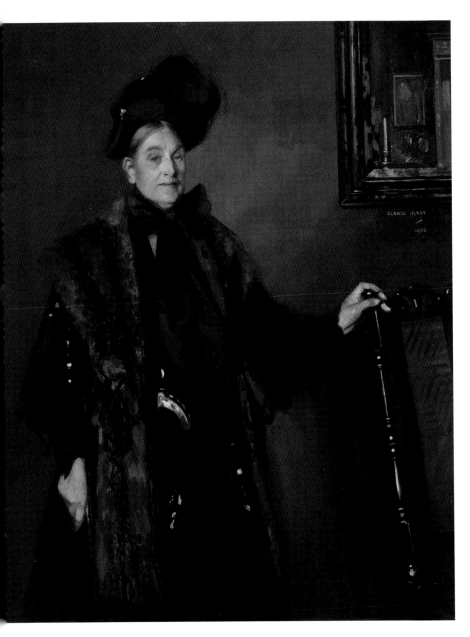

**Portrait of Mrs Isabella Burrell, 1903**
George Henry
Oil on canvas
150.6 cm x 125.1 cm
35.278

Edinburgh architect Robert Lorimer (1864–1929) described Sir William Burrell's mother, Isabella (1834–1912) as 'a fine old Trojan'. Although widowed for nearly 20 years, she still insisted on wearing black in mourning. Her furs are an ostentatious display of wealth. The interior setting is probably 4 Devonshire Gardens, Glasgow, the Burrell family home. A black chatelaine bag and keys attached to her waistband indicate she is mistress of the household.

Isabella Burrell was a powerful presence behind her son's collecting. A collector herself, she ignited his passion for art and accompanied him on buying trips to Europe. William Burrell commissioned this imposing portrait from Glasgow Boy George Henry (1858–1943) in 1903.

## The Thinker, 1880–81

Auguste Rodin
Cast in bronze by Alexis Rudier
Foundry, 1902–22
71 cm x 39 cm x 58 cm
7.8

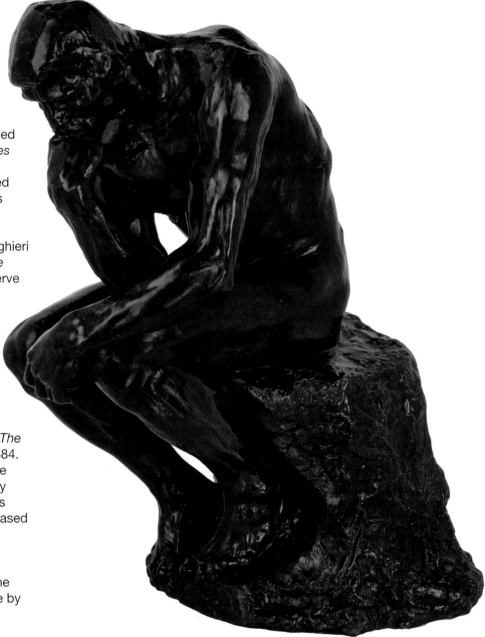

*The Thinker* was originally designed
to sit towards the top of *The Gates
of Hell,* the artist's monumental
sculpture, originally commissioned
as doors to a new decorative arts
museum, the Musée des Arts
Decoratifs, Paris. The sculpture
depicts the Italian poet Dante Alighieri
(1265–1321), author of *The Divine
Comedy*, leaning forward to observe
the seven circles of hell. Rodin's
famous sculpture soon became
known as 'The Thinker', owing
to the expression of intense
thought etched not only on his
face but contained within his
entire body. He is shown nude
to make him appear timeless.
Initially modelled in plaster in
1880–81, the first bronze cast of *The
Thinker* was probably made in 1884.
Around 30 casts in its original size
were made by the Rudier Foundry
from 1902 onwards, including this
version that William Burrell purchased
in 1922.

A controversial sculptor, Rodin
(1840–1917) received early
recognition in Glasgow. In 1906 he
was awarded an honorary degree by
the University of Glasgow.

**Queen chess piece, 1300–50**
Walrus ivory
Made in Germany or Scandinavia
7.5 cm x 7.1 cm x 2.5 cm
21.3

Sir William Burrell acquired this queen chess
piece in 1938. He was an avid chess player
and was undoubtedly attracted to this piece
for its function and form.

   Walrus ivory was taken from the upper
canine tusks of the walrus. Such ivory was
highly valued in medieval Europe and used
for decorative items and ornaments. Chess
pieces carved from walrus ivory and in the
same style can been found in the collections
of the Walters Art Museum, Baltimore, the
British Museum, London, and the Musée de
Cluny, Paris. It is likely these were part of a
set with this queen piece.

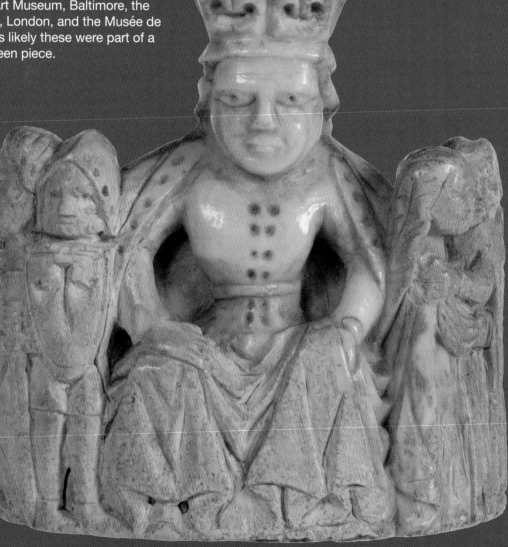

### Two of the 12 Spies returning from Canaan, 1450–75 or later
Oak
Made in Flanders, Southern Netherlands, now Belgium
23 cm x 20.3 cm x 10.1 cm
50.91

The Burrell family displayed their vast sculpture collection across Hutton Castle in both public and private rooms. This sculpture was placed on the mantelpiece of Sir William Burrell's bedroom. It was bought in September 1929 from dealer Sydney Burney (1878–1951) who, only four months before, used an image of the sculpture in an advertisement for his London gallery in *The Burlington Magazine*.

The sculpture shows a scene from the Old Testament of two of the 12 spies sent ahead by Moses to scout out the land of Canaan. Two spies returned carrying a pole laden with grapes – proof that riches awaited them in the Promised Land.

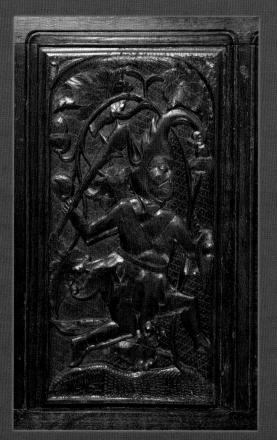

### Carved linenfold panelling, 1500–50
Oak
Made in England
245 cm x 206 cm x 3.7 cm
32.5.b

This carved oak linenfold panelling is one of a series of wall-mounted panels that came from Harrington Hall, Lincolnshire. Harrington Hall was built by the Copeldyke family during the reign of King Henry VII (1457–1509). Above the bottom panels are carved scenes of flowers, foliage, fruit, and mythical beasts, including centaurs and wild men hunting.

William Burrell bought this panelling in 1926 from dealers Acton Surgey Ltd. They were commissioned by Burrell to refurbish the interiors of his new home, Hutton Castle, in the Scottish Borders, just outside Berwick-upon-Tweed. The Harrington Hall panelling was used to line the walls of the dining room.

## Charity Overcoming Envy, about 1500 ▶

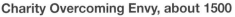

Wool, silk
Probably made in Brussels, Brabant, Southern
Netherlands, now Belgium
254 cm x 216 cm
46.95

This tapestry shows Charity in a red gown, sitting astride a white elephant, sword raised in one hand while the other restrains the wrist of Envy, seated on a kneeling dog. Allegorical scenes of personified virtues overcoming vices, battling for the soul of mankind, were popular subjects for Renaissance tapestries. The red banderol at the top translates as 'The sorrow of an envious spirit comes from the prosperity of its neighbour – rejoicing at his misfortunes like a dog. But the elephant does not know that. And fraternal love overcomes this wickedness as well'.

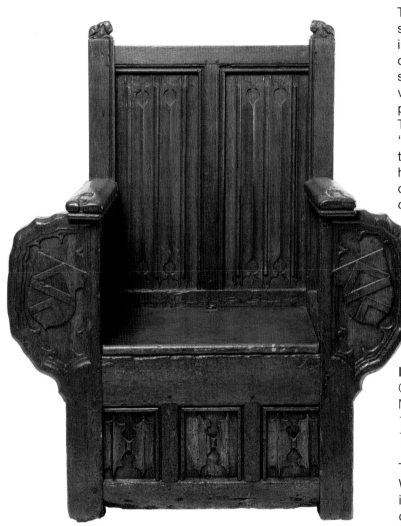

## Imprisoning chair, possibly 1500–1600

Oak, iron, with later additions and restorations
Made in England
115 cm x 96.1 cm x 91.7 cm
14.43

This 'trick' chair is one of the curiosities of William Burrell's furniture collection. Hidden in the rounded arm supports, behind the carved heraldic shields, are two curved iron bars. When you sit down on the chair, iron mechanisms underneath the seat are triggered, forcing the iron bars to fly out, clamping down on the sitter's legs and imprisoning them.

Examples of trick chairs are rare and little is known about Burrell's chair before he bought it in 1932. However, he found much use for it and is said to have taken great delight in trapping unsuspecting guests at Hutton Castle.

Mundi dolor anum reprobrus est proxum · gaudens cuis de malis
ut canis · sed hpe elephas nescit vincit et hoc nephas caritas fracti

charite

## Venus and Cupid the Honey Thief, 1545

Workshop of Lucas Cranach the Elder
Oil on panel
51.8 cm x 36.4 cm
35.74

Cupid, the Roman god of desire, is stung by bees after raiding a hive for honey. His discomfort is apparent but his mother, Venus, lacks sympathy. As the Latin inscription in the top left-hand corner explains, like the sting of a bee, Cupid's arrows of desire can cause sadness and pain.

William Burrell bought this painting in 1902 from the collection of Sir Thomas Gibson-Carmichael (1859–1926) after seeing it in the 1901 Glasgow International Exhibition. In his copy of the exhibition catalogue Burrell noted that he hung the painting in his Business Room at Hutton Castle.

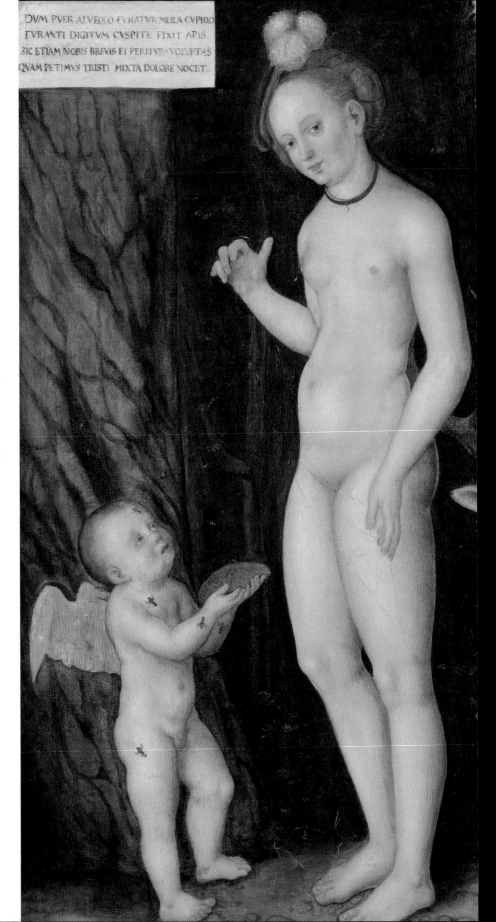

DVM PVER ALVEOLO FVRATVR MEILA CVPIDO
FVRANTI DIGITVM CVSPITE FIXIT APIS.
SIC ETIAM NOBIS BREVIS ET PERITVRA VOLVPTAS
QVAM PETIMVS TRISTI MIXTA DOLORE NOCET.

### Upholstered armchair, about 1690–1710

Walnut, linen, wool, silk
Made in England
122.9 cm x 81 cm x 77.5 cm
14.191

In the early eighteenth century it was fashionable for English-made winged armchairs to be covered with needlework. The upholstery is from a late seventeenth-century hanging, embroidered with tent stitch and depicts a continuous landscape of trees, flowers, and grape vines populated with animals such as horses, deer, birds, rabbits and lions. The back is decorated with two Biblical scenes: Susannah and the Elders; and Elijah being fed by the Ravens. It is possible that the frame of this chair was specifically constructed to accommodate the needlework.

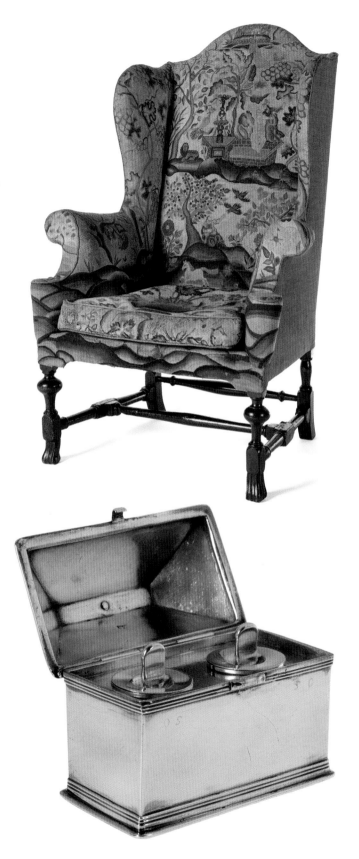

### Casket with inkwells, 1946

Silver
Probably made in the Netherlands
Given by Robert S. Shiel, 2018
7.5 cm x 7.3 cm x 4 cm
E.2018.2

This silver casket, which possibly dates from the eighteenth century, was given to Ethel Todd Shiel (1915–2011) by Sir William Burrell. It has a hinged lid surmounted with a finial, which opens to reveal two cylindrical inkwells with lids. Ethel Todd Shiel worked as Burrell's secretary at Hutton Castle between 1933 and 1939. Her daily tasks included registering Burrell's regular acquisitions in his purchase books and dealing with correspondence. She married five years after leaving Hutton Castle – Burrell sent this as a wedding present.

**Part statue of Pareherwenemef,
son of Ramses II, 1279–1260 BC**
19th Dynasty
Granite
Made in Egypt
65.6 cm x 23 cm x 30.5 cm
13.83

Pareherwenemef (around 1286–1260 BC)
was the third son of the pharaoh Rameses
II (1279–1213 BC) and the inscription states
he was the 'First Charioteer of His Majesty'.
As a royal prince, he may have expected to
become pharaoh himself one day. However,
as Rameses II ruled for 66 years, many of his
88 children, including Pareherwenemef, died
long before he did.

Pareherwenemef fought at the battle
of Qadesh in 1264 BC, which his father
proclaimed throughout Egypt as a complete
victory over the Hittite army; in reality the
encounter was inconclusive and not a
military success.

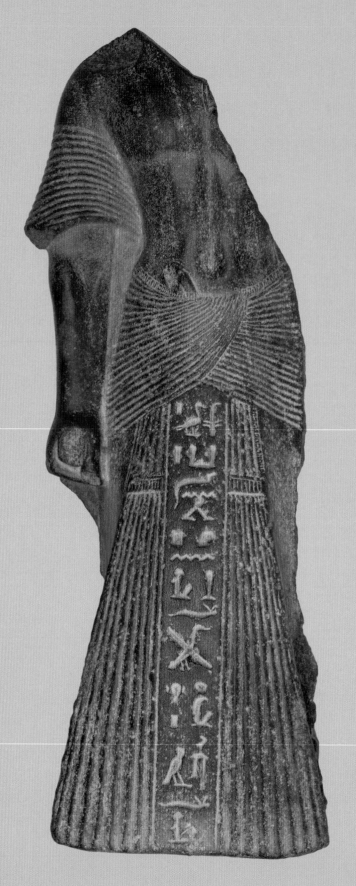

## Royal attendant's head, 883–859 BC

Neo-Assyrian, Ashurnasirpal II
Gypsum
From Room C, the North-West Palace,
Nimrud, Northern Iraq
48.1 cm x 47.2 cm x 4.6 cm
28.35

The inner walls of the palace of Ashurnasirpal II (reigned 883–859 BC) were completely covered with stone relief scenes to emphasize the king's power – with images of military victories and religious ceremonies on a massive scale. Many important royal officials were eunuchs who were depicted over and over on Ashurnasirpal's palace walls. As eunuchs could not have children and had no family ties, their loyalty was only to the king.

From the nineteenth century onwards excavators and looters removed large numbers of these reliefs – cutting them into smaller sections to transport and sell more easily.

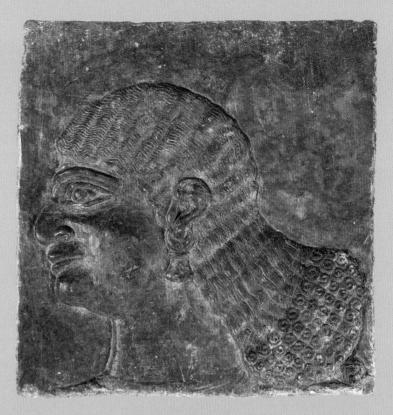

## Guandi and Leigong, about 1550–1640

Ming Dynasty
Porcelain, overglaze enamels
Made in China
51 cm x 24.7 cm x 14.5 cm
38.420
49.5 cm x 26.5 cm x 16.5 cm
38.422

These figures would have been placed on an altar in a home or in a temple. The left figure is Guandi, the god of War. He represents the historical hero General Guan Yu (about 161–220) whose exploits were celebrated in stories, in particular the famous Ming novel, *Romance of the Three Kingdoms*.

The right figure is Leigong, the god of Thunder in Chinese mythology and folk religion. People sometimes pay homage to Leigong because they hope he will exact revenge upon their enemies. Perhaps because of this vengeful association there are few temples dedicated to him.

### Bust of a young man, 100 BC–AD 100
Bronze
Made in eastern Mediterranean
41.9 cm x 27.9 cm
19.162

This head and bust of an *ephebe* – young man – was possibly inspired by the work of the famous Greek sculptor Polykleitos from the fifth century BC. It was probably once a complete standing figure. It was sold to Sir William as a representation of the god Hermes.

Greek and Roman statues of gods were often furnished with identifying symbols or clothing. Hermes might be shown with winged sandals and carrying a *caduceus* – a herald's wand. However, no trace of these remain and it is possible that this figure was originally a decorative element in a wealthy Roman's house, like the 'Idolino' statue in the Museo Archeologico Nazionale, Firenze, Italy.

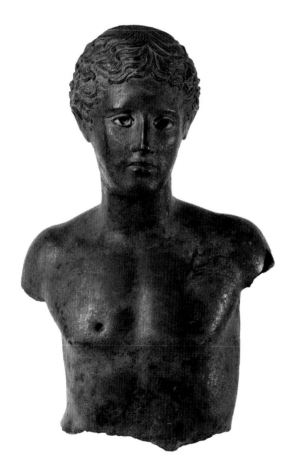

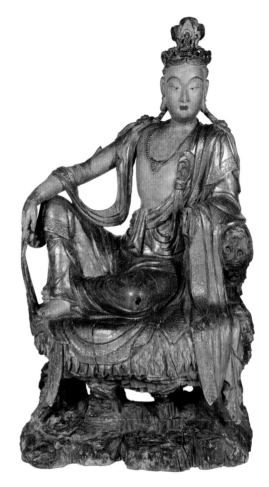

### Guanyin, goddess of Mercy, 1100–1200
Song Dynasty
Wood, polychromy, clay, gypsum, gold
Made in China
132 cm x 72 cm x 50 cm
50.59

This statue is a portrayal of the Guanyin known as the 'goddess of mercy and compassion'. Guanyin is the Chinese form of the Indian Bodhisattva Avalokiteśvara, who has attained the highest level of spirituality but remained on earth to help others. In Buddhist tradition, Guanyin hears and saves anyone who recites her name during a disaster. She remains the most famous figure in Buddhism in China, associated in particular with helping fishermen and pregnant women – fish being a symbol of fertility. This may be why thousands of temples scattered along the coast of China are dedicated to Guanyin.

### St Catherine of Siena, 1400–1500

Wood, polychromy
Made in Siena, Italy
overall: 137.1 cm
50.47

Caterina di Giacomo di Benincasa (1347–80) was one of the most influential and powerful women of the European Middle Ages who is celebrated today as St Catherine of Siena. She was born into a wealthy family and like most girls of her social standing was supposed to marry and have children. However, Catherine refused, and instead joined the Dominican Order as a lay member. During this time she reported experiences of mystical visions, most famously of being married to Christ. She also took an active role in politics, writing many letters and travelling to Rome, Italy, and Avignon, France, to mediate between arguing parties.

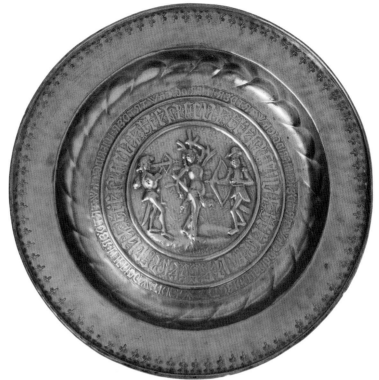

### Dish showing the Martyrdom of St Sebastian, 1500–1600

Brass
Made in Germany
47 cm x 47 cm x 4.8 cm
5-6.185

This dish is one of over 70 brass German dishes collected by William Burrell. The central medallions of these dishes show different religious or secular scenes usually surrounded by bands of Gothic majuscule (upper case) letters. The central medallion shows the Christian martyr St Sebastian at the moment of his execution. He is tied to a tree, semi-nude, flanked by archers who fire arrows into his body. St Sebastian has had many symbolic meanings throughout history. He was once the patron saint of plague victims and today he is regarded as a gay icon.

## Wall clock, about 1670
Walnut, oak, brass, steel, glass
Made by Henry Jones, London, England
42 cm x 42 cm x 11 cm
10.8

Henry Jones (1632–95) was one of the leading English clockmakers during the late seventeenth century. After completing his apprenticeship with Edward East (1602–96) in 1663, he was made a Freeman of the Clockmakers Company, and later became their Master in 1691.

This diamond-shaped wall clock contains an early example of a mechanism that uses a pendulum rather than a balance wheel to regulate its timekeeping. The use of a pendulum in this manner was patented by the Dutch mathematician and scientist Christiaan Huygens (1629–95) in 1656 and helped to improve the accuracy of clocks significantly to within seconds a day.

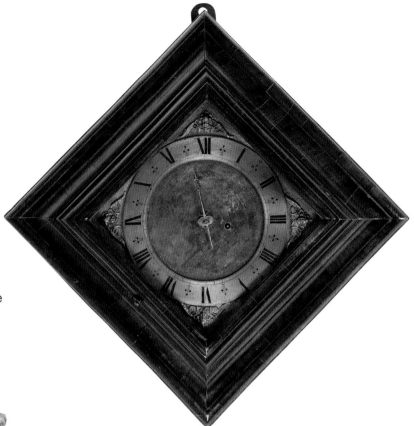

## Isabella Andreini, about 1749–52
Soft-paste porcelain
Made by the Chelsea Porcelain Factory, London, England
overall: 24.1 cm
39.57

Isabella Andreini (1562–1604) was an Italian actress. Together with her husband, Francesco (about 1548–1624), she managed the successful *commedia dell'arte* Gelosi theatre troupe who toured Europe performing for the aristocracy. Andreini was also a celebrated poet, and in 1601 became the first woman member of the literary society of the *Accademia degli Intenti* in Pavia.

Chelsea porcelain figures of Andreini are extremely rare – with only two other examples like the Burrell figure known to exist. Burrell once refused an offer to buy his Andreini figure for £4,000.

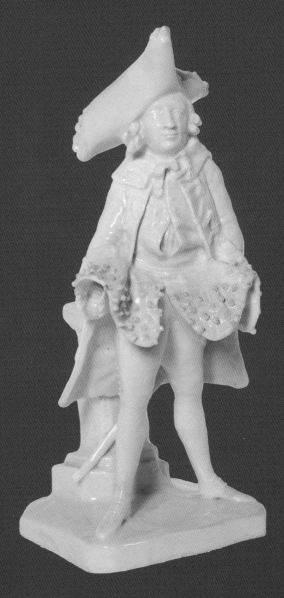

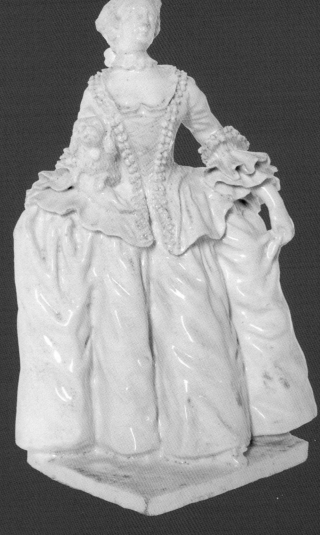

**Kitty Clive and Henry Woodward, 1750–52**

Soft-paste porcelain
Made by the Bow Porcelain Factory, London, England
overall: 27 cm
39.55, 39.56

Catherine 'Kitty' Clive (1711–85) was a celebrated actress and singer of the London stage in the eighteenth century, performing in some of the most high-profile ballad operas of the day. The figure of Clive is one of a pair with her fellow actor, Henry Woodward (1714–77), who was known for his comedic, pantomime performances.

The figures depict Clive and Woodward in their roles from David Garrick's satirical farce *Lethe* which they performed together in 1749. Clive and Woodward played a married couple – sometimes known as 'Mr and Mrs Riot' – who come to the mythical waters of the River Lethe to forget their troublesome marriage. Clive and Woodward were themselves notorious for feuding with each other, sometimes fighting during performances.

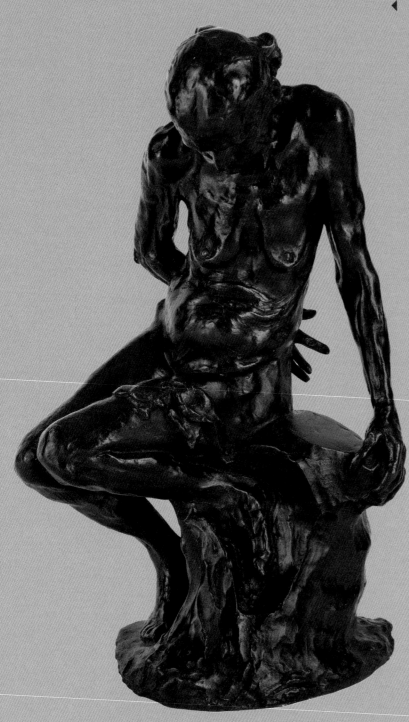

**She Who Was the Helmet-Maker's Once Beautiful Wife, 1885–87**
Auguste Rodin
Cast in bronze before 1889
51 cm x 32 cm x 24 cm
7.7

In no other sculpture is Rodin's fascination with flesh and form more evident than in this visceral study of aging. Originally exhibited as *Old Woman*, in 1891 the sculpture was given the title it has today, linking it to François Villon's poem, *Ballade de la Belle Heaulmière aux filles de joie* (The Ballad of the Beautiful Helmet-maker's Wife to the Ladies of Joy), written in about 1461. An elderly Italian woman called Maria Caira posed for the sculpture. She also posed for sculptors Jules Desbois (1851–1935) and Camille Claudel (1864–1943).

**Lilian Shelley, 1920** ▶
Jacob Epstein
Bronze
70.5 cm x 58 cm x 38 cm
7.3

Lilian Shelley (1892–after 1933) was a popular entertainer known for her risqué singing and dancing acts. One of her nicknames was 'the Merry, Mad, Magnetic Comedienne'. She performed at cabaret clubs including The Cave of the Golden Calf, arguably London's first gay nightclub. Promoting sexual freedom, it was a popular meeting place for artists and writers.

   New York-born sculptor Jacob Epstein (1880–1959), who designed parts of the club's interior, probably met Shelley there. His sculpture seems to suggest she is on-stage holding the last notes of one of her racy songs. The portrait is inscribed to Victoria Sackville-West, Baroness Sackville (1862–1936), the mother of Bloomsbury writer Vita Sackville-West (1892–1962), who was a socialite and patron of Epstein.

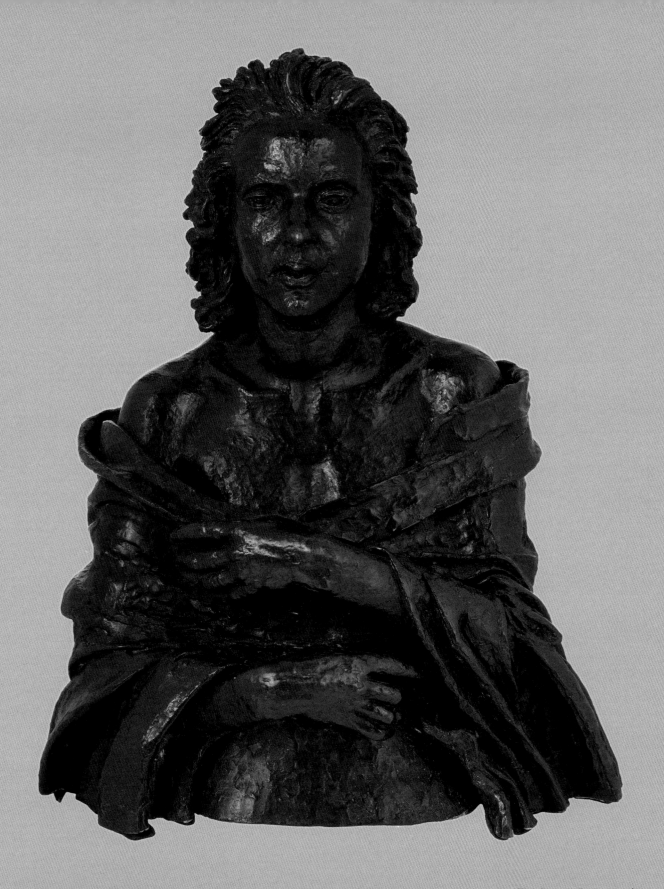

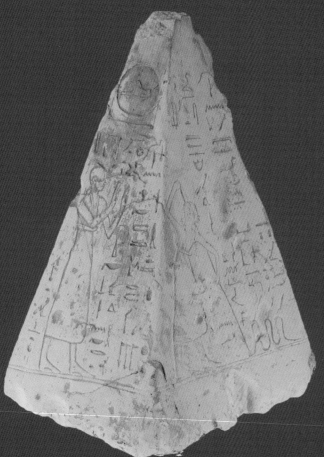

## Grave relief of a Palmyran woman, about 200–274
Limestone
Palmyra/Tadmur, Syria
25.6 cm x 23 cm x 19.4 cm
19.57

This portrait came from the tomb of a wealthy woman who lived in the ancient Syrian city of Palmyra. The site contains a large number of burials where names and family relations were identified through inscriptions surrounding portraits like this. Since the eighteenth century this site has been damaged and gravestones removed and sold to museums and collectors around the world. When an object is removed from its original setting it loses important information.

Sir William Burrell bought this thinking it was a portrait of the famous queen Zenobia who ruled Palmyra in 267–274 but as the inscription has been removed there is no evidence to back this up.

## Pyramidion of the Vizier Nespakashuty, 747–525 BC
Late Period
Limestone
Found in Tomb 216, Abydos, Egypt
38.5 cm x 21.9 cm x 25.6 cm
13.176

Placed at the top of a small pyramid at the entrance to a tomb, this pyramidion gives the name of the owner – Nespakashuty, Vizier to the pharaoh Shebitqo (around 707–690 BC) – and shows him worshipping the god Re-Horakty.

This pyramidion was found in 1907 during the excavation of a tomb complex in the vast burial ground at Abydos. This site contained the royal tombs of the 1st Dynasty and one of these was thought to be the grave of the Egyptian god Osiris himself. Abydos was used for thousands of years for burials and religious ceremonies.

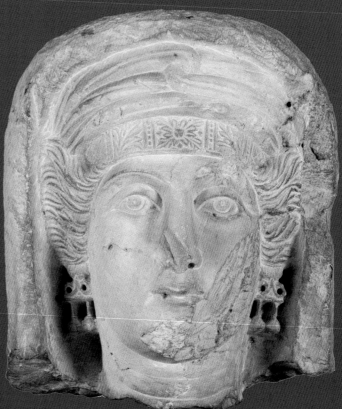

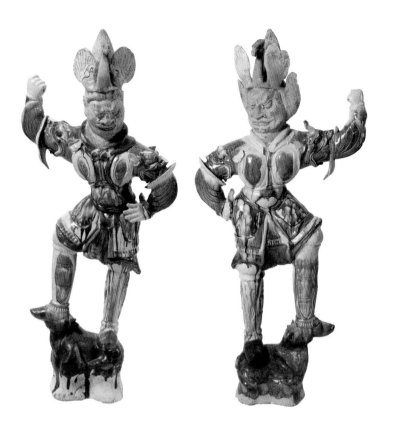

**Tomb guardians, 618–907**
Tang Dynasty
Earthenware, Sancai glaze
Made in China
91.6 cm x 45 cm x 20.2 cm
91 cm x 42.7 cm x 15.7 cm
38.183, 38.184

Lokapalas, the Guardian Kings, were originally Indian Deities that came to China with Buddhism. Some of their features are emphasized to make them appear more impressive. Large figures like these were popular funerary objects during the Tang Dynasty. They were meant to exorcise evil spirits for the deceased. Wearing a crested helmet, magnificent armour and tight, high boots, each figure has one hand raised high and the other on his hip. With his bushy eyebrows and bulging eyes enhancing the fierce expression on his face, the guardian king tramples a demon underfoot.

**_Châsse_ or reliquary casket showing the murder of Thomas Becket, Archbishop of Canterbury, about 1200–10**
Copper, gold, enamel, wood core
Made in Limoges, France
17.1 cm x 12.1 cm x 7 cm
26.6

This reliquary casket shows the murder of St Thomas Becket (b. 1118), Archbishop of Canterbury, which took place in December 1170. The site of his sacrilegious death immediately became a place of spontaneous popular pilgrimage. Becket was canonized in 1173 and his relics were carefully circulated in precious reliquaries, such as this, to promote devotion.

The casket came with collecting pedigree. Burrell acquired it from Leopold Hirsch (1857–1934) but it had also been owned by Walter Sneyd (1752–1829) and Horace Walpole, 4th Earl of Orford (1717–97), an English writer and antiquarian. Walpole's neo-Gothic home, Strawberry Hill in London, inspired the resurgence of interest in the medieval Gothic style that so dominated Burrell's home at Hutton Castle.

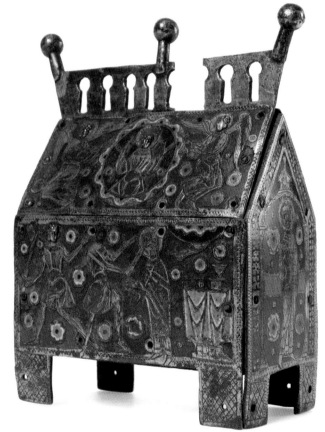

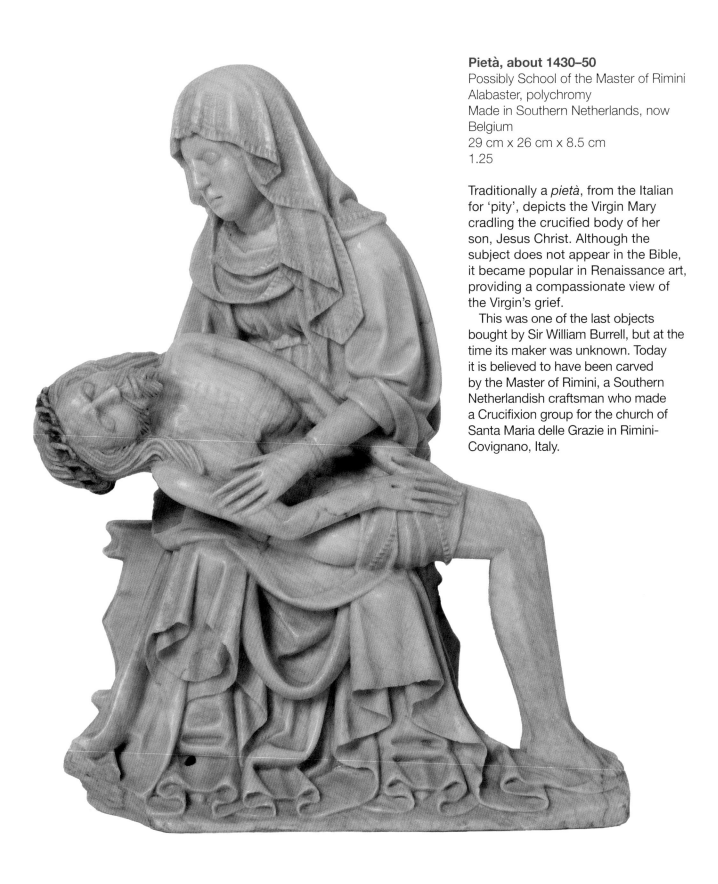

**Pietà, about 1430–50**
Possibly School of the Master of Rimini
Alabaster, polychromy
Made in Southern Netherlands, now
Belgium
29 cm x 26 cm x 8.5 cm
1.25

Traditionally a *pietà*, from the Italian for 'pity', depicts the Virgin Mary cradling the crucified body of her son, Jesus Christ. Although the subject does not appear in the Bible, it became popular in Renaissance art, providing a compassionate view of the Virgin's grief.

This was one of the last objects bought by Sir William Burrell, but at the time its maker was unknown. Today it is believed to have been carved by the Master of Rimini, a Southern Netherlandish craftsman who made a Crucifixion group for the church of Santa Maria delle Grazie in Rimini-Covignano, Italy.

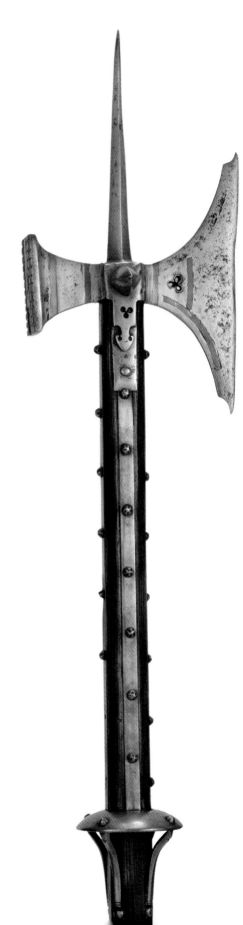

## Pollaxe, about 1450
Steel, wood, copper alloy
Made in France
175.3 cm x 17.6 cm x 8.5 cm
2.48

The name 'pollaxe' comes from an English word 'poll', meaning 'head'. It is a very effective fighting weapon and was wielded by warriors from across Europe. Constant training ensured lightning-fast strikes were dealt with lethal effect.

In addition to the main axe blade it has a hammer with textured face like that of a meat tenderizer, a vicious thrusting spike, and yet another spike at the haft-end: the queue (tail). An expert fighter of the time advises thrusting continuously with the queue at an opponent's eyes and groin. Swinging wildly to defend himself, he'll soon tire – and become much easier to finish off.

## Dirk, about 1700–1800
Steel, wood, copper
Made in Scotland
44 cm x 3.8 cm x 3.3 cm
2.108

Fearsome Highland warriors wielded the dirk along with their swords and targes (round shields) to devastating effect.

A major who fought for the government forces at the Battle of Culloden in 1746 tells us that: 'in this close confusion, where a man had no room to swing a sword or to lunge with a bayonet, the clansmen stabbed and thrust with the dirks in their left hands'.

It is deadly but also beautiful. The wooden hilt is skilfully carved in an intricate interlace design. Simplified versions of this design are worn with Highland dress across the world to this day.

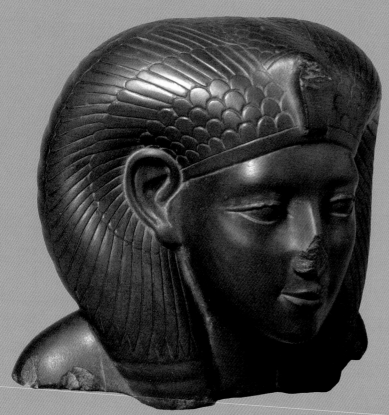

### Head of an Egyptian queen, 1295–1213 BC
Early 19th Dynasty
Schist
Made in Egypt
16.6 cm x 19.1 cm x 13.3 cm
13.132

This Egyptian queen is shown wearing a vulture cap with a rising cobra – *a uraeus* – at the front over a large wig. The vulture was associated with the goddess Nekhbet and the cobra with the goddess Wadjet. The feet of the vulture hold *shen* rings – a hieroglyph symbolizing eternal protection. The statue is broken below the line of the shoulders but the missing part of the wig may originally have had the curled ends of the hairstyle associated with the goddess Hathor.

As the Egyptians considered their pharaoh to be a living god, members of the royal family were often depicted with symbols associated with gods and goddesses.

### Head of Sekhmet, about 1390–1352 BC
18th Dynasty, reign of Amenhotep III
Granodiorite
Probably from Temple of Mut, Karnak, Egypt
31 cm x 32 cm x 42.2 cm
13.181

This head was originally part of a complete life-size statue. It has a rectangular slot in the top of the head which held a solar disc headdress. There may have been 730 of these figures – two for each day of the year. They were created for the mortuary temple of Amenhotep III (1411–1353 BC) at Thebes. Only traces of this vast temple now remain and many of these Sekhmet statues were probably moved across the River Nile to the temple of Mut at Karnak by Pinudjem I (d. 1031 BC) around 1050 BC.

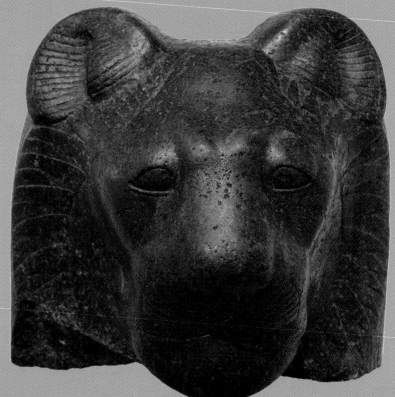

**Tanagra figurine,
about 300–200 BC**
Earthenware
Made in Greece, possibly Tanagra
29 cm x 13 cm x 9.8 cm
19.36

Figurines of this type have been found in many places in Greece but the main source is the cemetery for the ancient town of Tanagra. Illegal excavation took place in the late nineteenth century when many thousands of graves were destroyed by looters searching for figurines to sell in the antiquities market. As many of these figures were broken when they were found, they were often restored, repaired or even built up completely from arms, legs and bodies which were originally from other entirely separate figures. Modern copies were also produced by forgers. Although this is an original Tanagra figurine, some of the others in the Burrell Collection are modern fakes.

**Figure of a Luohan, 1484**
Ming Dynasty
Stoneware, polychrome enamel decoration on biscuit
Made in Shanxi Province, North China
overall: 126.7 cm x 63.5 cm
38.419

The figure known as 'Meditating Luohan' belongs to a group of at least four figures from the same temple, all dedicated on the same occasion and inscribed with the maker's name, Liu Zhen. A man named Wang Jinao, his wife Miaojin and son Wang Qin gifted this figure of a Luohan to an unknown northern Chinese temple in 1484. The priest Dao Ji conducted the offering ceremony. The date is inscribed on the left-hand side of the figure. Normally such an inscription includes the name of a private individual and indicates a family's desire to convey harmony to others in their community.

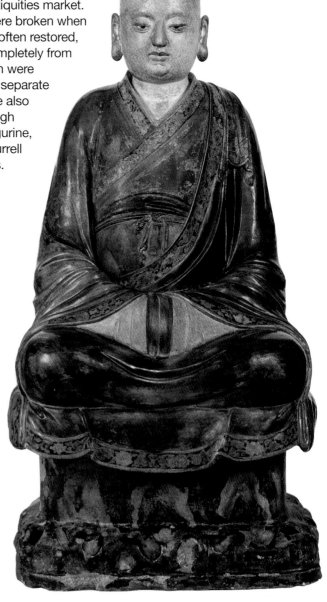

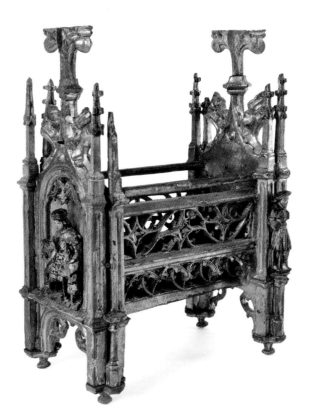

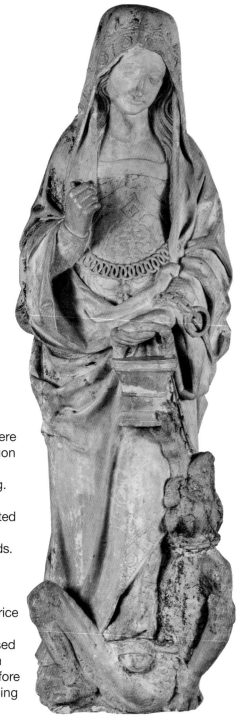

**Miniature cradle,
about 1480–1500**
Oak, polychromy, gold, painted
parchment
Probably made in Brabant, Southern
Netherlands, now Belgium
25.3 cm x 19 cm x 11.5 cm
50.239

This little cradle was probably once
part of a larger structure, suspended
within a framework in which it could
be moved to and fro. It is a rare
survivor of a type of devotion which
encouraged cloistered women to
come closer to God by caring for a
doll-like statue of the infant Jesus as
if it were a real baby.

   This took the form of washing,
swaddling and dressing the doll,
laying him in the crib beneath
embroidered sheets, rocking the
cradle and mimicking lulling a real
baby to sleep, for example through
song.

**St Martha and the tarasque,
1470–1530**
Limestone, traces of colour
Probably made in Provence,
Southern France
163 cm x 50 cm x 41 cm
44.20

St Martha travelled to France, where
she encountered a fearsome dragon
known as a *tarasque*. She tamed
this monster with prayer and song.
As in this sculpture, St Martha is
often shown standing on the defeated
dragon which is bound by chains,
and with a padlock held in her hands.

   In 1949 a London critic saw
St Martha exhibited in Glasgow
and questioned its authenticity.
Burrell immediately contacted Maurice
Stora, the original dealer. Stora
replied that the sculpture had passed
an expert vetting committee when
exhibited in Paris in 1937 – just before
Burrell himself purchased it – helping
to assuage Burrell's concerns.

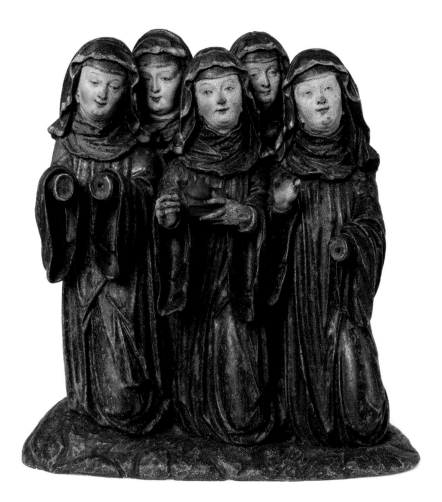

## St Walburga of Eichstätt accompanied by four nuns, about 1600–25
Limewood, polychromy, gold
Possibly made by Martin Zürn, in Bad
Waldsee, Swabia, Germany
44.4 cm x 35.5 cm
50.19

When Burrell bought this sculpture of five
nuns in 1935 he gave it the poetic title of 'The
Singing Virgins'. However, recent scholarship
has identified the central figure as St Walburga
of Eichstätt, an eighth-century West Saxon
princess and abbess. Much of the original
polychromy remains on the sculpture,
including the pink fleshy tones of the faces.
A similar group carving of a bishop and four
monks is currently held by the Suermondt
Ludwig Museum in Aachen, Germany, and is
thought to be from the same altarpiece as the
Burrell nuns.

## Eve After the Fall, 1880–81
Auguste Rodin
Cast in bronze by Alexis Rudier Foundry, 1928
170 cm x 49 cm x 60 cm
7.19

*Eve* was most likely based on one of Rodin's
favourite models, Adèle Abbruzzesi, or her
sister, Maria. During the course of sculpting
the figure, Rodin began to notice changes
in the model's body and learnt that she
was pregnant. The cold studio made it
difficult for the model to pose comfortably
and eventually she had to stop. Rodin later
described Eve's unanticipated pregnancy as
a 'fortunate accident'.

The sculpture remained in Rodin's studio,
unfinished, until it was eventually cast in
bronze in 1897. By that time Rodin had come
to appreciate its raw, rough appearance.

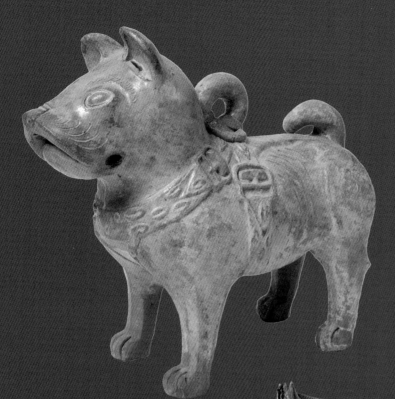

## Model of a dog, 206 BC–AD 220
Han Dynasty
Earthenware, lead glaze
Made in China
32 cm x 37.5 cm x 13.5 cm
38.57

Dogs were the first animals to be domesticated in China, where they were initially used for hunting. This tomb watchdog with its protective stance, head alert, legs squarely set, ears pricked up and eyes staring angrily, guards someone or something from harm. There is one reference to dogs in *The Book of Songs*, China's earliest anthology of poetry, some of which was possibly written as early as 1000 BC.

## Figure of a horse, 618–907
Tang Dynasty
Earthenware, Sancai glaze
Made in China
50 cm x 50 cm x 16.5 cm
38.133

In the Tang Dynasty (618–907) horses were used to carry troops and supplies over vast distances within China and played a decisive role in campaigns against hostile nomadic tribes outside the realm. As a result, their owners established close relationships with them, developing a powerful attachment to them. Sculptures of horses were included in burial offerings so that they could accompany the dead on their journey in the afterlife. The figures may also have been exhibited to show the status and identity of the deceased during the burial preparations and the funeral.

## Cockerel mosaic fragment, 100 BC–AD 0
Stone, plaster
Made in Rome, Italy
32 cm x 36.7 cm x 3.2 cm
42.3

Cockerels and chickens were domesticated by the Greeks and Romans and images of these birds are commonly found on coins from around the Roman Empire. Chickens were sometimes associated with gods, particularly the god Mercury, and were used as temple offerings. Their entrails were thought to be able to be used to predict the future. Although we do not know where this came from, a mosaic of this style and quality would have decorated the floor of a public building or a rich person's house. Similar quality depictions of birds have been found in excavations of a house floor on the Via Portuensis in Rome, Italy.

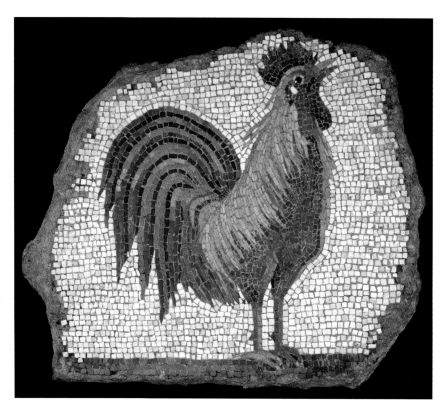

## Roof tile in the form of a lion, 1600–1700
Ming Dynasty
Earthenware, Sancai glaze
Made in Northern China
23.5 cm x 44.5 cm x 17 cm
38.637

This roof tile is a refined example of architectural components used in temples or palaces. Chinese roof tiles were generally glazed and therefore protected the building and its inhabitants from rain and snow much more effectively than thatch or wood. A tile lasted far longer, and its colour and form made the adorned roof stand out and gain prominence. During the Ming Dynasty it was believed that a building's roof was a platform of communication between the mortal and spirit worlds. People believed that having mythical creatures, such as this lion, standing guard on the roof would ward off evil.

**Nocturne: Grey and Gold – Westminster Bridge, 1872/74**
James McNeill Whistler
Oil on canvas
47.5 cm x 63 cm
35.642

In 1874 the American artist James McNeill Whistler (1834–1903) described this painting to a prospective buyer as, 'A very warm summer night on the Thames – lovely in colour they say – A Nocturne in blue and gold – view of the river from the Houses of Parliament.'

Influenced by the art of Japan, Whistler transformed the industrial riverside. He restricted his palette and minimized detail, focusing on the harmonious arrangement of colour and form. Using thin washes of paint, he created a poetic, ethereal vision. Burrell bought the painting in July 1938, perhaps regretting having previously sold three other Whistler oils.

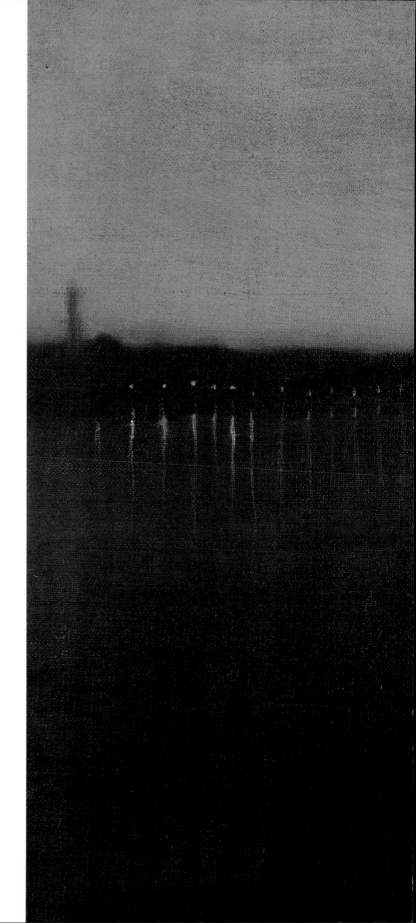

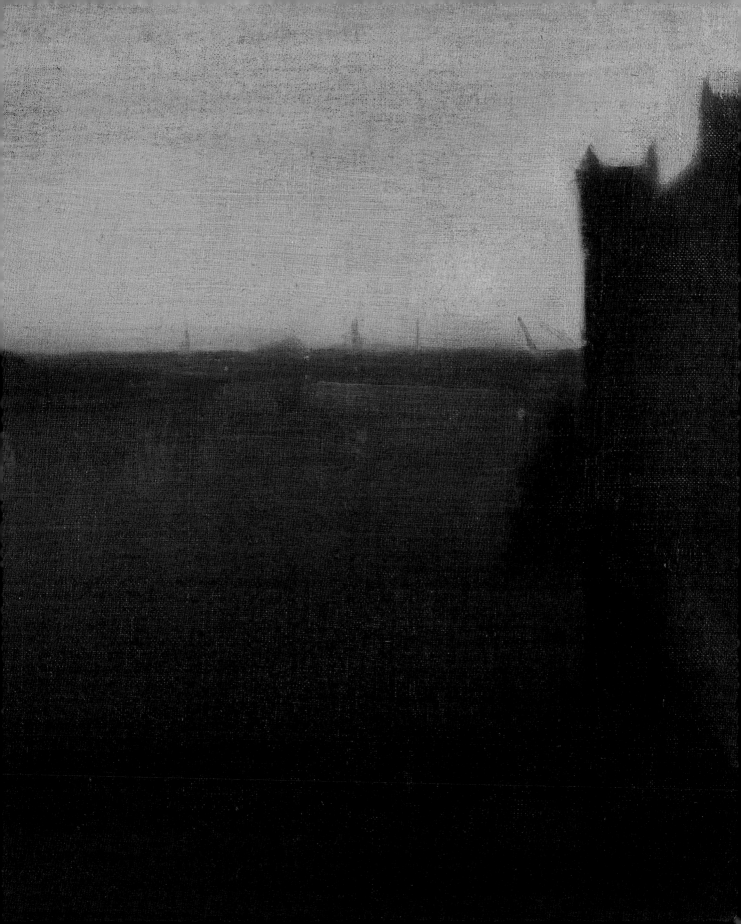

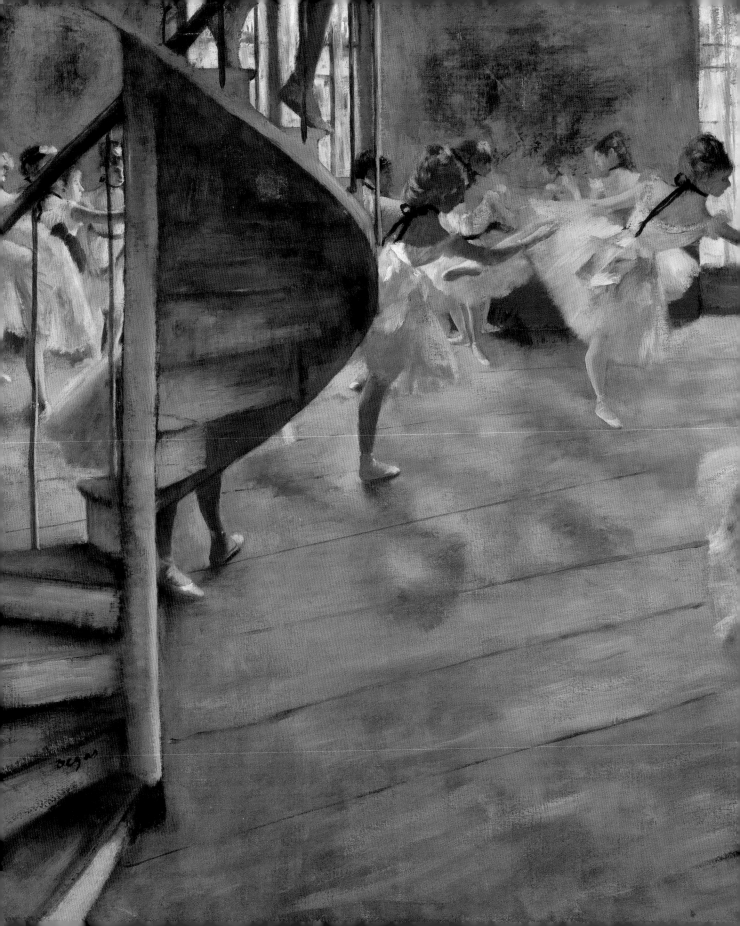

## The Rehearsal
## (La Répétition'), about 1874
Edgar Degas
Oil on canvas
58.4 cm x 83.8 cm
35.246

*The Rehearsal* was one of
the first depictions of ballet
painted by Edgar Degas
(1834–1917), a subject that
was to interest him for the
rest of his life. Whilst other
members of the corps
de ballet practise their
arabesques, a pair of cropped
dancer's legs descend the
staircase, and much of the
foreground features an
expanse of wooden floorboards.
These details help to create
the impression of a snapshot
in time, giving the sense that
we are standing in the room.
Despite its apparent spontaneity,
the scene was painted in the
studio based on photographs,
Degas' sketches, memory and
imagination.

William Burrell purchased
23 works by Degas over the
course of his collecting career.

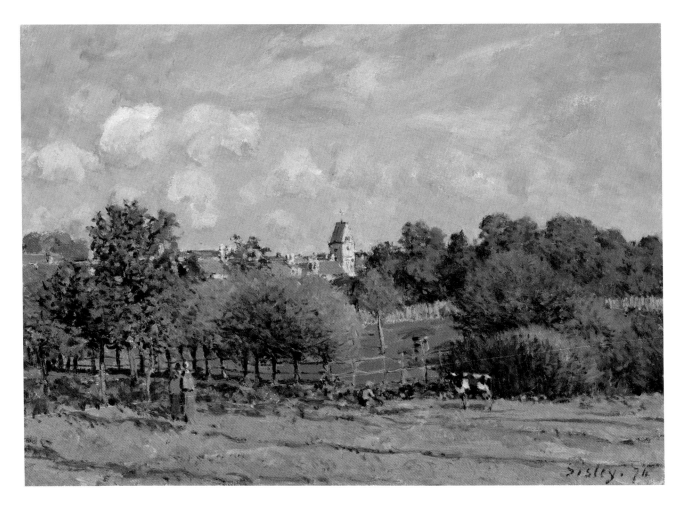

**The Bell Tower at Noisy-le-Roi, Autumn, 1874**
Alfred Sisley
Oil on canvas
46 cm x 61 cm
35.625

This tranquil autumnal scene shows the small village of Noisy-le-Roi, which lies just north-west of Versailles, France. It is one of the finest landscapes by Alfred Sisley (1839–99), who worked outdoors, and demonstrates how his modified palette, with its subtle selection of colours and tones, has captured both a specific time of day and a certain time of year, as the afternoon sun begins to recede and the season changes to autumn.

It was painted in 1874, the year that a small group of artists including Edgar Degas, Claude Monet (1840–1926), Camille Pissarro (1830–1903), Berthe Morisot (1841–95) and Alfred Sisley (1839–99) decided to mount their first exhibition in Paris. Known as the French Impressionists, these artists organized a further five exhibitions, their art creating a lasting impact across the world.

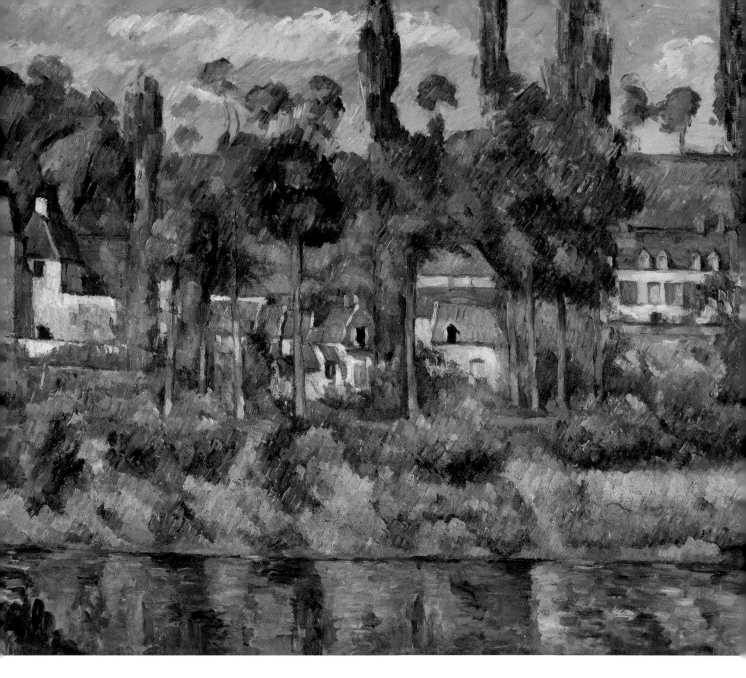

**The Château of Médan,
about 1879–80**
Paul Cézanne
Oil on canvas
59 cm x 72 cm
35.53

This canvas was painted by Paul Cézanne (1839–1906) while staying with his childhood friend, Émile Zola (1840–1902). The chateau, on the banks of the River Seine, had been purchased by Zola in 1878 with the profits of his successful novel *L'Assommoir*.

Despite showing a real scene, Cézanne wanted to leave us in no doubt that we are looking at a painting. He brings our attention to the way the oil paint is thickly applied to the canvas using a series of 'constructed' parallel brushstrokes, diagonal for the sky, trees and riverbank and horizontal for the water. Cézanne is often called the 'Father of Modern Art' for innovative techniques such as these, which would have seemed radically modern at the time.

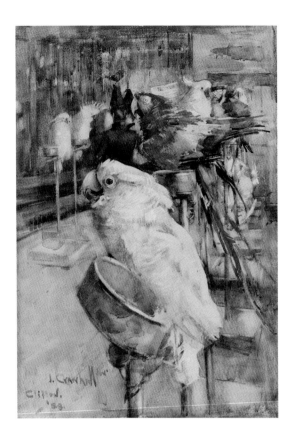

**The Aviary, Clifton, 1888**
Joseph Crawhall
Watercolour with bodycolour on paper
50.8 cm x 35.6 cm
35.77

This colourful watercolour was one of the first works by Joseph Crawhall (1861–1913) that Burrell bought. Inspired by the 'Parrot House' at Clifton Zoo, Bristol, it demonstrates Crawhall's skill in capturing the character and vitality of birds, and also his sense of humour. A mynah bird appears to perch on top of the tall black hat of Crawhall's sister, or possibly her friend, their costume quite outdone by the bright plumage of the macaws. The watercolour brought Crawhall international recognition, winning a gold medal in Munich in 1890. However, always critical of his own work, Crawhall had originally thrown it in the bin, where it had been rescued by Glasgow art dealer William Bell Paterson (1852–1952).

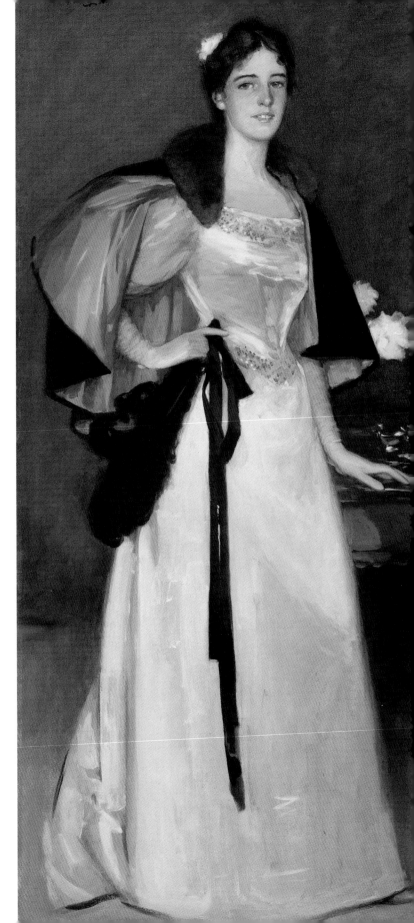

**The White Girl, 1918–19** ▶
S. J. Peploe
Oil on canvas
61 cm x 40.7 cm
35.587

A girl, dressed as a Pierrot, sits pensively on a bed. Pierrot clowns were characterized by their melancholy. Virtually monochromatic, this painting contrasts with the brightly coloured landscapes and decorative still lifes that Scottish Colourist S. J. Peploe (1871–1935) usually produced. World War I brought trauma, loss of life and huge societal changes. It also caused Peploe to question his artistic identity. Rejected for active service on health grounds, he was left depressed and unable to work. Glasgow art dealer Alexander Reid (1854–1928) tried to support him, promoting his work to collectors like Burrell. This painting is one of seven works by Peploe that Reid sold to Burrell between 1919 and 1926.

◀ **Portrait of Miss Mary Burrell, 1894–95**
John Lavery
Oil on canvas
183 cm x 91.5 cm
35.297

Wearing a white silk evening dress and velvet cape, with a black ostrich feather fan, Mary Burrell (1874–1964), William's sister, is presented as the epitome of sophistication and refinement in this full-length portrait by Glasgow Boy painter Sir John Lavery (1856–1941). The furniture, Chinese porcelain and silver are all placed to create a balanced composition and make an aesthetic statement about the sitter's beauty and her collecting taste. The background is undefined, but a contemporary photograph suggests Mary posed in the Burrells' luxurious Devonshire Gardens home in Glasgow's West End. The painting was commissioned by William Burrell on the occasion of her twenty-first birthday.

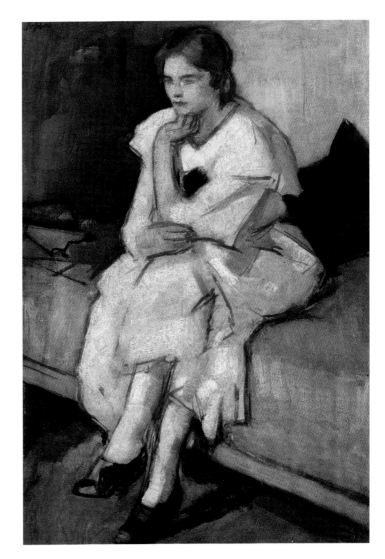

**Verdure with Thistles,
about 1490–1520**
Wool
Made in Brussels or Bruges,
Southern Netherlands,
now Belgium
271 cm x 249 cm
46.108

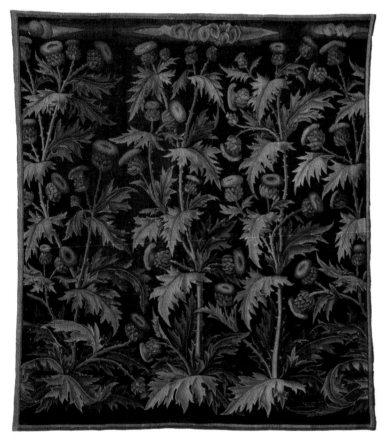

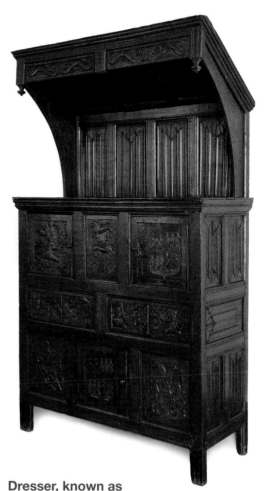

**Dresser, known as
the John Wynn Dresser, about 1540**
Oak
Made in Wales
242.2 x 143.5 x 58.4 cm
14.436

Arrangements of lush green vegetation, known as *verdure*, were popular designs for tapestries during the late 1400s and early 1500s. They were originally made in shades of green using dyes that were often a mixture of blue and yellow. With time the yellow dye has faded, so many of these tapestries now look blue. Often created in sets, verdure tapestries were hung together to create a unified interior decoration scheme. Plants were shown naturalistically, but often did not represent a specific species or meaning. Thistles were particularly favoured, not only appearing on tapestries displayed in Scotland, but also on sets made for European rulers.

This oak dresser was made for John Wyn ap Maredudd (d. 1559) – in English, John Wynn – of Gwydir Castle, North Wales. The shelf of the top canopy would have been used to display the Wynn family silver and plate, with the cupboards below used for storage. Carved with heraldic armorials of the Wynn family ancestry and Renaissance-style grotesque motifs, these decorations were painted in bright colours when the dresser was first made. John Wynn's initials 'I' and 'W' have been carved as a prominent symbol of his ownership and status.

**Chair, with the Cann family coat of arms, 1699**
Walnut, cane
Made in England
140.5 cm x 74.2 cm x 60.5 cm
14.195

Caned chairs grew in popularity with both the aristocracy and merchant classes from the late seventeenth century. London was the main centre of manufacture, with the rattan cane for the chair backs and seats imported from Asia. Burrell collected several exquisite walnut and cane chairs, including this one, with an ornamental crest carved with the Cann family, who were Bristol merchants. The front stretcher is carved with an interlaced cipher of 'WC', probably the initials of Cann family member William Cann, 2nd Baronet of Compton Greenfield (d. 1698).

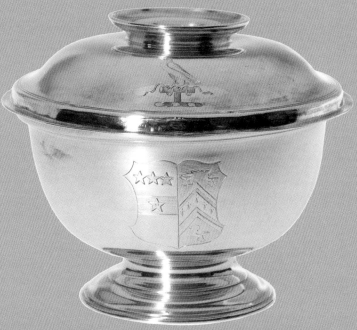

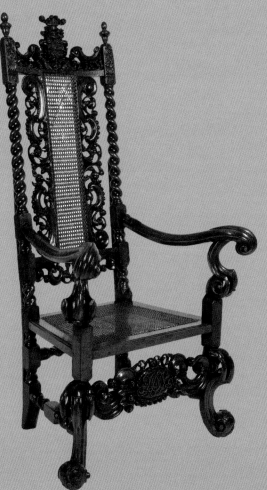

**Sugar bowl with lid, 1729–30**
Elizabeth Goodwin
Silver
Made in London, England
9 cm x 11.5 cm x 11.5 cm
43.20

For those wealthy enough to afford it, the drinking of tea and coffee sweetened with sugar became increasingly fashionable during the eighteenth century. Services for taking tea included sugar bowls made from expensive materials, like silver, and sometimes decorated with the coat of arms of its owner. The cover of this bowl is engraved with the heraldic crest of the Towneley family, Lancashire; a belled falcon on a perch. The bowl would have held small lumps of sugar, cut from a large sugar cone with tongs. Sugar cones were imported from British plantations in the Americas and Caribbean where enslaved Africans were forced to work in inhumane conditions to produce sugar.

### The Ham, about 1875–80
Édouard Manet
Oil on canvas
33 cm x 41 cm
35.308

This still life by the French artist Édouard Manet (1832–83) focuses on a single joint of ham. However, X-rays of the painting show that Manet had originally included other objects in the composition that he later painted out deliberately in order to create this simpler scene. The textures of the fat, rind and bloom on the meat were achieved by applying the paint in thin, translucent layers.

   Prior to its 1936 purchase by Sir William Burrell the painting had at one time been owned by Edgar Degas. It appeared in a photograph of his apartment from 1895.

### Women Drinking Beer, 1878  ▶
Édouard Manet
Pastel on primed linen canvas
61 cm x 51 cm
35.305

Whilst appearing to be a candid scene of everyday life, this pastel was in fact drawn by Édouard Manet using models posed in his studio. It was exhibited in Manet's solo show in the offices of the literary review *La Vie Moderne* in April 1880.

   Prostitution was rife in Paris during Manet's time. However, it was also illegal and therefore often well-hidden. It is unclear whether Manet intended to show two unescorted women taking a break from soliciting or if they are just meant to be fashionable Parisiennes. Beer was viewed traditionally as provincial compared to wine, but by the 1870s it had become a chic drink in Paris.

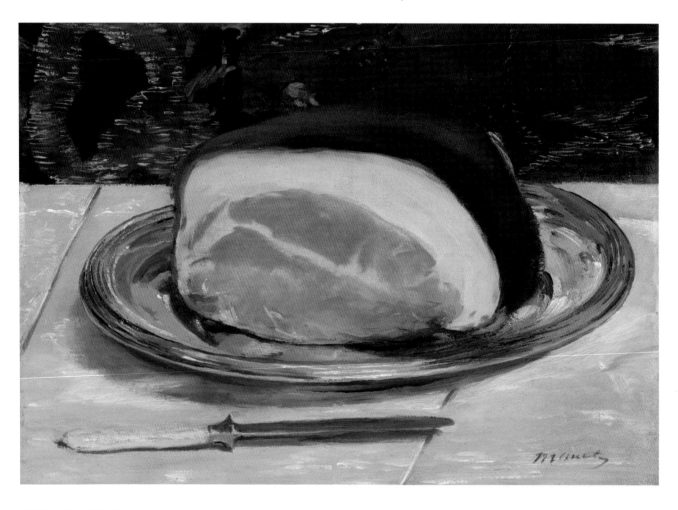

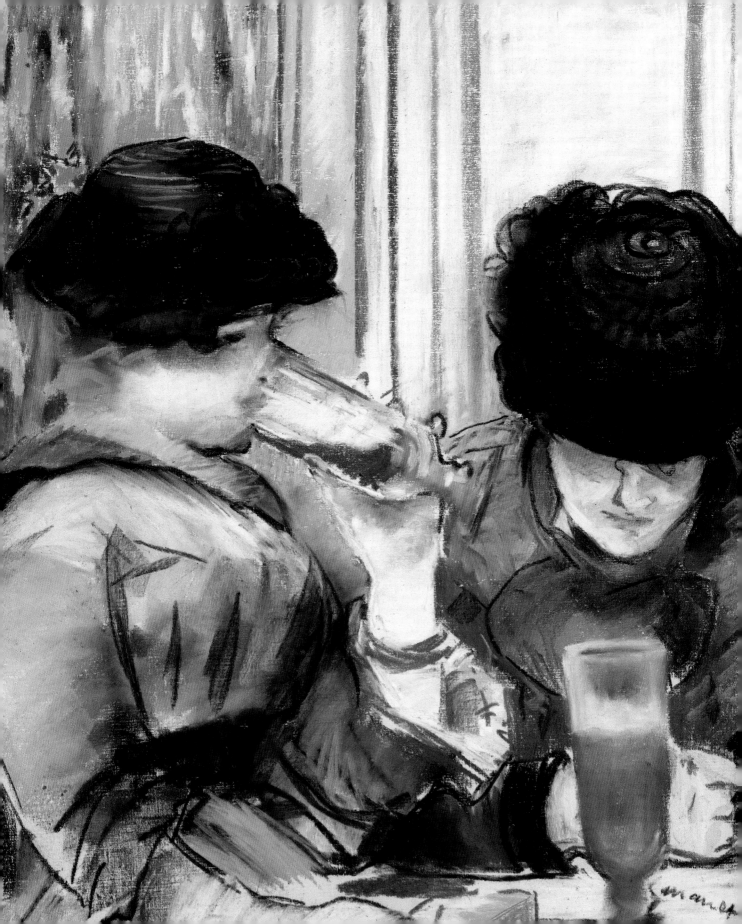

### Elizabeth Wriothesley, née Vernon, Countess of Southampton, 1622

Possibly School of Marcus Gheeraerts the Younger
Oil on canvas
200 cm x 129 cm
35.672

This full-length formal court portrait of Elizabeth Wriothesley, Countess of Southampton (1572–1655), aged 50, depicts her wearing a black velvet dress adorned with pearls and precious stones. Former Maid of Honour to Queen Elizabeth I (1533–1603), she is shown in sumptuous surroundings, standing on a precious Turkish carpet, framed by heavy embroidered curtains. Her hand rests on a richly embroidered chair that was probably given to her at the coronation of James VI of Scots (1566–1625) as James I of England in 1603.

The portrait has been attributed to the School of Marcus Gheeraerts the Younger, a Flemish artist working in the Tudor and Jacobean/Stuart courts, who had a large studio workshop with many assistants.

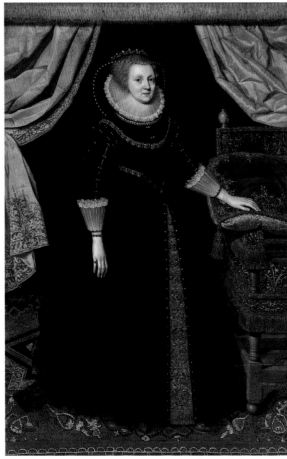

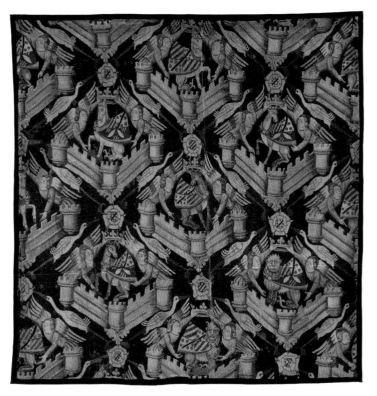

### Armorial Tapestry of Beaufort, Turenne and Comminges, about 1350–95

Wool
Possibly made in Paris or Arras, France
225 cm x 224 cm
46.50

Coats of arms were only granted to important individuals and therefore were often shown off through their repeated use on personal possessions and interior furnishings. This tapestry incorporates the arms of Guillaume III Rogier (1310–95), Count of Beaufort and Viscount of Turenne, and his wife, Aliénor de Comminges (d. 1397). The battlements are a visual pun on his name, Beaufort, which means 'beautiful strong' in French. Storks are associated with Avignon, the Papal State of which Rogier was Rector, and the roses refer to his family's historic title of 'Lords of the Rose Gardens'.

## Peasant Children, about 1630–40
Attributed to Antoine Le Nain
Oil on copper on wood
22 cm x 28 cm
35.578

The Le Nain brothers, Antoine (about 1600–48), Louis (about 1603–48) and Mathieu (1607–77), were French artists who were inspired by Dutch art. They produced a number of paintings showing scenes of everyday life, especially poor rural labourers.

During the 1600s very thin sheets of copper were favoured by artists as they could paint fine details on the smooth surface. Unlike canvas, paint on copper does not fade over time, the colours remaining jewel-like centuries after they were first applied.

This painting is one of two almost identical versions that were bought by Sir William Burrell. He donated the second, along with other items, to Berwick Museum and Art Gallery in Northumberland.

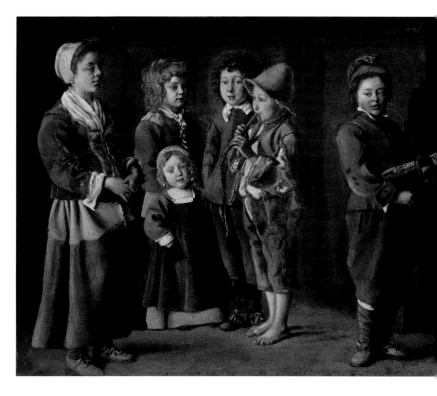

## Portrait of a Girl Aged One with a Rattle, 1635
Dutch School
Oil on panel
107 cm x 84 cm
35.253

Although both boys and girls wore skirts at the time this was painted, we can tell this is a little girl by her tightly scraped-back hairstyle and coral necklaces. The clothes and objects shown in this portrait were chosen to show off how wealthy the family of this infant was. Her bodice is of black silk cut velvet, which was one of the most expensive fabrics available and her crisp white linen cap, collar and apron are all trimmed with luxurious lace. The silver rattle or *rinkelbel* she holds in her hand served both as a toy and as a talisman; at one end are bells that when shook were believed to keep evil spirits at bay.

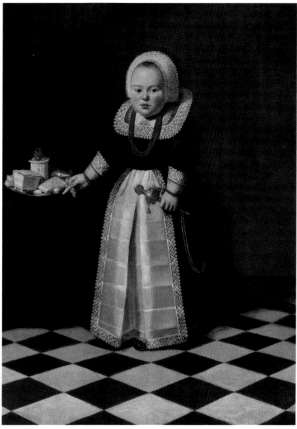

## Embroidered panel, about 1700–15

Linen, wool, silk
Probably made in England or possibly
Scotland
39.3 cm x 32.3 cm
29.92

This embroidered panel depicts a woman in a red mantua set in a stylized landscape with trees, flowers, and parrot. An enslaved child follows holding her train, dressed as in page uniform of red and white hat, yellow coat, and red stockings.

Enslaved African boys and girls were brought to Britain in the eighteenth century by slave traders and merchants. They were forced to be domestic servants. It was common for young Black enslaved boys to wait in attendance on their owners as pages. Like the child in this embroidery, they were made to wear colourful liveries.

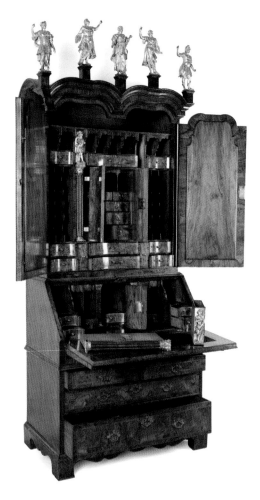

## Writing cabinet, about 1720–30

Oak with walnut and burr walnut veneer, brass, gold, mirrored glass, green baize
Made in England
260 cm x 139 cm x 60.7 cm
14.331

This theatrical piece of furniture, veneered in burr walnut, combines cabinet, writing desk and bookcase. Behind mirrored doors are fluted pilasters with gilded capitals and figures, a writing slope lined with leather, holes for letters and numerous secret compartments and drawers. The cabinet is mounted with gilded classical heroes including Apollo (god of music, truth and prophecy), Mars (god of war) and Justice.

The cabinet once belonged to Rosalind Howard, Countess of Carlisle (1845–1921), known as the Radical Countess. She was an activist who campaigned for women's education and the right to vote, and was also a leader in the Temperance Movement.

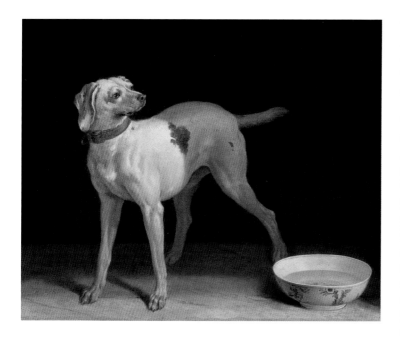

### The Dog, 1751
Jean-Baptiste Oudry
Oil on canvas
90 cm x 113 cm
35.585

The son of a Parisian artist, Jean-Baptiste Oudry (1686–1755) was trained by Nicolas de Largillierre, one of France's leading portrait painters. Despite this, Oudry became famous for his scenes of hunting and animals, in particular dogs. Whilst the majority of his dog paintings are set outside against a landscape, here the dog, perhaps a pointer, stands in a dark panelled niche that provides a stark contrast to its mostly white coat. Designed to cover the opening of a fireplace when it was out of use during the summer months, this painting would have given the illusion of an alert, life-sized dog in the room.

### The Ray, about 1728
Jean-Siméon Chardin
Oil on canvas
81 cm x 64 cm
35.57

Jean-Siméon Chardin (1699–1779) was a French artist famous for his paintings of simple objects, often food or kitchen items. At the time the still life genre was seen by the art world as unimportant. Nevertheless, Chardin's skilful rendering of texture and colour saw him carve out a reputation as a master of the still life, and even the French king Louis XV (1710–74) became a patron.

Chardin has balanced the stillness of the dead sea creature, suspended on a hook, with a lively cat, who tentatively reaches a paw towards two oysters. A knife, balancing on a ledge in the foreground, adds further interest, and helps to create a sense of depth and perspective.

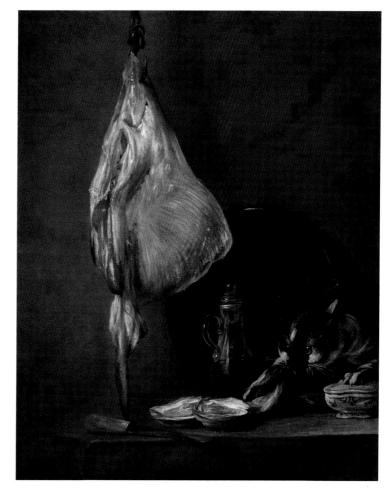

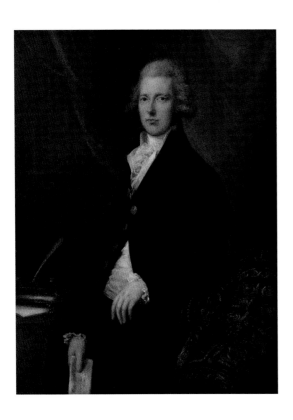

## William Pitt the Younger, about 1790

Gainsborough Dupont
Oil on canvas
127 cm x 101.6 cm
35.263

William Pitt the Younger (1759–1806) famously became the youngest ever British Prime Minister in 1783, aged only 24. In this elegant portrait he holds a letter addressed to him as 'First Lord of the Treasury'. His ceremonial robes are draped over a chair.

Pitt sat for the fashionable portrait painter Thomas Gainsborough (1727–88) in 1787. This portrait from the collection of the Dukes of Richmond and Gordon at Goodwood House, West Sussex, was one of many later authorized copies made by the artist's nephew Gainsborough Dupont (1754–97). It was exhibited throughout the 1800s as an autograph work by Gainsborough and Sir William Burrell bought it in this belief in 1931.

## Portrait of Edmond Duranty, 1879 ▶

Edgar Degas
Gouache with pastel enlivenment on linen
100 cm x 100 cm
35.232

In this informal portrait Edgar Degas (1834–1917) shows his close friend, the art critic and novelist Edmond Duranty (1833–80) seated in his study, surrounded by colourful books, papers, magnifying glasses and ink. Duranty's 1876 essay, *Le Nouvelle Peinture* (The New Painting), was closely linked to one of the main ideas of Impressionism, that art should find its inspiration in everyday life. With his portrait of Duranty, completely surrounded by the tools of his trade, Degas illustrates this concept perfectly.

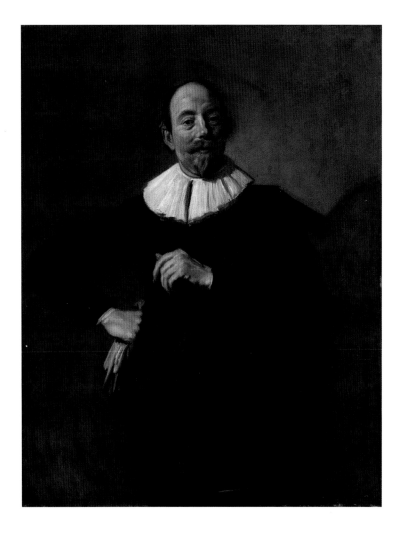

### Portrait of a Gentleman, about 1630–35
Frans Hals the Elder
Oil on canvas
117 cm x 92 cm
35.276

Commissioning a portrait was a way for citizens of the Dutch Republic to record their wealth and status. This prosperity was due to the young republic's global seafaring activity, which included aggressive colonialism and involvement in the transatlantic slave trade.

This painting was discovered in poor condition in an English manor house in 1937. It was restored and sold to Sir William Burrell as a painting by Frans Hals the Elder (1580–1666) for £14,500, the most he ever paid for an item. Due to the historical damage, questions over its authenticity have been raised, but it is believed that the finely painted face is the work of the master. Other areas, such as his dress, may have been painted by artists in his workshop.

### Virgin and Child, about 1485–88  ▶
Giovanni Bellini
Oil on panel
63.1 cm x 48.5 cm
35.4

Venetian Giovanni Bellini (1430–1516) was one of the first Italian artists to use oil paints extensively rather than tempera, a type of paint made by mixing colour pigments with egg. Oil paints allowed bright colours to be subtly modelled to produce a more naturalistic image. Here the Madonna in her traditional blue mantle supports the Christ Child as he balances on a marble balustrade. Christ holds a string with a sprig on the end, possibly a myrtle sprig (*virga*), symbolizing that he was a shoot from the tree of Jesse (Isaiah 11:1).

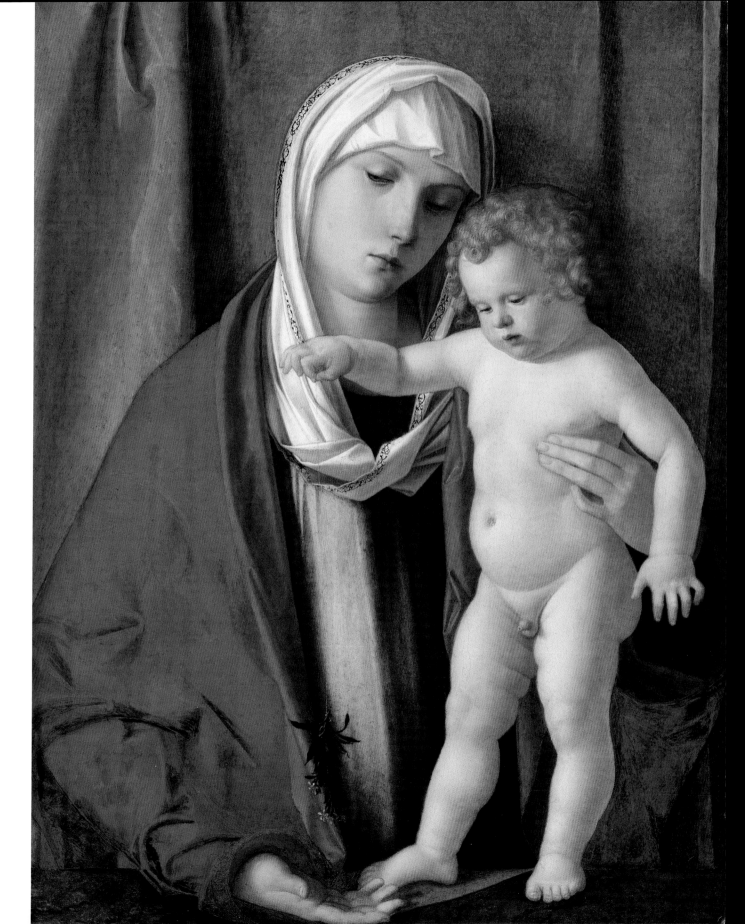

## Mrs Ann Lloyd, about 1744
William Hogarth
Oil on canvas
76 cm x 64 cm
35.283

Ann Lloyd (1716/17–57) was the daughter of William and Anne James of Ightham Court. This portrait probably commemorates her marriage to Thomas Lloyd in 1743. Around 1744 the English artist William Hogarth (1697–1764) also painted portraits of Ann's brothers William and Richard, and her cousin Elizabeth.

Hogarth's portraits are known for their directness and lack of idealization. He did not use preparatory drawings, but painted directly on to the canvas, often in a slap-dash manner. Here paint from the background overlaps with Ann's dress. There are also significant *pentimenti*, or changes of mind. Ann was originally painted wearing a flowered hat and her right arm was in a different position.

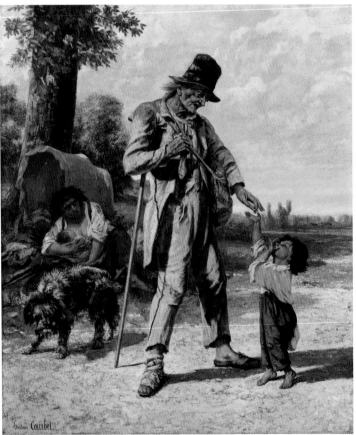

## Charity of a Beggar at Ornans, 1868
Gustave Courbet
Oil on canvas
211 cm x 175 cm
35.64

Gustave Courbet (1819–77) was the leading artist in the Realism movement who created a scandal when he chose to depict everyday subjects on a scale of canvas previously used only for classical or historical paintings.

This painting, Courbet's last in his 'roadside' series, was shown in the Paris Salon – a huge annual exhibition of art – and was so controversial that even his friends thought he'd gone too far by choosing to depict such an unattractive central figure. Courbet was a politically active artist who spent some time in jail for his actions during the French Commune. This painting can be read as a statement that it is only the poorest in society – in this case a bandaged and ragged old beggar man – who can be relied upon to help their fellow poor.

### Chrysanthemums, 1874

Ignace Henri Jean Théodore Fantin-Latour
Oil on canvas
55 cm x 65 cm
35.260

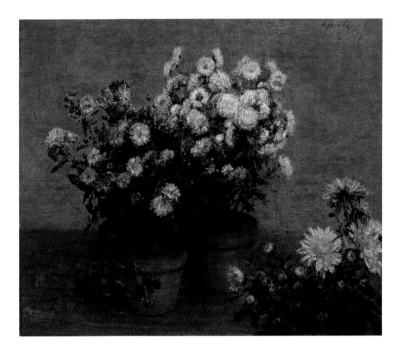

A contemporary of the French Impressionists, Henri Fantin-Latour (1836–1904) preferred to work indoors in contrast to his friends Claude Monet (1840–1926), Pierre-Auguste Renoir (1841–1919) and Camille Pissarro (1830–1903), who painted directly from nature outdoors. This resulted in a different use of colour from his peers, with objects appearing darker and cooler in tone, giving them a more realistic feel. Fantin-Latour became famous in particular for his paintings of flowers, and his depictions of roses were so popular that a blush-pink variety of the flower was named after him. While the majority of his paintings contain cut blooms arranged in a vase, in this painting chrysanthemums are shown as living plants still growing in their earthenware pots.

### Pink Roses, 1920–25

S. J. Peploe
Oil on canvas
61 cm x 50.8 cm
35.588

This still life is typical of the stylized studies of fruit, flowers and ceramics that Scottish Colourist painter S. J. Peploe (1871–1935) produced in the early 1920s. Each object is simplified and placed to create a balanced, decorative whole. Influenced by his hero, the French Post-Impressionist artist Paul Cézanne (1839–1906), Peploe returned to paint the same objects again and again as he rigorously explored colour, form and pictorial composition.

Peploe's still lifes were considered startlingly modern by contemporary critics who found their concentration on formal values difficult to understand. However, there were still collectors like Burrell who were prepared to buy them.

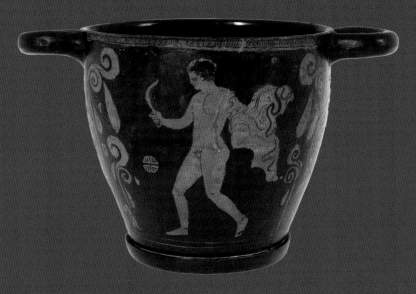

**Skyphos pot, about 360–350 BC**
Earthenware, red figure decoration
Made in Apulia, Southern Italy
21.2 cm x 35.5 cm x 23.5 cm
19.45

Potters in the Greek cities of southern Italy used the same methods used in Ancient Greece to create ceramics with black gloss decoration. In this case, the black gloss covers the background, while the foreground images show the original red colour of the clay.

On one side the design shows a male athlete holding a *strigil*, a metal curved implement used to scrape the skin while bathing, and a *himation* – a cloak or wrap. The other side shows a female follower of the god Dionysus, identified by the distinctive *thyrsos* with the pine cone top, in her right hand.

**Hunping funerary jars, about 1250–1320**
Song–Yuan Dynasty
Stoneware
Made in China
77 cm x 18.3 cm x 18.3cm
76 cm x 18 cm x 18cm
38.222, 38.223

This pair of elaborately decorated jars are known as *hunping* or soul jars. Their decoration includes dragons, Immortals, *ruyi* or ceremonial sceptres, and finials in the form of birds.

*Hunping* jars were created as burial objects to contain offerings, such as rice, for the dead. Some people think that the jars were intended as dwelling places for the soul after death, hence their name. By honouring the dead in this way, the living could hope for protection.

### The Tondi Family Shield dish, 1430–70

Mudéjar Period
Earthenware, cobalt blue underglaze,
overglaze lustre decoration
Made in Manises, Valencia, Spain,
for the Tondi family, Siena, Italy
45.1 cm x 44.9 cm x 6.6 cm
40.25

Descendants of Muslim potters in the
Spanish region of Valencia made dishes
like this for wealthy clients around the
Mediterranean. This dish bears the family
crest of the Tondi family of Siena, Italy.
The Tondi family was rich and powerful,
and part of the local government of Siena.
The Tondi shield here is surrounded by
radiating and intertwining tendrils of bryony
flowers, blue parsley-shaped leaves and
gold-coloured fern leaves. Such dishes were
displayed on dressers to reflect the privileged
status of their owners.

### The Coventry sword, about 1460

Steel, gold, silver, ivory, copper alloy
Made in England
27.5 cm x 19.5 cm x 3.5 cm
2.83

Weapons can serve as powerful symbols.
The pommel of this elaborate sword hilt is
decorated with the heraldic coat of arms
of the kings of England and the City of
Coventry: the elephant and castle. The
cross-guard is festooned with images of the
white rose and the sun in splendour. This
stylized sun design was the personal badge
of King Edward IV (1442–83).

By granting a civic sword to a city, rulers
ensured the loyalty of its citizens and
recognized their rights. Highly decorated
civic swords are still used in ceremonies
and royal processions across Europe.

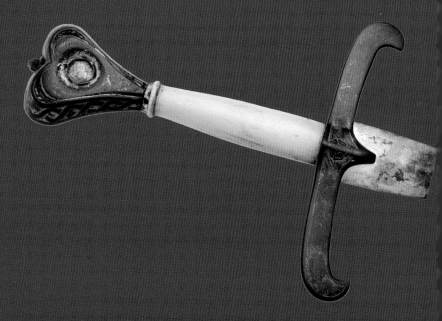

**Bell salt, about 1603–04**
Silver-gilt
Made in London, England
23.5 cm x 12 cm x 12 cm
43.152

This elaborate silver container was made to hold salt. In the 1600s, salt and pepper were precious commodities used on special occasions.

   Known as a bell salt because of its shape, this item can be split into three distinct parts. The larger part at the base was placed by the host, to help signal their importance. The middle segment and the crowning 'sprinkle' or salt and pepper box, were placed at the end of the table. A salt could also be personalized, as in this case, with the initials 'HTM' appearing on the bottom segment.

*Meiping* **vase, 1662–1722**
Qing Dynasty, Kangxi Period
Porcelain, underglaze blue, overglaze enamel decoration
Made in Jingdezhen, China
39.9 cm x 19.8 cm x 19.8 cm
38.452

This appears to be the only Chinese *meiping* vase known to have been decorated with an Arabic script. The Islamic mystical sayings occupy three squares and one circle on the upper part of the body. Meant to be read in any order, they tell of giving thanks to God, acknowledging his bounty, confirming that the best food is that eaten with God's permission, and that the pure are blessed. The 'Sini' calligraphic style of this script is influenced by the aesthetics of Chinese brush scripting.

**Akrafokonmu disc, 1870–74**
Gold
Made in Kumasi, Ghana
15.7 cm x 15.3 mm x 3 cm
18.1

In the Asante royal court in Ghana, 'soul washers' were important attendants of the *Asantehene* or king, responsible for the purification of his soul. They wore solid gold discs called *akrafokonmu* like this one purchased by Burrell in 1949.

This disc was taken from the Asante people after the British destroyed their capital city of Kumasi in 1874. Recent research has revealed that it was part of the gold taken back to London and sold at auction by the jeweller Garrard.

**Jue wine vessel, about 1600–1046 BC**
Shang Dynasty
Bronze
Made in China
18.8 cm x 15 cm x 19 cm
8.14

This *jue*, or tripod libation cup, is a classic example of Shang Dynasty metalwork. It requires a high degree of technical skill as well as artistic imagination and was more widely used during the Shang (about 1600–1046 BC) and early Zhou (1046–256 BC) dynasties. *Jue* contained wine made from *chang,* a type of aromatic plant. *Chang* was used during ritual ceremonies. The decorations on the three-footed form are grotesque *taotie* faces that have a serious expression. The purpose in putting this kind of ornament on bronze vessels was to warn people that drinking too much was harmful.

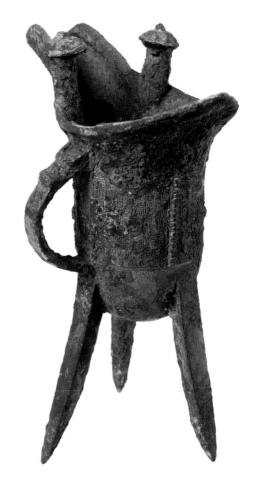

**Amphora, about 530–520 BC**
Earthenware, black figure decoration
Made in Attica, Greece
40.5 cm x 28 cm x 27 cm
19.59

Greek vases like this one were made using a complicated technique that required the manipulation of conditions inside the potter's kiln to achieve black glossy surfaces on red earthenware vessels. The black gloss required the addition of a slip – a clay solution – to the clay before it was fired. In this case, the background areas were left uncovered, giving black images on a red background. These were then enhanced by further painting.

The scene shows a man putting on his armour assisted by a woman and flanked by two soldiers, while the other side shows the same man with two archers setting off for battle.

### Tea bowl, 960–1279

Song Dynasty
Stoneware
Made in Jian Kiln, Jianyang, Fujian Province,
China
5.4 cm x 12.2 cm x 12.1 cm
38.359

This black tea bowl, known as Jian ware,
or *temmoku* after its Japanese name, offered
a stylish way of drinking tea during the Song
Dynasty (960–1279). It was established by
the Emperor Huizong (1082–1135) and his
Minister Cai Jing (1047–1126). From royal
court to commoner, black-ware bowls were
popular throughout the country. Bowls of this
kind with 'hare's-fur' glaze were also admired
by Japanese monks who visited China to
study and carried them back to Japan. The
Japanese tea ceremony still uses tea bowls
and powdered tea, preserving habits that
developed during the Song period.

### Bowl, 1200–58

Seljuk Period
Frit body, underglaze colours, overglaze
enamels, gold leaf
Made in Kashan, Iran
9.2 cm x 21 cm
33.202

This bowl exploits the skills in the Islamic
arts of miniature painting, glass enamelling,
gilding and ceramic technology, to depict
allegorical themes from the Persian mystical
tradition. The extra smooth frit body allowed
the decorators to draw in a style that
emulates miniature paintings in manuscripts.
Using coloured glass enamels let them add
the colour red to their composition, and
gold leaf enabled them to decorate the
rider's headdress and the horse's trappings.
On this bowl, the horseman in the centre
represents a chivalrous Persian hero – a
symbol of good and noble power. The seated
men surrounding him are contemplating the
qualities that the horseman represents.

**Epergne, 1730–50**
Glass, metal
Made in England
overall: 50.8 cm
15.267

By the eighteenth century, the vogue for indulgence in sugar found its way onto the dinner table. Elaborate and exuberant dessert services were a fixture of any dinner entertainment, with stylish glass *epergnes* featuring as a luxurious and dramatic centre piece. This glass *epergne* has two tiers each with four serpentine glass arms, and hanging from each a glass basket. Succulent sweetmeats, candied fruits, and sugared nuts would have been displayed within the baskets for guests to help themselves to. The central bowl probably held an arrangement of flowers, adding colour to the table.

**Stem cup and cover, 1619–26**
Silver-gilt
Possibly made by John Vanderheyden or Jasper Vanderscarre, London, England, decoration after designs by Paul Flindt the Younger, Nuremberg, Germany
overall: 29.5 cm x 11.2 cm x 11.2 cm
overall: 13 cm x 11.5 cm x 11.5 cm
43.15.1, 43.15.2

This cup and cover is stamped with the assay mark of London, but its design is European in style. This cup may have been made by John Vanderheyden or Jasper Vanderscarre. Both were registered as European goldsmiths working in London in the early seventeenth century. The cup is decorated with landscapes in medallions surrounded by ornamental motifs of flowers, foliage, and winged cherub heads. The cover finial is topped with a figure of the Roman god Jupiter and an eagle.

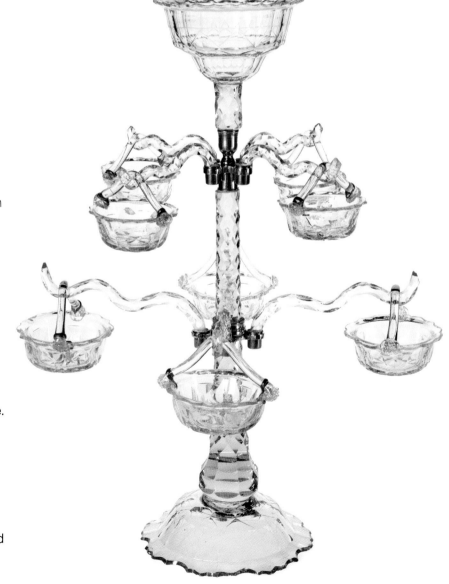

**Tea pot, about 1750**
Soft-paste porcelain
Made by the Bow Porcelain Factory,
London, England
overall: 13.7 cm
39.64

Tea drinking in Britain soared after
1700, and the drink became a staple
across society. The serving of tea to
guests was a way of showing wealth
and good taste. Tea, unlike food,
could be offered at any time. Tea-
drinking became a focal point for
social activities.

With the taking of tea came the
associated teawares. The wealthy
initially used Chinese porcelain but
this was soon supplanted by more
affordable alternatives made by the
rapidly expanding local potteries.
The influence of China can be seen in
the decoration of this Bow porcelain
teapot, with its enamel-painted floral
decoration echoing Chinese export
wares.

**'There is a Time for Everything' wine
glass, about 1765**
Glass
Made in the Dutch Republic, now the
Netherlands
15.6 cm x 7.1 cm x 7.1 cm
16.86

This wine glass is part of a larger set, all
engraved with different sayings and symbols.
They were most likely used by a club or society
in the Dutch Republic during the eighteenth
century to raise toasts.

Engraved on the bowl are musical
instruments and an hour glass, relating to time
passing and, in Dutch, the proverb 'There
is a time for everything'. Inscriptions on the
other glasses range from the instructive, 'Be
kind to your enemies', to the descriptive, 'The
delightful life in the country' as well as the
slightly scary 'Live and suffer'.

**Inner panel from Coffin of Djedmut, 945–900 BC**
Wood, polychromy
Made in Egypt
39 cm x 25.4 cm x 5.8 cm
13.257

This painted coffin panel shows the temple singer Djedmut praising the god Ptah-Sokar-Osiris with a prayer to provide her with bread, beer, oxen, fowl, incense and clothing for the afterlife. Temple singers were priestesses who played an important role in religious ceremonies. The painted side of this panel was inside Djedmut's coffin, meaning that only the gods and Djedmut herself were able to see it.

Djedmut may have had at least two coffins – one inside the other – as her name appears on coffin parts that are now in museums in La Rochelle, France, and Padua and the Vatican in Italy.

## Stele of Huy and Hathor-Meryt, 1550–1069 BC
New Kingdom
Limestone
Found probably Saqqara, (Al Badrashin, Giza Governate), Egypt
114.4 cm x 99 cm x 9 cm
13.286

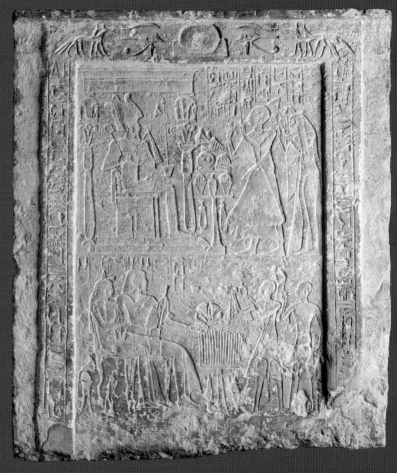

The top image on this stele shows Huy and his wife making offerings to the god Osiris and the lower part shows their sons providing offerings. Hathor-Meryt's pet monkey is standing beneath her chair.

The stele was one of several Egyptian objects collected in Egypt by Jeremiah Rawson (1787–1839) in 1839 and donated to the Halifax Literary and Philosophical Society where it was built into a wall. Sixty years later the society built a lavatory around it and the stele became damaged. It was eventually sold to the Bankfield Museum before being acquired from there by Burrell when the museum disposed of much of its Egyptian holdings in 1956.

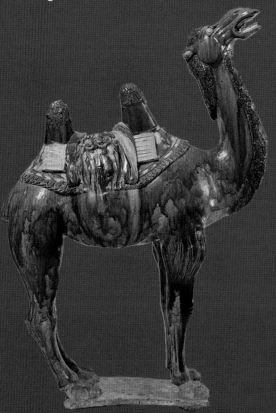

## Figure of a Bactrian camel, 618–907
Tang Dynasty
Earthenware, Sancai glaze
Made in China
83.1 cm x 55.8 cm x 22.5 cm
38.119

This figure of a Bactrian camel is a splendid example of the Tang Dynasty (618–907) sculptural tradition. It was made as a burial object to accompany the deceased into the afterlife. It is significant because it reveals much about Ancient Chinese trade and transport and the type of objects that were traded. It also shows the aesthetic thought and advanced *sancai* (three colours) techniques of that time. William Burrell acquired his first Tang Dynasty burial object in 1911, although it was not until the 1940s that he began collecting other such sculptures in earnest.

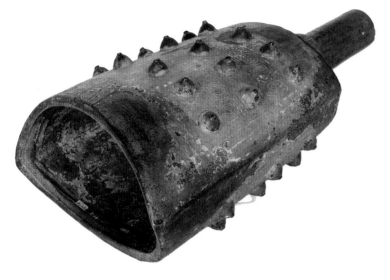

## Bell, 770–256 BC

Eastern Zhou Dynasty
Bronze
Made in China
46.4 cm x 31.2 cm x 20.6 cm
8.48

This type of bronze bell is called *nao* in Chinese. It was used as an important musical instrument in ancestral worship. Decorated with a studded surface and bands of spiral relief, its body appears as if two curving roof tiles have come together, the opening curves forming an arc with a slightly inward rim. This *nao* was set up on a stand connected to a wooden post below. It was placed upside down and struck on the outside. In Ancient China, the sound of bells being rung had ritual significance in communicating life and death. They were also used during military campaigns.

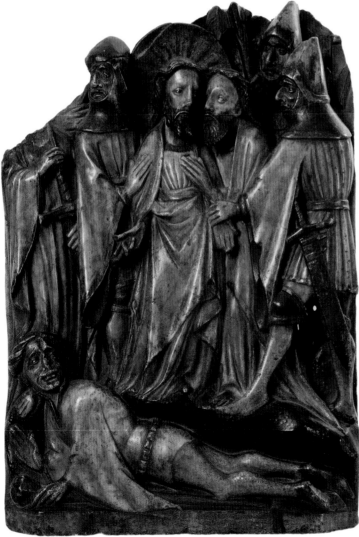

## The Betrayal of Christ by Judas, about 1400–30

Alabaster, polychromy, gold, lead
Made in England
37.5 cm x 26.5 cm x 4.7 cm
1.11

The High Priest's guards seize Jesus. They are represented in the armour and weapons of English solders of the fifteenth century. A combination of mail and plate armour protects their bodies: basinets with aventails for the head and neck, plate gauntlets on their hands, and legharness with prominent poleyns at the knee. One has a large curved sword slung from his hip; another brandishes a fearsome pollaxe.

What remains of the figure of St Peter holds a large longsword. Peter, enraged at what is happening to his master, has just struck the man on the ground, hacking off his ear.

**Wall tiles from Imamzada Yahya Shrine, 1263**
Ilkhanid Period
Frit body, overglaze lustre
Made in Kashan for the Imamzada Yahya in Varamin, Iran
Cross: 21.5 cm x 21.5 cm
Star: 31.1 cm x 31.2 cm
33.54, 33.55, 33.232, 33.233

These tiles are part of a massive composition of star and cross-shaped tiles that covered the interior walls of the burial chamber in Imamzada Yahya's shrine. Yahya was a Muslim martyr of the ninth century. In 1261 the ruler of Varamin, al-Malik Fakhr al-Din, rebuilt Imam Yahya's shrine and commissioned the famous Al-Tahir family of potters from Kashan to

craft the luxurious wall tiles for it. Each tile has been carefully decorated and its borders inscribed with verses from the Qur'an. Tiles 33.54 (bottom cross tile) and 33.55 (right-hand star tile) have the Qur'anic verses from chapters 1; 112; 36:1–10; and 65:2–3. Such inscriptions invoked God's protection and blessings.

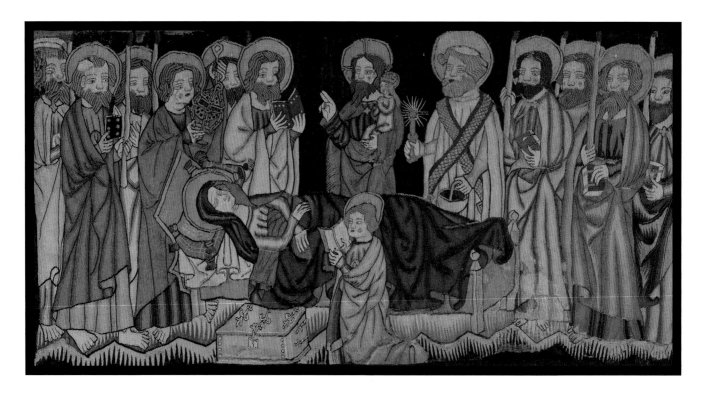

**Death of the Virgin, about 1450**
Linen, wool
Made in Middle Rhineland, Germany
82 cm x 159 cm
46.17

Relatively small, rectangular tapestries woven with religious scenes were made to be hung on the front of altars. This one shows the dying Virgin Mary lying in the centre, her traditional blue mantle wrapped over her, with her son, Jesus Christ, above holding a small crowned child to represent Mary's departing soul being accepted into heaven. On either side stand the Twelve Apostles who administer the last rites including, on the left, St John in a red cloak blowing out an incense burner to signify the end of Mary's life.

**Grief, 1887**
Matthijs Maris
Oil on canvas
34 cm x 86 cm
35.346

The hazy and obscured style of this painting is typical of the experimental late works of Dutch artist Matthijs Maris (1837–1919). He explained once that *Grief* represented his own misfortune after becoming disillusioned with the art world, which he saw as restricting his artistic freedom.

This painting was bought by William Burrell twice. After the first purchase, Maris requested it back, informing Burrell that it was just a sketch and promising to replace it with a better version. However, the artist died before this later painting was completed so Burrell ended up buying the original back from the widow of Maris' art dealer, 30 years later.

## Bella Donna dish, 1490–1510

Tin-glazed earthenware, painted decoration
Made in Faenza, Emilia-Romagna, Italy
4.8 cm x 27.7 cm x 27.6 cm
40.40

In Renaissance Italy dishes decorated with portraits of women were given as gifts to express love. Known as *belle donne*, or beautiful women, they could be personalized with the addition of a name and adjectives such as *bella*, *unica* (unique) or *diva* (divine). The portraits themselves did not represent actual individuals, but showed an idealized version of female beauty.

The central *bella donna* is surrounded by fans of leaves known as Persian palmettes. This type of decoration has also been found on textiles and carpets of the same period, both in Italy and the Middle East.

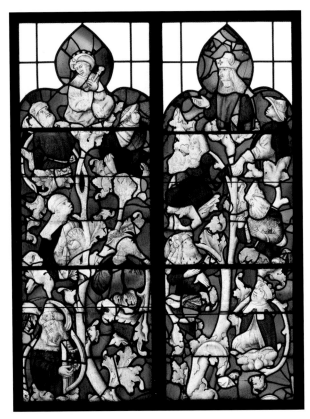

## Two lights from a Tree of Jesse Window, about 1520

White, coloured, stained and painted glass, lead
Possibly made in Rouen, Normandy, France
190 cm x 138 cm x 1 cm
45.393, 45.394

The Tree of Jesse is a family tree showing the ancestors of Jesus Christ, inspired by a passage in the Old Testament (Isaiah 11:1). There would originally have been a third light in the middle showing the tree sprouting from Jesse, the father of King David, and rising up to the Virgin Mary and Jesus. They are thought to have been made in Rouen, France, and to have been brought to England by John Christopher Hampp (1750–1825), who also acquired the John the Baptist lights (pp.133–135). They were installed in the chapel at Costessey Hall in Norfolk, built by William Jerningham, 6th Baronet Jerningham of Cossey (1736–1809), in 1809. After World War I all of the glass in the chapel was removed and sold, allowing Sir William Burrell to acquire several fine pieces.

**Fragment of a bed, possibly the marriage bed of Henry VIII and Anne of Cleves, about 1540**
Oak, polychrome gilding
Made in England
83.9 cm x 195.6 cm x 11.4 cm
14.236

This painted and gilded bedhead was said to be made for the marriage of King Henry VIII (1491–1547) to his fourth wife, Anne of Cleves (1515–57), and is one of very few surviving furniture items from Henry VIII's court. The painted panels proclaim Henry's divine rights as monarch and Head of the Church of England, and symbolize the new union between Henry and Anne with an 'HA' monogram. The bedhead is flanked with classical figures, a youthful woman and man with bulging codpiece, symbolic of fertility, and the aspirations of Henry VIII to produce male heirs.

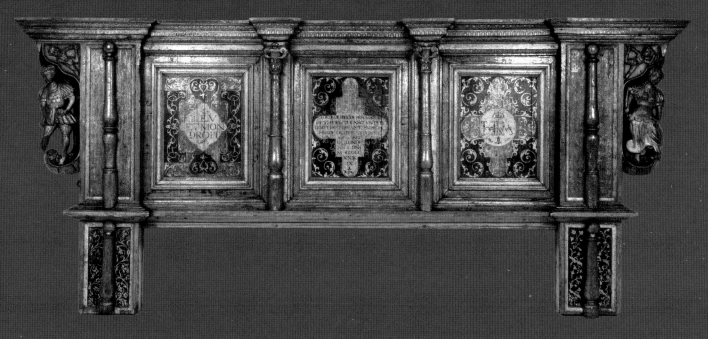

**Bed valance, 1532–36**
Silk, linen
Made in England
37 cm x 252 cm
29.178.b

The conjoined cipher HA on this valance commemorates the union of King Henry VIII of England (1491–1547) and his second wife, Anne Boleyn (about 1501–36). Embroidered with arabesque motifs, it also shows acorns, a symbol of royalty, and honeysuckle, commonly used by Anne as a symbol of romantic love.

It is a rare surviving example of the domestic furnishings used by the royal couple before Henry VIII ordered Anne's execution in 1536. It is likely that the valance was given to her cousin, Margaret Shelton, wife of Thomas Wodehouse of Kimberley.

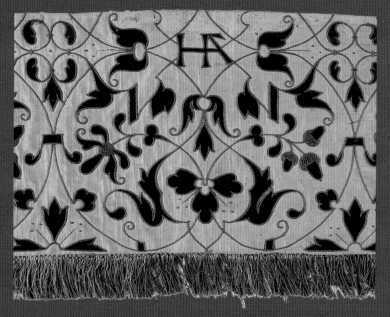

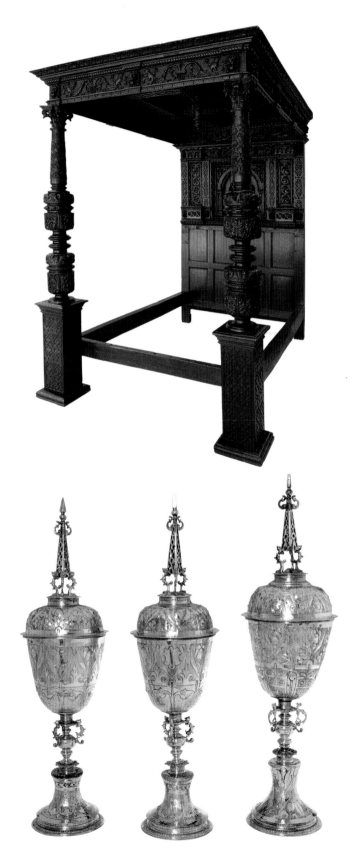

### Joined tester bed, 1600–30

Oak
Made in England
237.2 cm x 164.4 cm x 227.7 cm
14.226

In the 1600s joined tester beds helped to give their wealthy owners comfort and warmth in draughty houses. The bed space within the top canopy, bed posts, and back frame were enclosed with hangings that gave privacy as well as decoration. This bed is exquisitely carved with *guilloche* ornamentation and elaborate grotesque designs of mermaids, human faces, and lion heads. Carved into the back frame is the royal coat of arms of King James VI of Scots and I of England (1566–1625).

Burrell purchased this bed in 1929 shortly after moving into his new home of Hutton Castle. It was used in the principal guest bedroom.

### Set of standing cups with steeple covers, 1611–12

Silver-gilt
Made in London, England
45 cm x 13 cm x 13 cm
46 cm x 13 cm x 13 cm
47.5 cm x 14 cm x 14 cm
43.16, 43.17, 43.18

This set of three standing cups with covers is an exquisite example of Jacobean silver. It is extremely rare for a set of three cups to survive. These were almost certainly made as a set, each bearing the maker's mark of 'TB'. The cup and covers are highly decorated with similar chased and embossed patterns of foliage, carnations, and tulips, and each stem ornamented with handle-like scrolls embellished with female monster heads. The name 'steeple' is given for cups of this design after the elongated, decorative spire-like finials decorating the domed covers. The finials on these cups are triangular with pierced open work, supported by caryatid figures.

Steeple cups were mostly commissioned and used for domestic purposes, most commonly for display during grand entertainments, signifying the owner's wealth and status.

**Suzani wall hanging, 1800–1900**
Cotton, silk
Made in Khanate of Bukhara,
Uzbekistan
246.3 cm x 163.8 cm
30.12

Part of a dowry set, this densely
embroidered hanging was intended
for the walls of a bride's new
room at her groom's extended
family home. The Uzbek bride's
female relatives shared the task of
embroidering it over a number of
years prior to her marriage. *Suzani*
– meaning 'needle' in Persian –
became the name of this type of
Uzbek wall hanging. This particular
one is generously embroidered
with a variety of floral motifs and
compositions, amongst which
jewellery, charms and birds are
discreetly placed. All these motifs
bear symbolic invocations of health
and wealth, fertility and happiness,
and protection from evil and
misfortune.

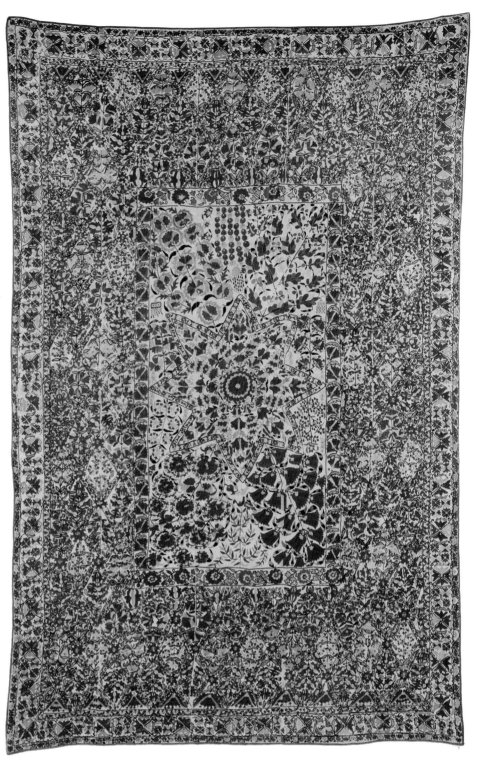

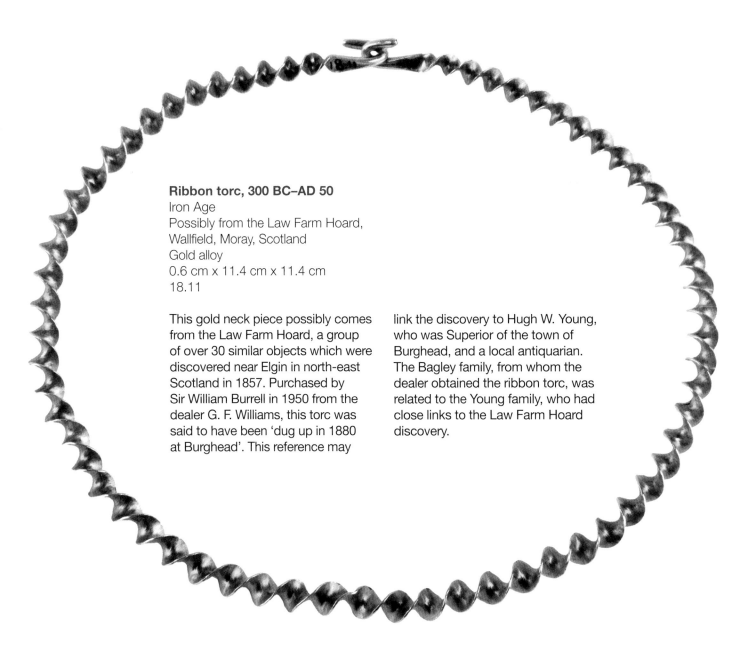

**Ribbon torc, 300 BC–AD 50**
Iron Age
Possibly from the Law Farm Hoard,
Wallfield, Moray, Scotland
Gold alloy
0.6 cm x 11.4 cm x 11.4 cm
18.11

This gold neck piece possibly comes from the Law Farm Hoard, a group of over 30 similar objects which were discovered near Elgin in north-east Scotland in 1857. Purchased by Sir William Burrell in 1950 from the dealer G. F. Williams, this torc was said to have been 'dug up in 1880 at Burghead'. This reference may link the discovery to Hugh W. Young, who was Superior of the town of Burghead, and a local antiquarian. The Bagley family, from whom the dealer obtained the ribbon torc, was related to the Young family, who had close links to the Law Farm Hoard discovery.

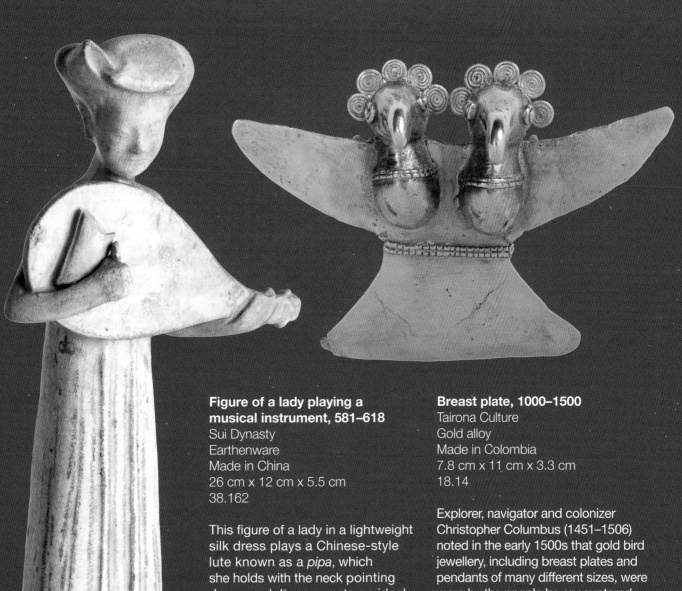

**Figure of a lady playing a
musical instrument, 581–618**
Sui Dynasty
Earthenware
Made in China
26 cm x 12 cm x 5.5 cm
38.162

This figure of a lady in a lightweight
silk dress plays a Chinese-style
lute known as a *pipa*, which
she holds with the neck pointing
downward. It represents an ideal
of feminine beauty – slenderness,
simplicity and elegance. Covered
overall with an ivory-tone glaze, this
figure was made during the Sui
Dynasty (581–618), a short-lived
imperial Chinese dynasty of major
significance. It set the stage for an
artistic development of Chinese
pottery.

**Breast plate, 1000–1500**
Tairona Culture
Gold alloy
Made in Colombia
7.8 cm x 11 cm x 3.3 cm
18.14

Explorer, navigator and colonizer
Christopher Columbus (1451–1506)
noted in the early 1500s that gold bird
jewellery, including breast plates and
pendants of many different sizes, were
worn by the people he encountered
in South America. It is likely that this
breast plate was made by people of
the Tairona cultural tradition, Colombia
to Panama region. It features two
condors which might have functioned
as protective emblems, symbols of
status or a family or clan emblem.
Small gold balls, braided and spiral
elements are typical of the Tairona
gold work of northern Colombia.

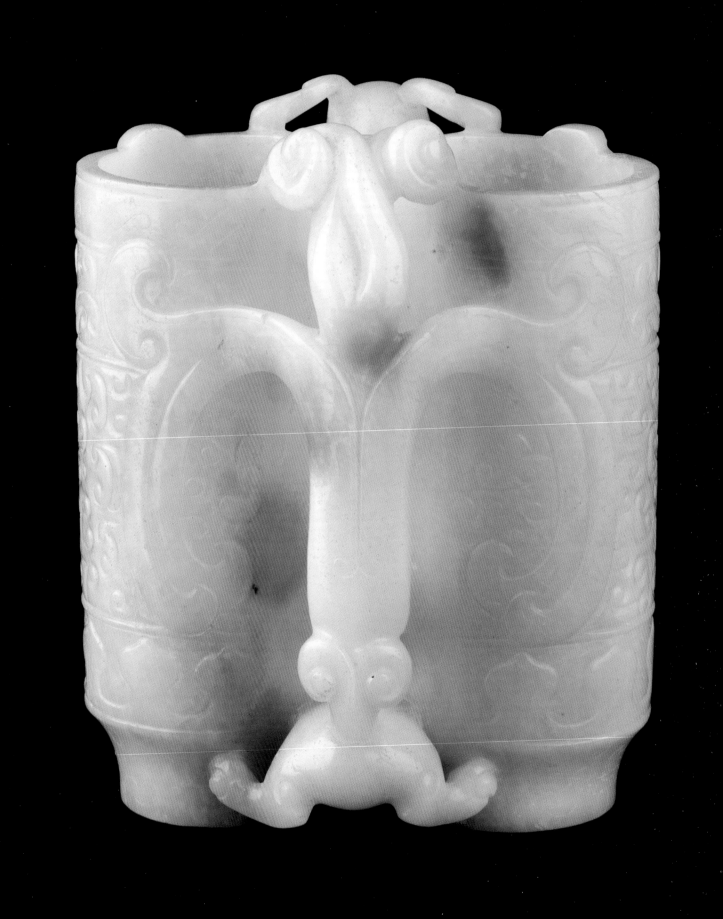

**Champion vase, 1279–1368**
Yuan Dynasty
Jade
Made in China
96 cm x 77 cm x 74 cm
22.35

Jade can be one of two minerals, nephrite
or jadeite. The stones differ in colour
and hardness. Nephrite lacks colour, and
impurities create variations of yellow,
green, brown, and black. Jadeite, which is
harder, comes in virtually every colour. This
beautifully carved nephrite vessel is formed
of two hollow cylinders linked on one side by
an eagle with outspread wings standing on
top of a bear. The name 'champion' vase is
a pun on the word *ying* for 'eagle' and *xiong*
for 'bear', which put together in Chinese
sounds like 'hero'.

**Armour in the Maximilian Style,
about 1515**
Steel
Possibly made in Nuremberg, Germany
180 cm x 80 cm x 60 cm
2.1

This style of armour is often referred to as
'Maximilian' because early collectors believed
that the Holy Roman Emperor Maximilian I
(1459–1519) had invented it himself. Although
that is unlikely, Maximilian did take a keen
interest in armour production, patronizing the
most skilled armourers in Europe.

The large, rounded forms are decorated
with fluting: ridges hammered into the steel
accentuated with incised lines replicating
the civilian fashion for slashed clothing. The
greaves (lower leg defences) are left smooth
to simulate silk stockings.

Made from the best quality steel, this
armour provided excellent protection against
the various weapons encountered on the
battlefield – even smaller firearms.

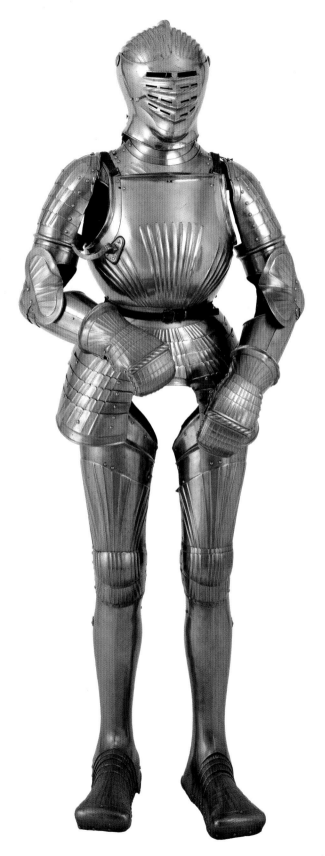

**Hairpin, about 1600–1700**
Ming Dynasty
Jade
Made in China
16.9 cm x 1.1 cm x 1.5 cm
22.88

In Chinese tradition, jade is a symbol of nobility and represents the gentleness and mercy of human nature. This hairpin is made of jadeite known in China as *feicui*, originating in Myanmar. It has an intricately carved hydra dragon head. The finest stone was used for making this precious hairpin, suggesting that its owner was of high social status. This pin is part of the owner's crown-like headwear, which was as important a part of their appearance as their clothes.

**Falconry pouch, about 1600–19**
Leather, silk, silver, silver-gilt threads, gold, enamel
Made in England or Scotland
37 cm x 45 cm
29.151.1

This pouch is a type of bag that was worn tied around a falconer's waist to hold small falconry accessories and pieces of food for their bird. It is part of a set of falconry accessories that belonged to King James VI of Scots and I of England that he gave to Sir William Pope (1573–1631) when he visited him at Wroxton Abbey, Oxfordshire, on 23 August 1619. It is made from fine leather professionally embroidered in coloured silk, silver and silver-gilt threads with a design of intertwining mistletoe and brambles, which also decorate the matching enamelled gold mount at the top.

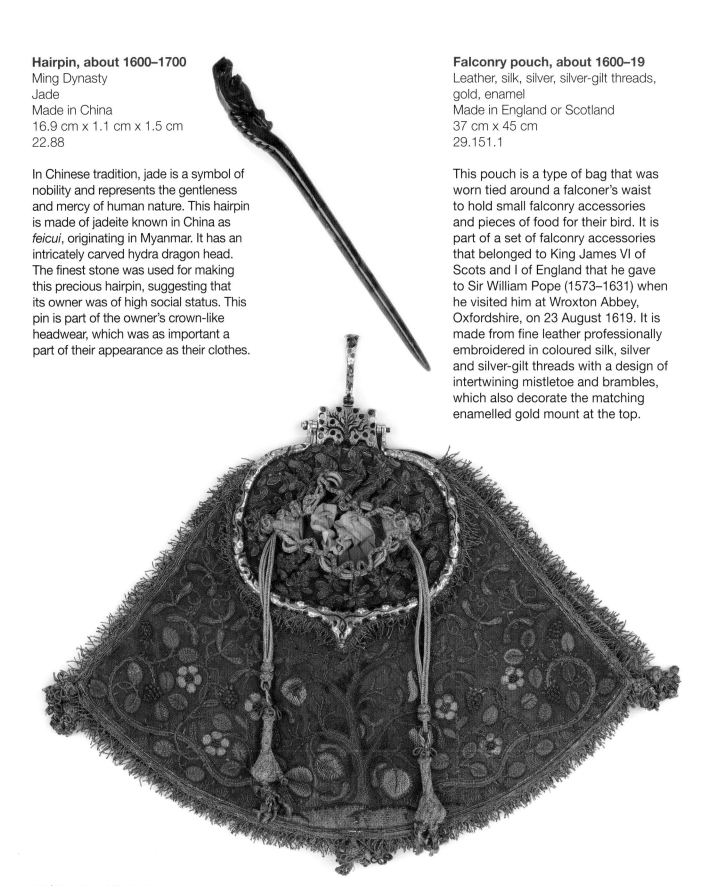

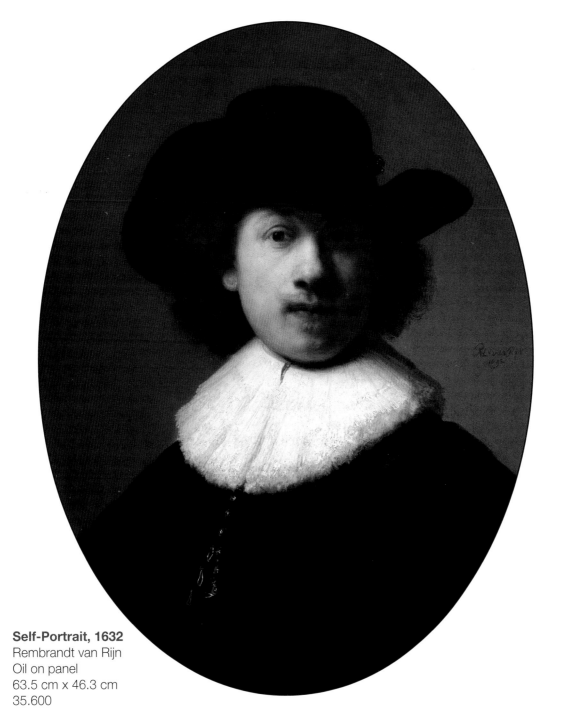

**Self-Portrait, 1632**
Rembrandt van Rijn
Oil on panel
63.5 cm x 46.3 cm
35.600

Rembrandt van Rijn (1606–69) was 26 years old when he created this polished self-portrait. It is one of over 70 self-portraits by the Dutch artist. However, unlike the majority that depict him in his artist's smock or dressed up in various costumes, this one shows him in contemporary fashionable clothing. Rembrandt's early works were of religious or historical subjects, but in 1631 he left his native town of Leiden and moved to Amsterdam with the aim of becoming a portrait painter to the city's wealthy citizens. This painting would have provided a fitting example of his work to show to potential clients.

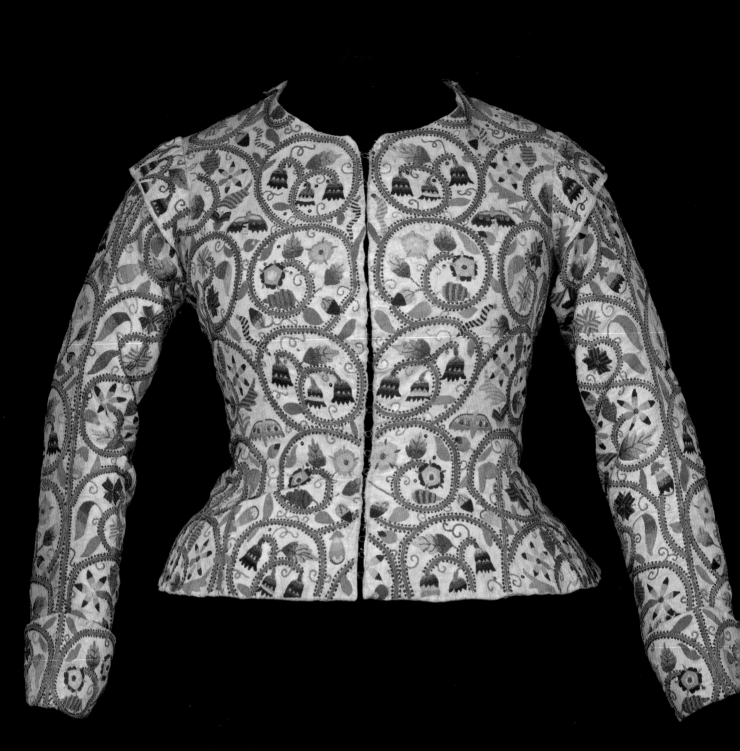

### Waistcoat, about 1615–18
Linen, silk, silver, silver-gilt
Made in England
65 cm x 60 cm x 50 cm
29.127

Embroidered waistcoats were worn by wealthy women in the early seventeenth century. These fashionable garments were made from finely-woven linen embellished with *rinceau* designs of stems that curled around flowers, fruit and in some instances birds, professionally stitched in colourful silk, silver and silver-gilt threads. This one was further decorated with small metal C-shaped discs, known as spangles, which have fallen off over time. Examples of similar waistcoats can be seen in contemporary Jacobean portraits worn layered with lace ruffs and embroidered skirts with gowns or mantles over to create lavish outfits that proclaim the wealth of the wearer's family.

### Bretonne, about 1886
Eugene Henry Paul Gauguin
Chalk on paper
46 cm x 31 cm
35.264

In 1886 when Paul Gauguin (1848–1903) visited Pont-Aven, Brittany, for the first time he made several idealized drawings of the area and the Breton peasant girls wearing their traditional dress. Some were drawn hastily in a sketchbook, while others were worked out carefully on sheets of paper, such as this one, which became the model for figures in some of his later Breton paintings.

It was during this first stay in Brittany that Gauguin, working away from the influence of his Parisian peers, began to develop his distinctive artistic style with its use of strong contours and bright colours.

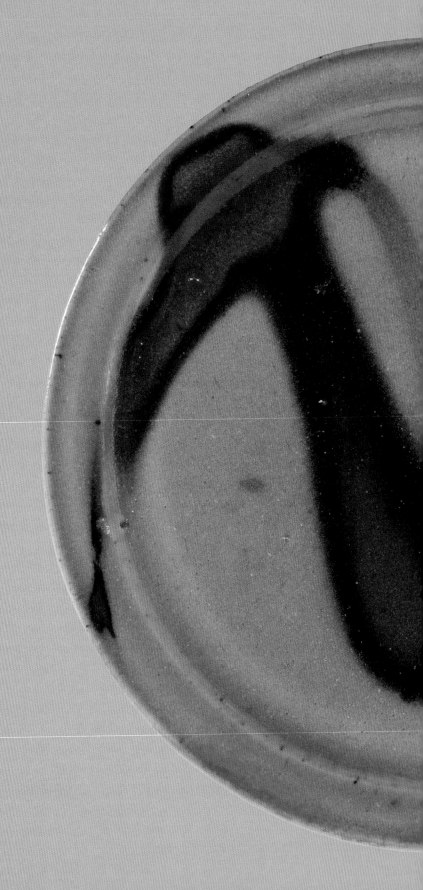

**Dish, 960–1279**
Song Dynasty
Stoneware
Made in Yuxian, Henan Province, China
2.2 cm x 18.2 cm x 18.2 cm
38.335

Made by imperial order, this *Jun* dish is
classified as one of the five famous wares
of the Song Dynasty (960–1279). The name
'Jun' comes from the Juntai kiln located in
Henan Province, central China. This dish has
a milky sky-blue glaze with vibrant purple
splashes. It was fired on a stand with five
spurs, which have left small white fireclay
marks on the base. The beauty of this
classic dish lies in its simplicity. Its success
depended on the potter's ability to create
an aesthetic shape and a colour known as
'sunset purple, emerald green and blue'.

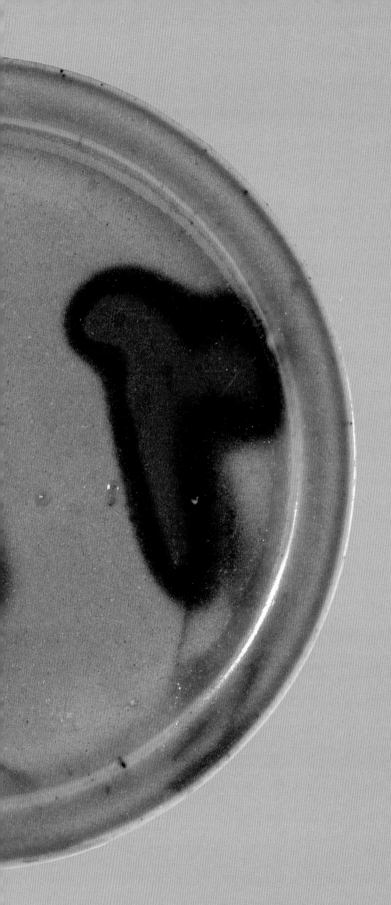

**Wall tile with part of Qur'an verse (48:4),
1100–1250**
Seljuk Period
Frit body, opaque turquoise glaze
Made in Iran
32.4 cm x 31.4 cm
33.50

One of the distinctive features of Islamic
culture is the use of calligraphy in decorating
religious buildings and monuments. This
large external wall tile is dominated by a
word and a half from a Qur'anic verse that
stretched across a long frieze adorning a
mosque or shrine's wall, dome or minaret.
The Qur'anic inscription belongs to chapter
48:4, which tells how God installs tranquillity
and calmness in the hearts of the believers
so that they grow in faith. The thick turquoise
glaze – a colour ubiquitous with the Middle
East – coating the hand-carved and moulded
tile complements the verses with its symbolic
connotations of protection against evil and
misfortune.

**Chest, known as the Richard de Bury chest, about 1340**
Oak, iron, linen, coloured pigments
Made in England
63.5 cm x 202 cm x 44 cm
14.352

This large chest is associated with Richard de Bury (1287–1345), Lord Chancellor and Bishop of Durham from 1334. It is constructed of large oak planks held together by decorative iron braces, nails and wooden pegs, and is a rare example of medieval furniture that has retained its original paintwork. Painted on the inside of the hinged lid are coats of arms associated with Bury's family ancestry and political allegiances with heraldic supporters and grotesque hybrid beasts. The chest was probably used for the secure storage of documents, valuables, and official seals used by Bury during important diplomatic missions.

**Ewer, 1279–1368**
Yuan Dynasty
Porcelain
Made in Longquan, Zhejiang Province, China
32.1 cm x 25.5 cm x 19.4 cm
38.306

Celadon ceramics were popular in China and further afield during the Yuan Dynasty. This large ewer with a jade-green glaze is a fine example, its shape inspired by Islamic metalwork. When Europeans first saw ceramics featuring this greenish colour they struggled to find an adequate word to describe it, because it appeared only in East Asian culture. The name comes from a character in the play *L'Astrée*, a seventeenth-century French pastoral romance by Honoré d'Urfe (1568–1625). The shepherd Céladon wore a dress of a similar hue, and so 'celadon' became the colour's name.

**Bowl, 1426–1435**
Ming Dynasty, Xuande Period
Porcelain
Made in Jingdezhen, China
8.1 cm x 18.7 cm x 18.6 cm
38.728

This copper-red bowl bears the reign mark of the Xuande Emperor (reigned 1426–35). It is a wonderful example of the copper-red glaze achieved by fifteenth-century potters. This red glaze is known in China as *jihong* (sacrificial red), which suggests this bowl was used for ceremonial occasions during the Xuande era. *Jihong* was the most challenging glaze colour used by Chinese potters. Its thickness and composition, the percentage of copper, and the many variants in firing – kiln atmosphere, temperature, firing and cooling time – all critically affected the final colour.

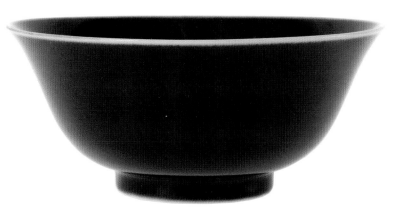

**Roundel with the arms of Henry VIII and Jane Seymour, about 1537**
Clear, coloured, stained and painted glass, lead
Made in England
40 cm x 40 cm x 1 cm
45.184

Heraldry is a language of power. Its combination of colours and symbols create a visual key to rank and status. This painted glass coat of arms roundel belonged to Jane Seymour, Queen of England (about 1508–37) and third wife of King Henry VIII (1491–1547).

When they married in 1536 Jane's family arms shown on the right were merged with Henry's on the left to create this elaborate combination. Every item has meaning and was designed to project power. This roundel was believed to have been part of a window at the long-demolished Nonsuch Palace in Surrey, Henry's most lavish royal residence.

**The Crucifixion of Christ, with St Mary, St John the Baptist, between St Michael, St John the Evangelist, St Peter and St Andrew, 1475–1500**
Limestone, traces of polychromy
Made in Burgundy, France
56.5 cm x 175.5 cm
44.36.1-2

This rectangular limestone altarpiece shows a Crucifixion scene. At the centre is the crucified Christ, the mourning Virgin Mary, and St John the Evangelist holding a book. To the left of this central scene is the Archangel Michael in armour and large wings fighting the devil and St John the Evangelist holding a lamb. St Peter and St Andrew are to the right. This panel has other interesting details. To the far left there is a snail and the sides and top are framed by a vine. Once very colourful, the panel retains some of its polychromy in shades of red and green.

**Dish, 1488–1505**
Ming Dynasty, Hongzhi Period
Porcelain with yellow glaze
Made in Jingdezhen, China
4.5 cm x 21.3 cm x 21.3 cm
38.647

The warm-toned glaze of this dish, called 'imperial yellow' in Europe and 'chicken-fat yellow' in China, owes its colour to a small amount of iron oxide. Vessels completely glazed in this colour were reserved for imperial purposes in palaces, altars and temples, as well as the personal use of the emperor, empress and dowager empress. They were also used in court rituals at the Temple of the Earth, since yellow also signified 'Earth', one of the five elements of Wood, Fire, Earth, Metal, and Water.

**Fragment from the Temple Pyx,
about 1140–50**
Bronze, gold
Possibly made in Germany or England
9.2 cm x 7.3 cm x 2 cm
5-6.139

Long thought to be a fragment of a pyx, a
container used to carry the Sacred Host,
this piece more likely formed part of a book
cover, shrine or reliquary. Here three soldier
posted to guard Jesus' tomb have fallen
asleep. They appear as well-armed warriors
of the twelfth century. All three bear hauberks
(long mail shirts) and helmets with nasals –
an extension of the helmet that protects the
face from sword cuts. Each has a sword in
a scabbard at their hip and leans on large
kite-shaped shields made of wood with a
metal rim and central boss. One grasps a
spear with a crossbar. This prevents the
spearhead penetrating too far into an enemy.

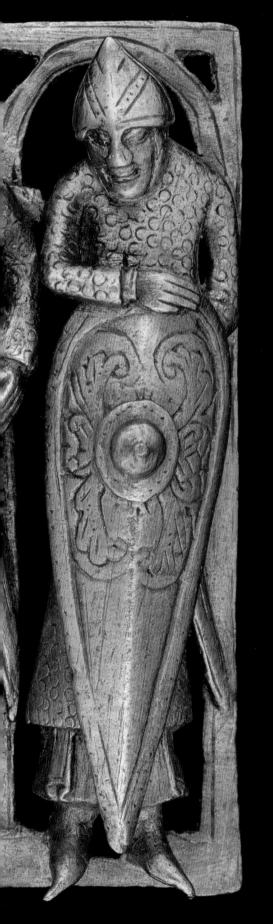

**Pigeon, 1200–1400**
Mamluk Period
Clay, cobalt-blue glaze,
overglaze lustre
Made in Syria
24.5 cm x 15 cm x 27 cm
33.164

In Middle Eastern cultures all objects, no matter how expensively made or lavishly decorated, usually have a practical function. This rare Damascus-made earthenware pigeon is unusual as it seems to be purely decorative. The bird's dark blue and lustre-painted details are reminiscent of the Syrian Tarbesh dewlap pigeon's plumage and sheen. The pigeon's body is moulded of clay and covered with an opaque cobalt blue glaze. The details of its face and feathers are painted over the blue glaze in metallic lustre pigments that range from a gold yellow and green to a copper red.

**St John the Evangelist and the Virgin Mary, 1275–1300**
Wood, polychromy
Made in Catalonia, Spain
Both 121.3 cm
50.28, 50.4

These two charming statues belonged originally to a larger group representing the Crucifixion with these two mourning figures and others surrounding Christ on the Cross. Both St John the Evangelist's and the Virgin Mary's facial expressions and body language show their grief at the death of Jesus. Scenes from Christ's Passion and his death on the cross were popular themes in medieval art.

The statues still retain much of their original painted colours, helping to distinguish their features and clothing. However, both their garments were decorated with elaborate patterns that have faded over the centuries.

**Church stall with misericord seat, about 1490–1540**
Oak
Made in England or France
117 cm x 66.6 cm x 57 cm
14.4

Folding seats in late medieval church choir stalls often had small ledges underneath known as misericords, from the Latin *misericodia,* meaning 'mercy'. These offered secret support to clergy members standing for long periods of time during services.
The Burrells collected several examples of misericords, with some still attached to their original stall, like this one. Misericords were decorated with intricate carvings, sometimes of Biblical or moral allegories, but often with imaginative grotesque or humorous scenes of figures or animals. This misericord is carved with an animal in the form of a dog or bear cub.

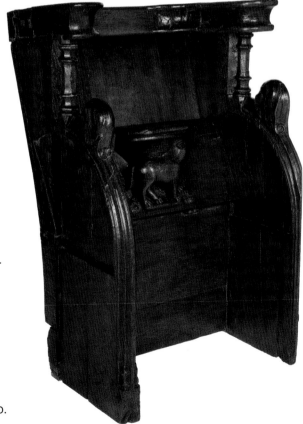

**Dalmatic, about 1415–35**
Silk, gold thread
Made in Italy and England
231 cm x 122 cm
29.2

This medieval dalmatic was worn by a deacon when assisting the priest during mass at Whalley Abbey, Lancashire. It is made using luxurious Italian brocaded silk velvets that may have been gifted to the abbey by a wealthy local family. The front and back are decorated with bands or orpheys, stitched in *opus anglicanum* (English work), a type of

embroidery that was famous throughout Europe. The orpheys show scenes from the life of the Virgin Mary, including, running chronologically from bottom to top on the back, St Anne giving birth to Mary; Mary learning to walk using a frame; and Mary's presentation in the temple.

## Drinking horn, before 1536

Possibly cow horn, silver-gilt
Possibly made in Riga, now in Latvia,
reworked in Vienna, Austria, about 1826
27 cm x 29 cm x 12 cm
43.12

Drinking horns were used by the nobility,
clergy and guildsmen at court celebrations.
This example is decorated with silver-
gilt inscriptions, including '*Jhesus autem
tranciens per medium illoru*' (But Jesus
passing through their midst went His way)
from Luke 4:30 and '*Herr Cord Durkop hat
mich gegeben zu seinem Gedaechtnis*'
(Cord Durkop gave me in his memory). Cord
is a shortened form of Conrad and he was
probably a member of the Durkop family who
were important merchants and burghers in the
Hanseatic trading town of Riga.

Later the horn was reworked with the nude
woman on the tip of the horn and new feet
decorated with kneeling wild men added.

## David and Bathsheba, about 1480

Linen, wool, silk, metal
Made in Alsace
930 cm x 104 cm
46.27

This attractive small tapestry
shows King David sending his page
with a love letter to the beautiful
Bathsheba, the wife of one his
generals, who is bathing her feet.
The page and Bathsheba wear
stylish late medieval fashions, such
as the page's long-toed shoes
or *poulaines*. The scrolls are the
equivalent of speech bubbles with
David's instruction to his page:
'Reveal to her my will; tell her of
my intention', the page telling
Bathsheba 'There never was a man
so in love as my master; he wants to
possess you' and her replying 'Tell
your master, what he wishes from
me shall be granted'.

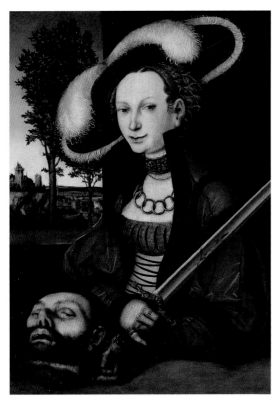

## Judith with the Head of Holofernes, 1530
Lucas Cranach the Elder
Oil on panel
77 cm x 56 cm
35.671

This is one of the more impressive versions of Judith, painted by the German artist Lucas Cranach the Elder. The apocryphal story of Judith tells of a virtuous widow of Bethulia who killed the military commander Holofernes in order to save her town from the besieging Assyrian army. In all of Cranach's depictions of this Jewish heroine he emphasizes her physical appearance, showing Judith in contemporary German Saxon dress of about 1530 'so as to allure the eyes of all men that should see her' (Judith 10:3-4). This may reflect the Renaissance fascination with the dual aspect of a sensual yet virtuous woman.

## Pharmacy jar, 1420–40
Tin-glazed earthenware, cobalt blue and manganese purple pigment
Made in Florence, Italy
23.4 cm x 21.5 cm x 20.5 cm
40.53

This bulbous double-handled jar is made of tin-glazed earthenware known as maiolica. Decorated with stylized oak-leaf motifs and strange human-headed animal figures, it is typical of pieces produced in Florence in the early 1400s. Painted with a thick cobalt-blue pigment and a purple-brown manganese oxide, the whole surface shines with a thick glaze.

Hospitals, apothecaries and pharmacies commissioned many hundreds of these jars. Hard-wearing and easy to clean, they offered ideal storage for a range of medical remedies, including pills, lozenges, roots, dried fruits and herbs.

**Star-shaped wall tile,
1100–1200**
Seljuk Period
Frit body, overglaze lustre
Made in Kashan, Iran
1.2 cm x 10.4 cm x 11 cm
33.44

Hunting with the aid of trained Asiatic cheetahs was a custom of the Seljuk ruling classes in Iran. This lustre-painted ceramic wall tile depicts such a cheetah, which is distinguished from wild cheetahs by his collar. He is walking by the edge of a fish pond. Cheetahs were especially admired for their excellent abilities as sight hunters and for their speedy sprint.

This tile adorned the walls of a hunting lodge or a pleasure palace to celebrate the patron's hunting prowess, which is seen as a reflection of his abilities as a successful warrior and ruler.

**The Stag Hunt, 1529**
Studio of Lucas Cranach the Elder
Oil on panel
96 cm x 120 cm
35.73

Like many rulers, the Electors of Saxony enjoyed hunting as a sport and this pastime became a popular subject for their court painter, Lucas Cranach the Elder. In this version of Cranach's *The Stag Hunt* a herd of deer are chased into a bend of the river around which nobles, possibly Johann Friedrich (1503–55), Frederick the Wise (1463–1525), Emperor Maximilian I (1459–1519), and Johann the Constant (1468–1532), hide strategically in the bushes. With the stags now caught in the water, the aristocratic hunters load and aim their crossbows.

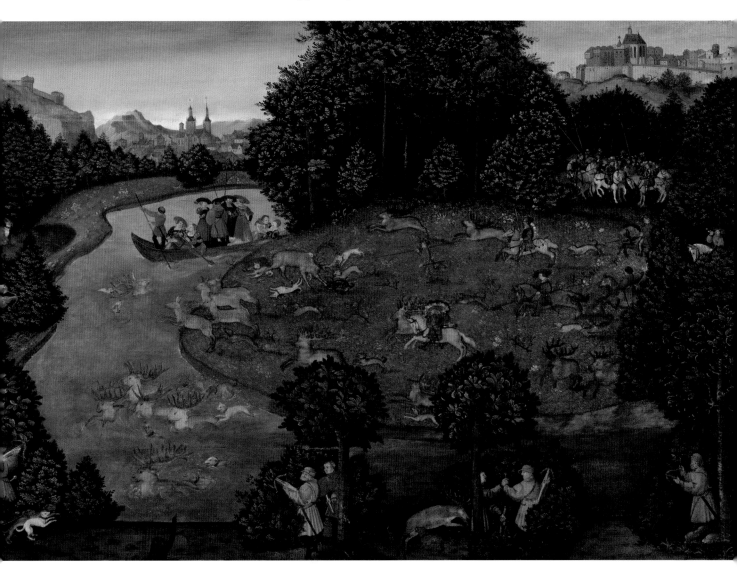

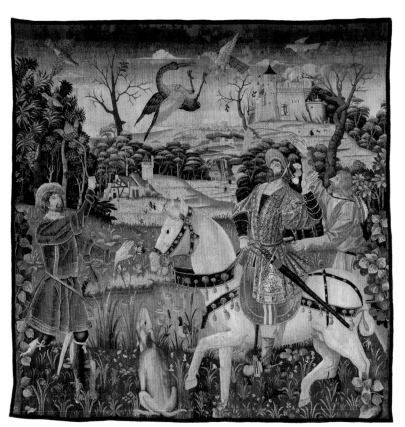

## Fight Between a Falcon and a Heron, about 1525

Wool, silk
Probably made in Paris, France
overall: 322 cm x 314 cm
46.60

Falconry, the sport of hunting with birds of prey, was popular in the 1500s. The use of highly trained birds, such as peregrine falcons, was restricted to the wealthiest members of society, as you needed to employ staff to train the birds and assist when hunting. In this dynamic scene an aristocratic French gentleman on horseback together with his two falconers and hunting dog watch as his falcon fights with a heron in mid-flight above their heads. Due to its large size and strength, a heron was a formidable prey for the smaller falcon.

## Mantelpiece and over-mantel, 1550–60

Oak, stone
Made in England
310 cm x 282 cm
27.15

The over-mantel of this chimney-piece features the Tudor coat of arms surrounded by the garter ribbon with '*Honi soit qui mal y pense*' (Evil to him that thinks evil). Carved below is '*Semper Eadem*' (Aways the same), the personal motto of Queen Elizabeth I of England (1533–1603).

Purchased by Sir William Burrell in 1953 from the collection of William Randolph Hearst (1863–1951), an American newspaper owner, it arrived in a packing-crate marked 'Mantelpiece from Oatlands Park'. Oatlands had been purchased by King Henry VIII in 1537, with the existing house extended to create a palace used by the Tudors as a hunting lodge.

## Grotesque animal carpet fragment, 1590–1600

Mughal Period
Cotton, wool
Made in either Fatehpur-Sikri, now in India, or in Lahore, now in Pakistan
266.7 cm x 269.2 cm
9.1

Believed to have been made for the audience hall of the Emperor Akbar (1542–1605), this carpet fragment belongs to an early genre of Mughal carpets known as Grotesques. It once formed part of an exceptionally large carpet, estimated to have measured 4 metres by 20 metres. It shows wild animals from the Indian jungle playfully springing out of each other's mouths in a chain of fantastical compositions. The range of animals is extensive and includes large and small mammals, reptiles, birds and fish. The only supernatural creatures on the carpet are two demonic heads. This imaginative design was influenced by both Islamic Persian and Hindu Indian art.

## Dragon carpet, 1600–1700

Safavid Period
Wool
Made in Baku region, Azerbaijan
505.5 cm x 243.8 cm
9.38

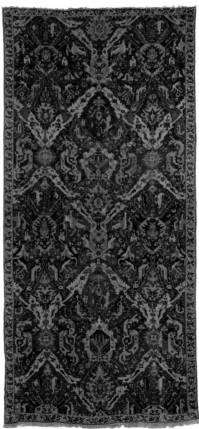

The yellow S-shaped dragons give this iconic type of Caucasian carpet its name – Dragon Carpet. This one has a wide variety of animals, including two rows of dragons, three rows of pairs of deer fawns, and two rows of fighting pairs of lions and wild asses, known as flaming-lion and chi-lin. On the blue lattice branches are placed pheasants and ducks.

Considered to be of one of the earliest types of Caucasian carpets, a product of a cottage industry, this dragon carpet's design is thought to be based on earlier, and much less abstracted, Iranian prototypes. These Caucasian versions were made to sell along the area's many trade routes.

## Wall tile, 1270–1300

Ilkhanid Period
Frit body, underglaze, overglaze painting, gold
Made in Kashan, Iran
21.5 cm x 21.4 cm x 1.5 cm
33.137

On this Persian ceramic tile a mythological bird soars. It is the *Simorgh*, a pre-Islamic Persian supernatural phoenix-like female bird that protected the ancient kings of Iran. During the Islamic Period it acquired the role of the compassionate King of the Birds, and was employed in Persian allegorical literature and Sufi mystical poetry to represent God, with the birds symbolizing humankind.

On this tile the Simorgh has been visualized in a Chinese manner, borrowed from the depiction of the Fenghuang bird on contemporary Chinese textiles traded along the Silk Road. This tile would have decorated the interior walls of a palace or similar high-status building.

## Textile fragment, 1200–59

Siculo-Arabic culture
Silk, gold
Made in Palermo, Sicily
14.5 cm x 49 cm
29.1

This fragment was part of a robe made for the crusading monarch St Louis IX of France (1214–70). The robe is known as the Cope of Parrots, but the pairs of addorsed birds are eagles, a symbol of royalty. The textile was designed and embroidered to be a royal robe in the Siculo-Arabic workshops of Palermo, Sicily. After leading the Seventh Crusade to the Holy Land, Louis IX gifted the robe to Bartholomew di Braganca (about 1200–71), the Papal Legate in Paris, who in turn gifted it to the Church of Santa Corona de Vicenza in Italy, where it still is today. In the 1880s the robe was altered and this off-cut became surplus.

## Chahar-Bagh carpet fragment, 1600–1700

Safavid Period
Cotton, wool
Made in the Kurdish region of
north-west Iran
431.8 cm x 337.8 cm
9.9

In the Islamic tradition the
heavenly Paradise is usually
thought to be made up of four
gardens and described in Persian
as a *Chahar-Bagh*, a phrase that
means four-gardens. The phrase
is also used to describe this type
of early garden carpet.

This fragment is a third of the
original whole carpet, and is
a bird's-eye view of a garden
that is symmetrically divided by
waterways and square-shaped
flowerbeds.

It is one of William Burrell's
early purchases that he lent to the
Glasgow International Exhibition
of 1901. The fragment previously
belonged to the renowned art
critic Sir Sidney Colvin (1845–
1927), who was a Slade Professor
of Fine Art and the director of
the Fitzwilliam Museum at the
University of Cambridge.

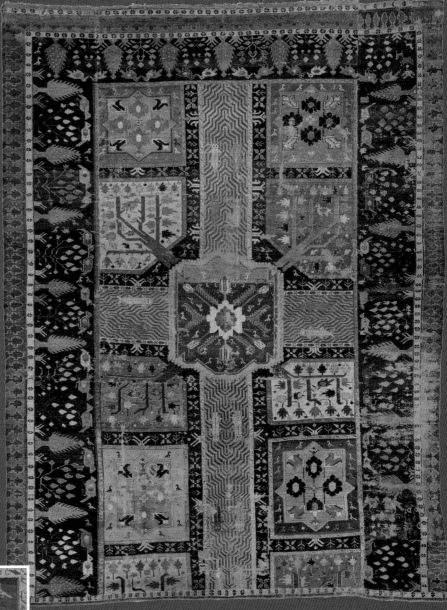

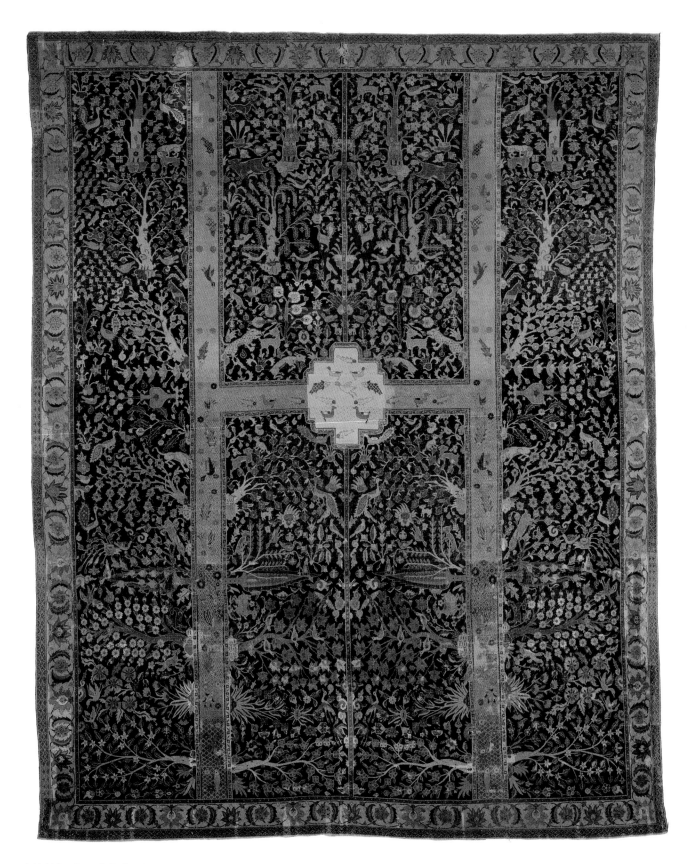

## Carpet with arabesque and medallion design, 1600–1700
Safavid Period
Cotton, wool
Made in Kirman, Iran
347.9 cm x 284.5 cm
9.3

Islamic arabesque, the quintessential pattern of many classical Persian pile carpets, is superbly laid out on this exceptionally fine carpet. The arabesque design here consists of two intertwined networks of meandering vegetal stems and tendrils with foliates and rosettes. One network is in dark blue with pink leaf scrolls, and the other is of a lighter blue colour with large leaf scrolls and coloured flowers. Multi-coloured palmettes are positioned at the junctions where the two networks criss-cross or overlap. The large pink medallion in the centre of the field is also decorated with an arabesque motif. William Burrell used all of the large carpets that he collected, including this one, as floor coverings at Hutton Castle, his home in the Scottish Borders.

## The Wagner Garden Carpet, 1600–1700
Safavid Period
Cotton, wool, silk
Made in Kirman, Iran
530.9 cm x 431.8 cm
9.2

A most unusual carpet, the Wagner's design was inspired by both the pre-Islamic Persian Paradise and the descriptions of the Garden of Heaven in Islam. It is named after a previous German owner about whom little is known. Resembling a walled park, its water channels and a central pool are teeming with fish and ducks. The garden spaces surrounding them are packed with a variety of trees, shrubs and flowering plants amongst which animals, birds, butterflies and moths live. The animals include foxes, deer, onagers (wild asses), goats, hares, wild boars, lions and leopards. The birds include storks, peacocks and pigeons. The layout of the flora and fauna gradually changes direction in the top half of the carpet, creating a panoramic view of the garden for the person sitting on it at the bottom half – a unique layout for a garden carpet. It almost invokes a heavenly walled menagerie that immerses the person sitting on it in its natural but well-ordered world.

***Meiping* vase, 1368–98**
Ming Dynasty, Hongwu Period
Porcelain, underglaze blue
Made in Jingdezhen, China
36.8 cm x 21 cm x 21 cm
38.433

This vase shows a five-clawed dragon above magical fungus-shaped clouds. The cobalt used to produce the sparkling blue is rich in the mineral manganese, giving the vase a characteristic grey-blue blotchy appearance. The two characters on the vase, *Chun Shou* in the seal script style, mean 'Spring longevity'. Only three other similar vases have been recorded to date – in the Shanghai Museum, China; the Museum of Oriental Ceramics, Osaka, Japan; and in a private Chinese collection. Emperor Zhu Yuanzhang (1328–98) founded the Ming Dynasty in Nanjing. His reign is called Hongwu, meaning 'Vast Military Power'.

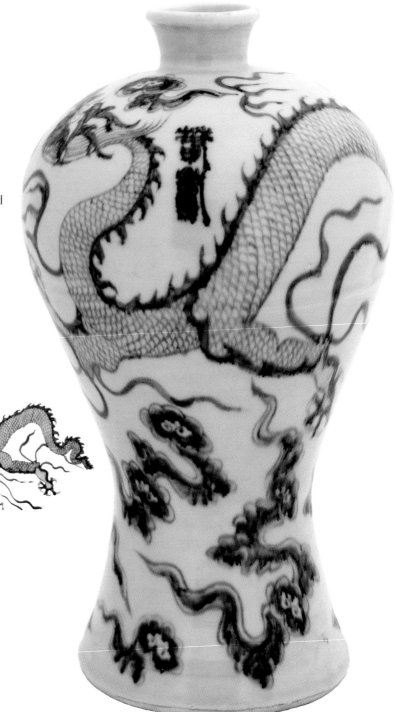

**Ewer, 1368–98**
Ming Dynasty, Hongwu Period
Porcelain, underglaze copper-red
Made in Jingdezhen, China
32.4 cm x 28 cm x 20 cm
38.455

This pear-shaped ewer has a high strap handle and a long spout attached by a cloud-shaped strut to the neck. The shape was influenced by Islamic metalwork imported into China from the Middle East. It is painted in underglaze copper-red, which is extremely difficult to fire successfully at high temperatures. If the process is effective, as here, copper oxide fires bright red, but if not, it fires grey or almost black.

**Tankard, 1403–24**
Ming Dynasty, Yongle Period
Porcelain, underglaze blue
Made in Jingdezhen, China
19.5 cm x 15.5 cm x 13.5 cm
38.443

This early fifteenth-century globular tankard, complete with its cover, is perhaps one of the finest in the world. This tankard has a distinctive handle in the form of an open-mouthed dragon and a design of stylized lotus scrolls around the body. While blue-and-white porcelain is often thought of as quintessentially Chinese, it was a product of cross-cultural interactions. The use of this innovative glaze was introduced to China from the Islamic world during the Yuan Dynasty (1279–1368). Tankards with this shape were very popular during the Timurid Period (1370–1506), in Iran and Central Asia.

## Dish, 1500–1600
Ottoman Period
Frit body, underglaze painting
Made in Iznik, Turkey
6 cm x 29.5 cm x 29.5 cm
41.36

The artisans of the Ottoman royal workshops in Istanbul and the potters in the town of Iznik created designs for ceramics that were rich in colourful naturalistic motifs. These had traces of Chinese influences but were distinctively Ottoman. Dominating the centre of the dish is a floral spray with carnations, tulips and hyacinths being blown about in the wind. Ottoman culture imbued flowers with meaning – both emotional and mystical – and used images of them to decorate their homes and public buildings.

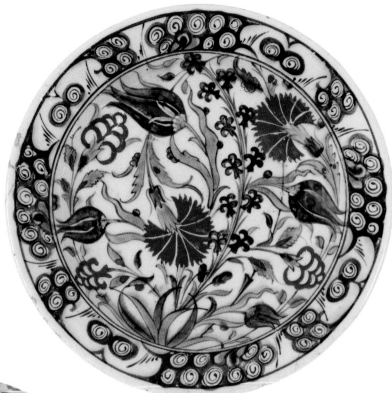

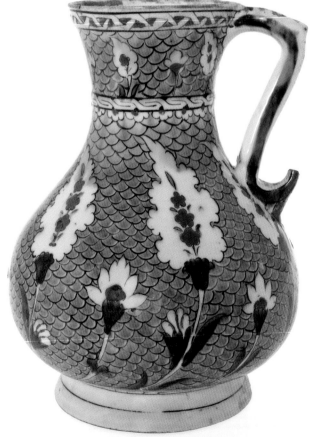

## Jug, 1570–80
Ottoman Period
Lead-glazed frit body, underglaze painting
Made in Iznik, Turkey
27 cm x 20 cm x 20 cm
41.28

The body of this large Iznik ceramic jug is elaborately decorated with large white flowers overlaid with red prunus blossoms on a jade-coloured fish-scale covered background. The fish-scales motif was a local imaginative application by the Iznik potters, who filled the plain spaces and empty surfaces with pattern and texture.

Jugs like this were made as tableware for everyday use in the royal courts of Istanbul. The small town of Iznik was a centre of pottery production, and during this period some 300 potters worked there, making vessels and tiles for Istanbul and beyond.

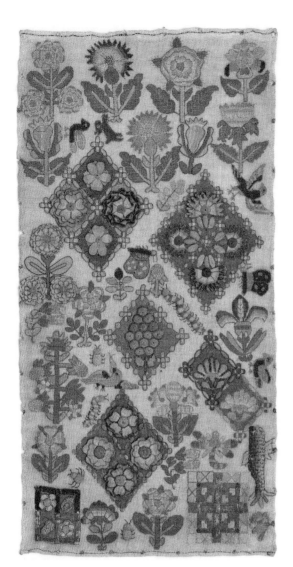

**Spot motif sampler,
about 1630–50**
Linen, silk, silver, silver-gilt
Made in England
53 cm x 26 cm
31.6

Samplers were made to not only practise
needlework stitches but also to record
different types of patterns that could be
copied later onto household linens and
clothing. This type of sampler is known
as a spot motif sampler. It is covered with
a random selection of unlinked designs that
may have been inspired by illustrations in
contemporary books, such the botanical
woodcut prints of flowers found in herbals.
It was worked by an accomplished
embroiderer who has used raised and
padded work to create individually-worked
and layered petals on some of the flowers
and fat, round caterpillars.

**Embroidered panel,
about 1700–25**
Linen, silk, wool
Made in England
41 cm x 41 cm
29.29

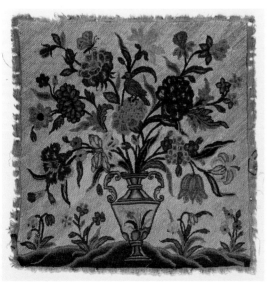

Large naturalistic floral blooms, including a
carnation, iris, lily, rose and tulip, dominate
this needlework panel. It was probably
made by an amateur embroiderer as a
leisure activity and may have been mounted
subsequently in a folding panel or fire screen.
The designs for embroideries of this type
were inspired by Dutch still life paintings and
engravings. These were used to illustrate
the first British seed catalogues, such as
Robert Furber's (1674—1756) *Twelve Months
of Flowers*. *The Flower Garden Displayed*,
published in 1732, even stated that its
illustrations were 'also for the ladies as
patterns for working' with their needles.

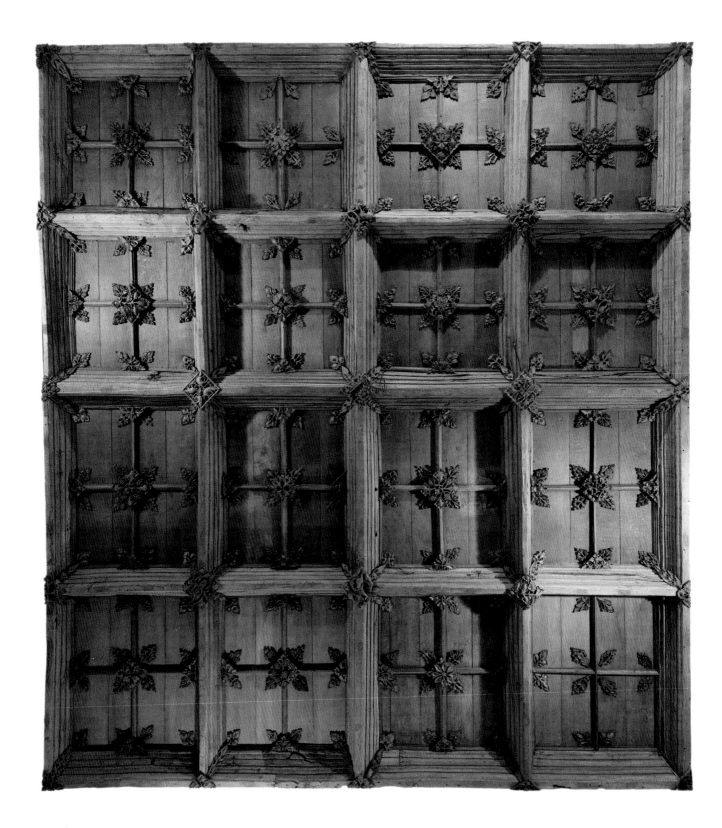

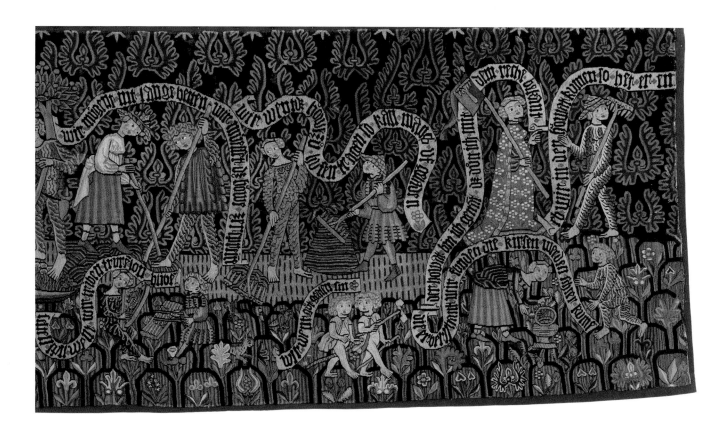

**Bridgwater ceiling, about 1400–1500**
Oak, wood
Made in England
overall: 540 cm x 480 cm x 35 cm
32.4

Panelled wooden ceilings were a particular feature of late medieval churches and houses in the south-west of England. This one was discovered in the late nineteenth-century hidden above a plaster ceiling in a house in Bridgwater, Somerset. Ten large beams support 16 oak panels that are each divided into quarters with delicate ribs. Each intersection of beams or ribs is reinforced with bosses carved with individual designs, including a variety of decorative foliage as well as figures of people and animals. The crowned Tudor rose in the centre may be original or have been added after 1485 when Henry Tudor was crowned King of England.

**Haymaking, about 1440**
Linen, wool
Made in Alsace
99 cm x 161 cm
46.26

Wild men and wild women covered in long hair work in harmony with a noble woman and villagers to make hay in this charming tapestry. On the far left a wild man cuts the grass with a scythe, while the pair next to him rake it out to dry in the sun and another gathers up the dried harvest into a neat haystack. Meanwhile, along the bottom children make music and play with hobby horses, whilst a woman and wild man remark in the scroll curving above them that 'we have found the strawberries; the cherries will be coming soon.'

## Labour of the Month: February, about 1475–1525
Stained glass, lead
Made in the Netherlands
23 cm x 23 cm
45.429

Illustrations showing the four seasons or 12 months of the year were a popular topic during the medieval period, appearing in books or on domestic furnishings such as tapestries or stained glass. Each showed a specific labour or pastime associated with that time of the year. February, which can often be one of the harshest winter months, is represented here on this small roundel with a well-to-do couple warming themselves in front of a roaring fire, its large flames aided by the use of bellows by the kneeling woman.

## Jack clock, 1500–1600
Iron, brass, other metals, wood, polychromy
Made in Europe
66 cm x 32 cm x 32 cm
10.3

A Jack Clock is named after the figure who sits on top of the clock. On this example the jointed, wooden manikin strikes the metal bell every hour with a hammer, and then every quarter of an hour with his feet.

This clock is particularly important because of its rarity and early date. Despite being approximately 500 years old the clock mechanism is still in working order, but as it is extremely fragile it is rarely wound up.

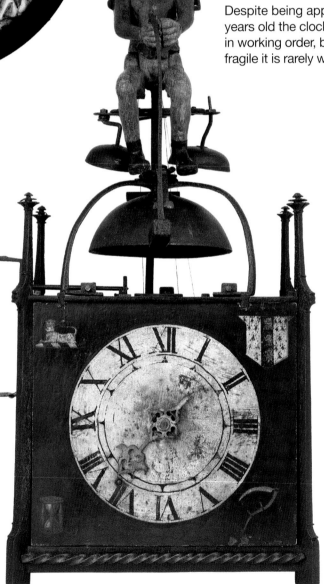

**The Months: January, about 1500**
Wool, silk
Possibly made in Tournai, Southern
Netherlands, now Belgium
276 cm x 328 cm
46.75

*January* is part of a set of 12 tapestries showing activities associated with each month of the year. Here a wealthy family entertains a guest with food and drink in the hope that it will bring them good fortune in the forthcoming months, whilst outside a group of men play an early form of hockey. Isabella Burrell lent this tapestry, together with ones representing April and September, to the 1901 Glasgow International Exhibition. William Burrell and his wife Constance later hung them in their dining room at 8 Great Western Terrace, Glasgow.

**Embroidered panel, about 1630–1700**

Linen, silk
Made in England
39 cm x 53 cm
29.89

This busy needlework panel is full of people employed in rural labours, including a shepherd playing a pipe to his sheep, an angler fishing, a dairymaid milking a cow and a farmer ploughing a field. Several of these figures, most notably the hunter and his dog chasing a stag top right, appear not only on other embroideries, but also on English tapestries, wallpaper fragments and plasterwork friezes, suggesting they were based on stock figures that appeared in printed books and pamphlets. The woman with a basket of fruit may be a personification of plenty or Ceres, the Roman goddess of agriculture.

**Goblet, 1700–1800**
Glass
Made in Bohemia, now part of the Czech
Republic
16 cm x 9 cm x 9 cm
16.22

Bohemia was one of the major glass-making
areas in Europe. From the late 1600s
Bohemian glass-makers became famous
for their cut and engraved
glassware.
   The cup-shaped bowl of this
glass goblet is decorated with
an engraved outdoor scene. On
one side a man is sat on a grassy
mound stroking his dog, while on
the other side a huntsman shoots
at a flock of birds. Traditionally
birds had been caught using nets,
traps or birds of prey, but with the
development of accurate firearms
it became increasingly common to
shoot them.

**Goblet, about 1730–40** ▶
Glass
Made in the Dutch Republic, now the
Netherlands
19 cm x 8 cm x 8 cm
16.54

Engraved wine goblets were used by the
Dutch elite for toasting and were often
decorated with scenes commemorating
the owner's personal successes, political
alliances, and business ventures. It is
probable this glass was used to toast to
a successful harvest.

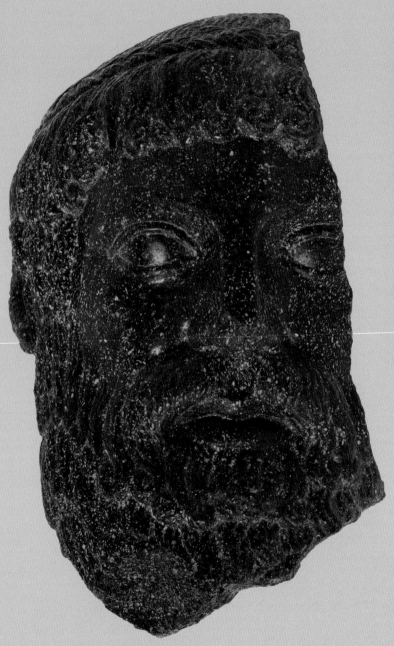

**Head of Zeus, 320–330**
Porphyry
Made in Italy
31.5 cm x 18 cm x 22.8 cm
42.1

Roman sculptors often copied Greek
sculptures made hundreds of years earlier.
This is thought to be a Roman copy of a
bronze head of the Greek god Zeus that
was made originally in the fifth century BC.
   Details such as the hairstyle and the
narrow headband are so similar in style
to marble figures on the pedimenta of the
Ancient Greek Temple of Zeus at Olympia
that it is likely that the same sculptor or
someone working with him also made the
now lost bronze original of this head.
   Vast quantities of 'imperial porphyry'
were quarried in the Eastern desert of Egypt
during the Roman period and reserved for
only the most prestigious work.

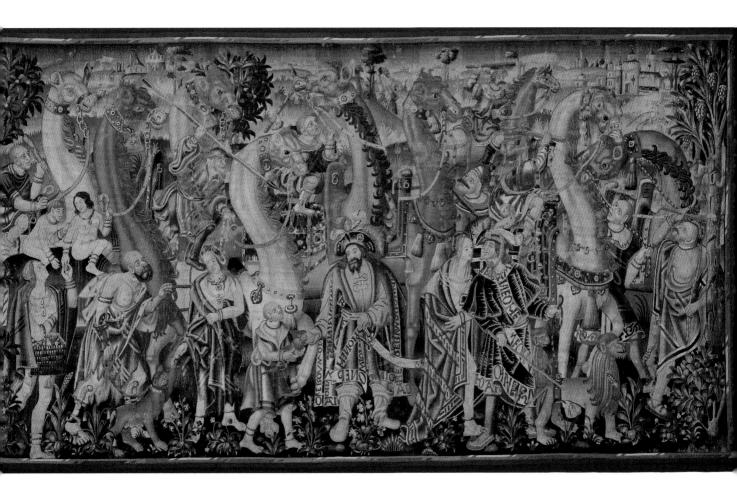

**Exploration of the Indies:
The Camel Caravan, about
1500–30**
Wool, silk
Made in the workshop of Arnould
Poissonier, probably Tournai,
Southern Netherlands, now Belgium
360 cm x 652 cm
46.94

This very large tapestry is one of
a group known collectively as the
*Voyage to Calicut*, which were
made to celebrate the expeditions
of the Portuguese explorer Vasco
da Gama (1460s–1524) around the
Cape of Good Hope, now South
Africa, to India in 1497–99 and
1502–03. It may have formed part

of a set of up to 10 tapestries, each
showing a different scene from
da Gama's adventures, including
his embarkation from Lisbon and
arrival at Calicut. This one shows
two Portuguese men dressed in
European fashions with a group of
local traders who are leading long-
necked camels.

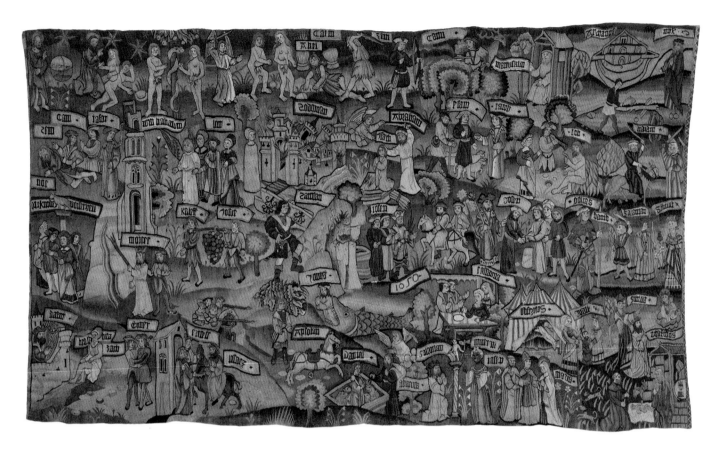

**The Bible Tapestry, 1550**
Linen, wool, silk, metal
Germany
159 cm x 276 cm
46.20

Depicting 34 scenes from the Old Testament and two from the New Testament, this tapestry is very unusual. The design can be read as a narrative, beginning with the Creation of the World in the top right and culminating with the Nativity of Christ in the lower left.

The tapestry's designer is not known but they may have been influenced by the fifteenth-century texts *Biblia Pauperum* or 'Pauper's Bible' and the *Nuremberg Chronicle*, an illustrated history of the world. Scenes including Creation of Eve and The Temptation bear a close resemblance to illustrations found in these books.

**Plate, 1662–1722**
Qing Dynasty, Kangxi Period
Porcelain, underglaze blue
Made in Jingdezhen, China
6.3 cm x 40.4 cm x 40.4 cm
38.1321

This plate depicts an episode from a Chinese play *The Romance of the Western Chamber* written by Wang Shifu (about 1250–1300). The scene shows a secret meeting of Zhang Sheng and Cui Yingying. The style of decoration, combining a central reserved medallion and eight cartouches painted in overglaze enamels, with a colour scheme known as *famille verte* and a powder-blue ground with gilded decoration, was extremely popular in Europe.

'Wind plays the sounds of bamboo:
I take it for the echo of her golden pendants.
Moonlight moves the shadows of flowers:
Can it be the jade person coming?'

Wang Shifu

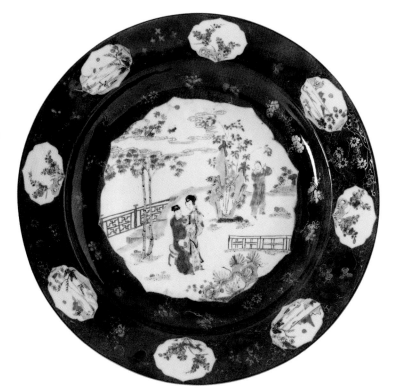

**Cock Escaping from Reynard, about 1896**
Joseph Crawhall
Watercolour on paper
17.1 cm x 14.9 cm
35.184

Feathers fly as a cockerel narrowly avoids the jaws of Reynard. This watercolour is one of 10 illustrations Joseph Crawhall (1861–1913) made of the medieval fable of Reynard the Fox for Glasgow textile manufacturer Thomas Glen Arthur (1857–1907). Based on the translation from Middle Dutch made and printed in 1481 by William Caxton (about 1422—91), they narrate the tricks that the wily Reynard plays on unsuspecting animals. Crawhall was a skilled visual storyteller and the scenes he portrayed were innovative and dynamic. They were later sold to Paisley thread maker William Allen Coats (1853–1926), another Crawhall collector. Burrell acquired the set from the sale of Coats' collection at Christie's in 1935.

**Scenes from the Life of Jesus Christ and the Virgin Mary, 1444**
White, coloured, stained and painted glass, lead
Made in Upper Rhine, Germany
From the Tree of Jesse window in the Carmelite Church, Boppard-am-Rhein
260 cm x 230 cm x 1 cm
45.485

This impressive group of six scenes was originally part of an even larger window in the Carmelite Church in Boppard-am-Rhein, Germany. Some of the other panels are also known to have survived.

*Clockwise from top left:*

**Christ before Pilate**
Jesus, in blue, is led by soldiers in medieval armour and surrounded by a mob. He is brought before Pontius Pilate, who sits on a throne, wearing scarlet and ermine.

**The Annunciation**
The Virgin Mary, wearing a blue mantle, kneels on the right, with the angel Gabriel in red on the left. The Dove descends in a stream of light from a bust of God.

**The Resurrection**
Jesus, in red, steps out of his tomb holding a banner, watched by two angels. One guard is asleep but the other is awake and reaches out to Jesus.

**Christ Appearing to St Peter**
This scene is based on a legend which does not appear in the Bible. Sometime after the crucifixion, St Peter is fleeing Rome when he meets the risen Jesus heading the other way. When asked where he is going, Jesus replies 'I am going to Rome to be crucified again'. This inspires Peter to turn around and continue his ministry.

**Birth of the Virgin**
This scene is also absent from the Bible. The infant Virgin Mary stands on the bed, between her mother and a servant, while a midwife washes linen in a tub.

**The Agony in the Garden**
After the Last Supper, Jesus went to the Garden of Gethsemane to pray. Three of his disciples joined him but fell asleep. An angel then appeared to Jesus. In the background, Judas leads the soldiers to Jesus. He carries a bag containing the 30 pieces of silver he was paid for his betrayal.

**Prophet Jeremiah, about 1145**
White, coloured and painted glass, lead
Made in France
63.2 cm x 35 cm x 1 cm
45.364

This panel depicting the Prophet Jeremiah is
the oldest piece of stained glass in Glasgow's
collections. It was commissioned around
1145, for the abbey church of Saint-Denis,
north of Paris. The church was being rebuilt
by Abbot Suger, who made it into the first truly
Gothic building. Although small, the brilliant
colours and finely painted detail mark this
panel out as an extremely rare and superlative
example of the Gothic glassmakers' art. There
are very few items of this age and quality to
be found in museum collections. Sir William
Burrell did not realize how old the panel
was when he acquired it in 1923 – its true
significance was only uncovered later.

**A Feast Scene, about 1255–85**
White, coloured and painted glass,
lead
Made in France, probably for the
cathedral at Clermont-Ferrand
165 cm x 62 cm x 1 cm
45.366

When Sir William Burrell
purchased these three panels in
1939 they were thought to depict
the Marriage at Cana, where Jesus
turned water into wine. They are
now believed to depict a courtly
feast. The *fleur-de-lis* motifs in
the margins represent the French
monarchy and the gold castles are
for the Kingdom of Castile. They
are probably from the cathedral
at Clermont-Ferrand, France,
which has similar windows. The
cathedral is built of black volcanic
stone and the vibrant colours
dazzle against the dark backdrop.
The craftsmen who made them
might have made the windows
for the Sainte-Chapelle in Paris,
which also has similar windows.

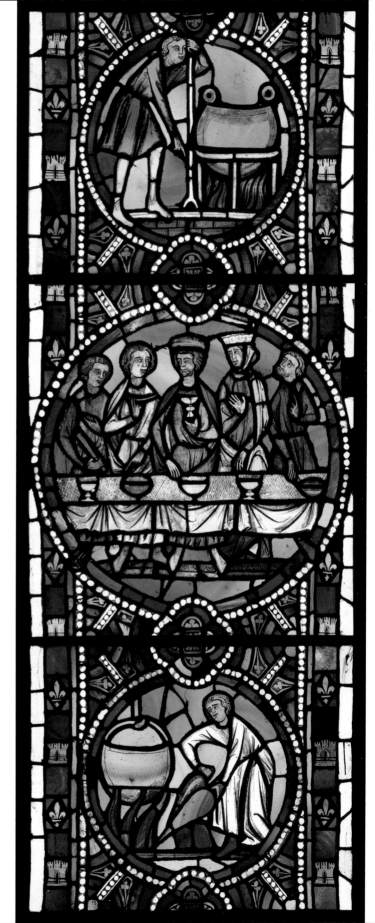

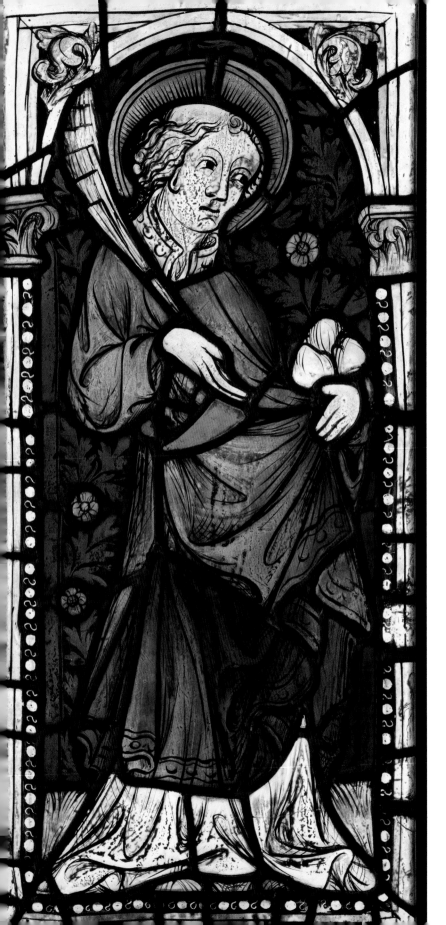

**St Stephen, about 1420**
White, coloured, stained and painted glass, lead
Probably made in Styria, Austria
79.5 cm x 36.8 cm x 1 cm
45.383

St Stephen is believed to have been a
Greek Jew who converted to Christianity.
He was accused of blasphemy in around
AD 34 and put on trial at the Sanhedrin, the
supreme Jewish law court, in Jerusalem.
The speech he gave so inflamed the crowd
that they stoned him to death. He was the
first Christian martyr. He can be identified by
his halo, the three white stones he carries in
his left hand and the palm frond in his right
hand. In west European Christian art martyrs
were often shown holding a palm frond.

(overleaf pp. 134, 135)
**A series of eight lights telling the life story
of John the Baptist, about 1510**
White, coloured, stained and painted glass, lead
Probably made in Rouen, Normandy, France
202 cm x 405 cm x 1 cm
45.417–45.424

Lights are vertical windows which are
sections of a larger window. This series
of eight lights tells the story of John the
Baptist. They probably came from the
church of Saint-Jean in Rouen, which closed
in 1793. They were brought to England in
1802 by John Christopher Hampp (1750–
1825), a Norwich weaver and merchant. He
took advantage of a brief lull in the wars
between the United Kingdom and France to
travel round Europe buying stained glass to
take home and sell to collectors. The lights
were bought by William Stevenson (1741–
1821) and his son Seth William Stevenson
(1784–1853), authors and antiquarians from
Norwich. By 1807, they were in Blithfield
Hall, Staffordshire, the home of William
Bagot, 2nd Baron Bagot (1773–1856). Sir
William Burrell bought them in 1946 from
Wilfred Drake, one of his trusted dealers.

## Arms of Edmund Knightley of Fawsley and Ursula de Vere, about 1540

White, coloured, stained, enamelled and painted glass, lead
Made in England, from Fawsley Hall, Northamptonshire
80.5 cm x 50.5 cm x 1 cm
45.332

Sir Edmund Knightley (bef.1491–1543) was knighted by Henry VIII, and served as a sergeant-at-law and commissioner for the Dissolution of the Monasteries. He married Ursula de Vere (1489–1558), co-heir of the Earls of Oxford, in 1520. This panel depicts their heraldic achievements. The escutcheon (shield) contains their coats of arms which are joined with the arms of their illustrious relatives. Either side are the supporters, a falcon for Sir Edmund's ancestors and a boar for the de Veres. Fronds of decorative drapery sprout from the helmet. Resting on a twisted roll of fabric is the crest, a stag's head representing the Knightley family.

From left to right:

**Zacharias' Vision in the Temple**
The Jewish priest Zacharias and his wife Elizabeth had no children. An angel appears and tells Zacharias that Elizabeth will become pregnant with a son, to be called John.

**The Virgin Mary visits Elizabeth**
When Elizabeth is six months pregnant her cousin Mary visits. Mary has just learnt that she will give birth to Jesus Christ.

**John is born**
Elizabeth looks at her new baby. Zacharias holds up a tablet with his name. The kneeling figures at the bottom of the first three lights represent the donors who paid for the window. They are probably a wealthy Rouen merchant and his family.

**John leaves his parents**
John grows up and leaves home to lead a simple life in the wilderness.

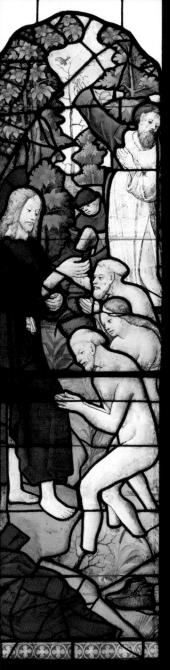

**John baptizes believers**
John starts to carry out baptisms in the River Jordan.

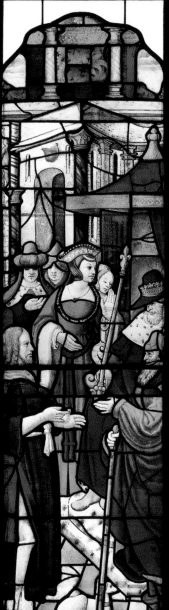

**John the Baptist rebukes Herod**
John angers King Herod by criticizing him for divorcing his wife and marrying his brother's wife.

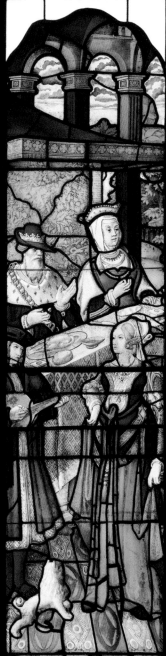

**Salome dances before Herod**
Herod's step-daughter, Salome, dances for him. He is drunk and promises her whatever she wants. Her mother, Herodias, persuades her to ask for John's head on a plate.

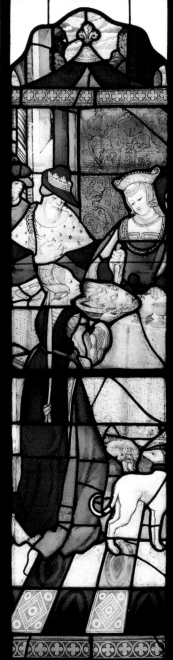

**Salome with John's Head**
Despite being disgusted by the request, Herod complies. Salome presents John's head to her mother.

**Jar, about 3000–2000 BC**
Banshan phase of the Yangshao culture
Earthenware
Made in Gansu Province, China
36.2 cm x 48 cm x 42 cm
38.1

The earliest Chinese ceramics collected by William Burrell are painted pots associated with the Neolithic Yangshao culture. It is best known for its pottery – the makers created fine white, red, and black painted pottery with geometric designs. The drawing on the jar shows an early example of two tones of reddish-brown brushwork for artistic compositions. The physical lightness of the jar comes partly from the hand-building skills of the potters but also from the kind of silty, lime-filled clays typical of the rich, yellow soil from north-west China.

**Vase, 1368–1644**
Ming Dynasty
Stoneware, black slip, turquoise glaze
Made in Hebei Province, China
22.9 cm x 10.8 cm x 10.8 cm
38.557

This vase has an ovoid body and
a short neck, a shape known as
*meiping* (plum vase) in Chinese.
Vases like this were widely used
during the Ming Dynasty (1368–1644)
to hold a single branch of plum
flowers. This example is covered
with a rich turquoise or peacock-blue
glaze, painted in black brushwork
with stylized peonies and foliage and
shows the influence of the Islamic
style of pottery in China.

**Ewer with lobed belly, 1100–1200**
Seljuk Period
Frit body, overglaze lustre
Made in Kashan, Iran
24.6 cm x 13.4 cm x 13.8 cm
33.201

This lustreware ceramic ewer's shape is based on metal prototypes made in northeast Iran and west Afghanistan. The body is decorated with a metallic compound that produces a lustre sheen over the white opaque glaze once it has been fired and polished. The motifs on the vertical segments of the body include alternating bands of arabesque decoration and calligraphy. The frit clay from which this vessel's body is made was an invention of Middle Eastern potters seeking to achieve a very smooth and light ceramic body that can be moulded into a variety of shapes, especially those more typically made in metal. They invented a clay mixture that was largely made up of quartz – crushed pebbles, sand and recycled glass.

**Dish with the Pelican in its Piety,** ▶
**about 1670–90**
Earthenware, trailed and jewelled slip
Made by Thomas Toft, North Staffordshire, England
7.2 cm x 49.1 cm x 49.5 cm
39.88

The elaborate decoration on this slipware dish depicts the pelican and her piety, with the pelican symbolizing Christ, cutting open her own breast to represent his death on the cross, his blood reviving humanity. The pelican is framed by a rosette and two *fleurs-de-lis* and a trellis border. The inscription 'Thomas Toft' points to one of the best-known makers of Staffordshire-made slipware pottery.

Thomas Toft (d.1698) is celebrated for his elaborately decorated dishes. Unusually for slipwares, they show the skills and imagination of those involved in creating them.

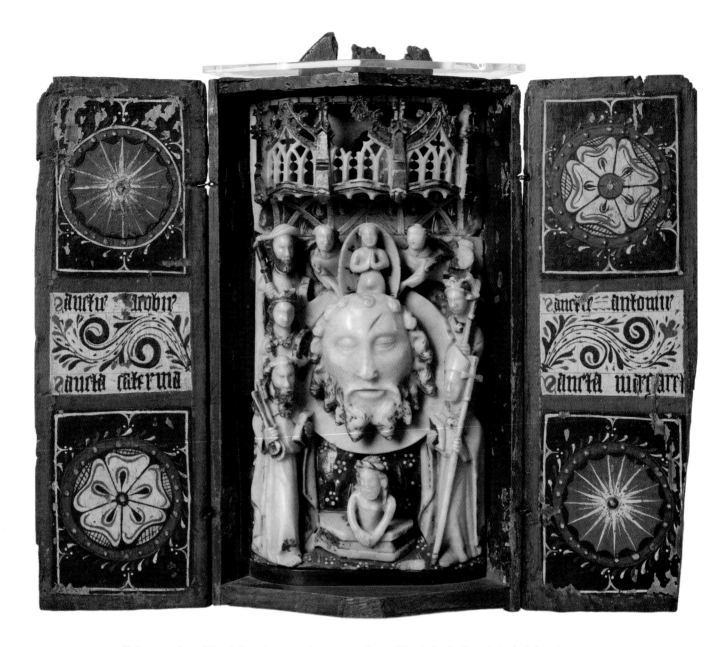

**Tabernacle with alabaster carving, about 1480**
Painted oak, alabaster, traces of polychromy
Made in England
47 cm x 45 cm x 11 cm
with wings open
1.34

Small tabernacles were made for private devotion by a family at home. This is the finest of three complete examples purchased by William Burrell that still retain their painted alabaster heads of St John the Baptist within their original painted oak boxes. Whilst they all show the decapitated head of St John prominently in the centre above Christ rising from the tomb, with St Peter on the left and a bishop, possibly St Thomas Becket, on the right, this one also includes St James, St Margaret, St Anthony, St Catherine and two angels bearing the soul of St John up to heaven.

**Folding diptych, about 1360–70**
Elephant ivory
Made in France
14.3 cm x 18.3 cm x 1 cm (opened)
21.8

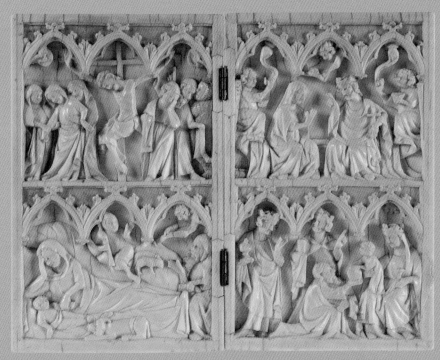

In medieval Europe elephant ivory was a prized material, used to carve luxury objects. Ivory diptychs, carved with tiny, detailed religious scenes, were often used for private devotion, the hinged panels allowing for the diptych to be closed over after prayer was completed.

This diptych shows four scenes from the life of Christ, including the Nativity, the Adoration of the Three Kings, the Crucifixion, and the Coronation of the Virgin as Queen of Heaven. The swaying, curved poses of the figures emphasized by dramatic folds of drapery is typical of high Gothic sculptural style found in this period.

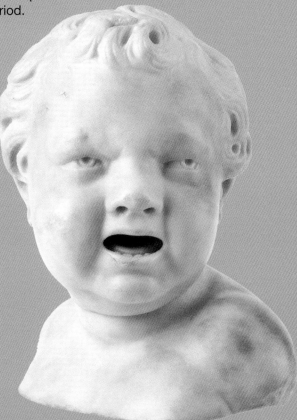

**Bust of a screaming child, about 1700–25**
Marble
Possibly made in Antwerp, Southern Netherlands, now Belgium
35 cm x 21.2 cm x 17.5 cm
44.30

When Burrell purchased this bust in 1950 it was thought to be from the school of the Italian sculptor Donatello (1386–1466). However, recent scholarship has attributed it as Netherlandish due to the fashion for sculpture of children with distinct facial expressions in Antwerp in the early eighteenth century.

Sculpted from one block of marble, the details of the child's hair and face were drilled carefully into the stone. Inside the open mouth, the sculptor has carved a flexed tongue in the movement of a piercing scream.

**Minnekästchen casket,
about 1450**
Probably fruitwood,
Made in Upper Rhine, Germany
11.1 cm x 28.6 cm x 18 cm
50.166

Since the nineteenth century, boxes
of this type have been known as
*Minneskätchen* (lover's caskets). The
boxes were believed to have been
exchanged as romantic gifts.

This box is decorated with low-
relief carvings with a distinctive
diamond diapered background. The
box panels, joined together with
dovetail corner joints, are carved
with real and mythical beasts,
including monkeys, Bactrian camels,
lions, griffins, unicorns, and rabbits
peeking from burrows. Traces of
colour can be seen on both the
animal carvings and in the flowers
on the grassy hillocks the carved
beasts stand upon.

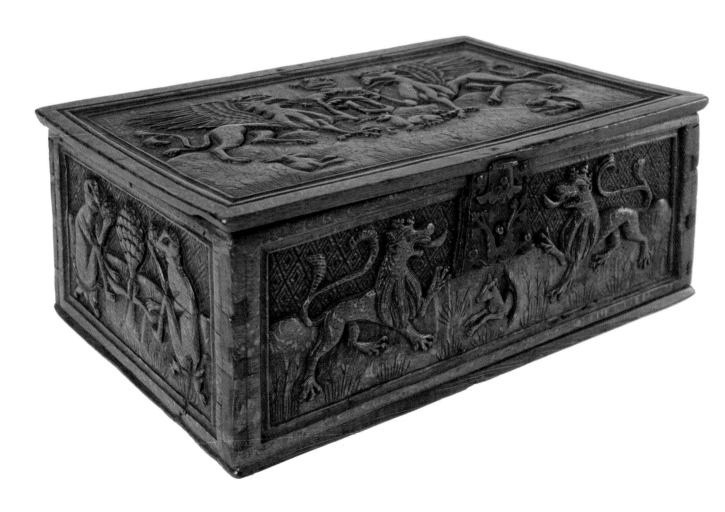

**St John the Baptist, about 1500–10**
Oak, polychromy
Probably workshop of Jan Crocq,
Lorraine, France
82.5 cm x 30.4 cm
50.24

This sculpture of St John the Baptist is intricately carved with striking facial features, long curled locks of hair, and dramatic, sweeping folds of the saint's robes. Traces of polychromy remain on the sculpture, suggesting that it had once been brightly painted.

In the crook of St John's left arm rests a lamb with a shaggy fleece. St John the Baptist is often shown in art with a lamb, a symbol of Jesus Christ. After baptizing Jesus, John proclaimed 'Behold the Lamb of God who takes away the sins of the earth'.

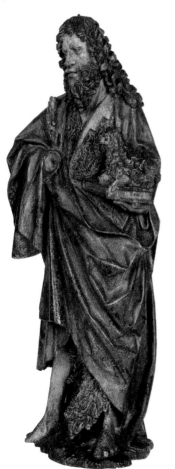

**Armchair with marquetry decoration, 1580–1620**
Oak, walnut, elm, ash
Probably made in England
141.6 cm x 70.7 cm x 49.5 cm
14.93

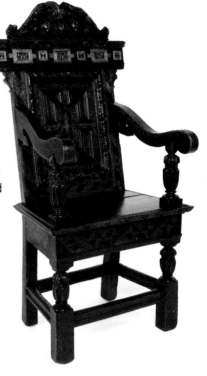

In the mid-sixteenth century German and Netherlandish furniture makers started to arrive in British towns to establish workshops. Many settled in Southwark, London, where they used local materials to create European style designs.

These craftspeople were specialists in marquetry – the cutting, joining together, and inlaying of different types of wood to create geometric and architectural patterns. This chair is decorated with triangular and diagonal bands of marquetry. This was most likely created by a European craftsperson and then added to the chair which was constructed by a native English furniture maker.

**The Hickman Chalice, dated 1608**
Fruitwood
Made in England
32.1 cm x 15.8 cm x 15.8 cm
49.7

The thin, delicate rounded form of this chalice suggests it was created by turning the wood on a pole lathe. Fruitwoods were often used for drinking cups as they are dense woods, which are less likely to break when turned. The chalice is decorated with scrolling foliage designs incised onto the wood by branding with a hot metal tool.

The name 'Hickman' comes from a previous owner. The Hickman family were prominent supporters of the Protestant faith in the late sixteenth and early seventeenth centuries. The chalice is inscribed with religious poems, including some hidden underneath the base.

## Self-Portrait as a Fisherman, about 1835

Katsushika Hokusai
Woodblock print
21.6 cm x 21.6 cm
37.13

This image of a fisherman is thought to be a self-portrait by Katsushika Hokusai (1760–1849). Hokusai, whose artistic career spanned almost 70 years, is renowned for his landscape paintings and drawings for woodblock prints known as *ukiyo-e* (pictures of the floating world). The early 1830s were a time of enormous creativity for him. During this period he produced the print entitled *A Fisherman Standing on a Rocky Promontory at Kajikazawa in Kai Province*, as part of the series *Thirty-Six Views of Mount Fuji*. The verses at the top right of the print are by Hokusai and his daughter, Katsushika Ōi (about 1800–66). This celebratory *surimono nishiki-e* print is lavishly coloured, using gold and silver, each colour applied and printed separately.

**Winter, The Plain of Chailly, about 1862–66**
Jean-François Millet
Pastel on paper
72 cm x 96 cm
35.542

This large and magnificent pastel shows the plain of Chailly on a cold winter's day as a desolate expanse of land and sky populated only by scattered, black birds. Human activity is suggested by the unused farming equipment, while the tower in the background seems a long, frosty walk away. Jean-François Millet (1814–75) lived and worked in the village of Barbizon, in northern France, where his studio had views of the plain of Chailly.

All the elements in this classically arranged composition of repeated diagonals, from the discarded harrow in the foreground, to the plough and then the hedges, map the perspective towards a single focal point on the horizon. Together with the soft colours, this pastel shows Millet's love for winter, quiet and solitude.

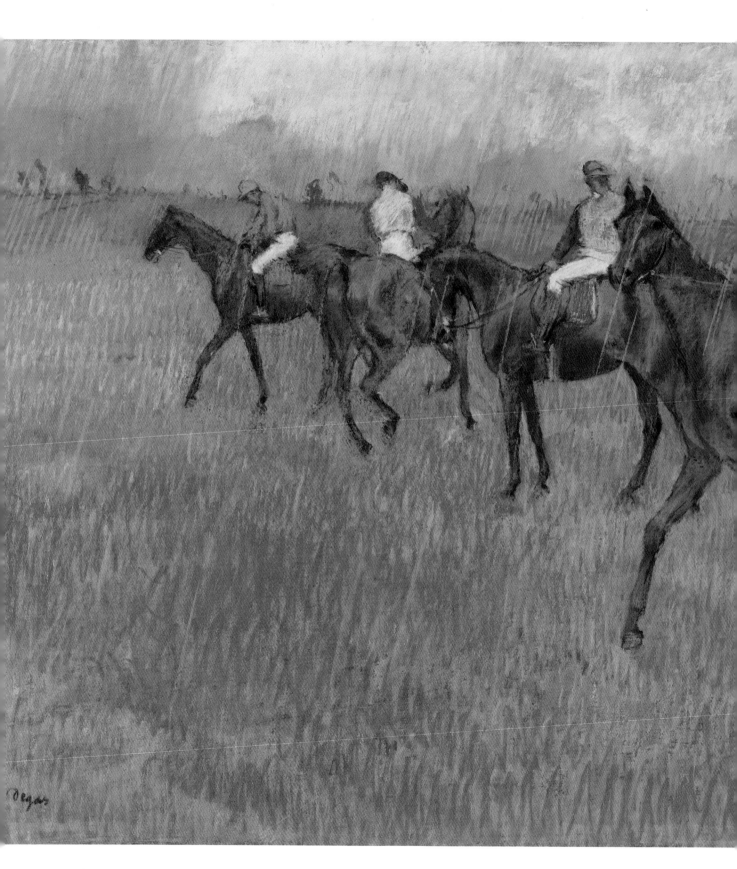

**Jockeys in the Rain,
about 1883–86**
Edgar Degas
Pastel on paper, laid down on board
47 cm x 63 cm
35.241

The atmospheric effect of driving
rain in this scene was created by
Edgar Degas (1834–1917) using
slim diagonal strokes of blue pastel
that cover and unify the work's
surface. This is just one of many
layers of pastel built up by the
artist to achieve a dynamic image
of horses and jockeys awaiting
their race. The green grass has
been constructed using different
shades of green, as well as more
surprising tones of purple and pink.

Degas has expertly created a
sense of tension by contrasting
the impatient horses and their
colourfully clad jockeys who
occupy one side of the diagonally
divided composition, against a
calm and clear expanse of grass
occupying the other.

**The Red Ballet Skirts,
about 1895–1900**
Edgar Degas
Pastel probably on tracing paper
81 cm x 62 cm
35.243

Three members of the corps de
ballet are shown not in the midst
of their graceful performance, but
in the moments before or after as
they rest in the wings. Their un-
choreographed bodies are relaxed
as they rest, stretch or adjust the
ribbons on their pointe shoes.

Edgar Degas captured the
glowing aniline dye of dancers'
tutus under the artificial stage lights
in his late pastels, experimenting
by changing the colour of the
costumes and the theatrical
scenery behind. Degas increasingly
used pastels, which became
available in a wider array of vivid
colours during his lifetime. From
about 1875, most of his artworks
were made using pastel.

**Yastik cushion cover, 1600–1700**
Ottoman Period
Cotton, silk, gilt metal
Made in Bursa, Turkey
131.4 cm x 66.1 cm
51.10

Ottoman reception rooms were adorned with large cushions covered with this type of voided velvet textile. These cushions were horizontally positioned as backrests for low divan seating. The city of Bursa in western Anatolia was the main centre for the hand-weaving of velvet textiles, including voided velvet, which is an elaborate weaving technique that combines silk threads for the velvet pile with gilt metal and silver-covered threads for creating the flat woven parts of the fabric's design. The design of this cover is dominated by a large roundel framing a floral arabesque composition of hyacinths, carnations, tulips and serrated leaves.

## Gros Point border, about 1650–75

Linen
Made in Venice, Italy
18 cm x 256 cm
24.58

Hunters and their dogs chase hares, stags and lions in this lively lace border. In the mid-seventeenth century Venice was famous throughout Europe for its needlelace – a type of lace made using a length of linen threaded on a needle rather than with multiple threads attached to bobbins. *Gros Point*, which means 'large point' in French, is characterized by its bold designs featuring raised scrolling stems and floral motifs worked in lots of tiny buttonhole and picot stitches. It was a highly skilled and time-consuming process that meant the resulting lace was extremely expensive and could only be bought by the wealthiest people.

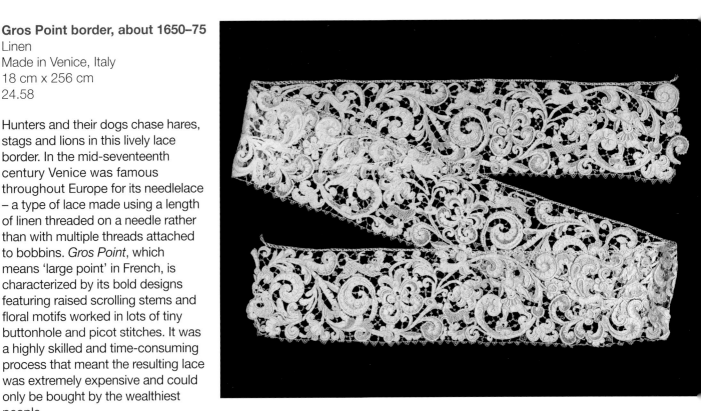

## Beadwork basket, about 1675

Glass, metal, silk
Made by Elizabeth Clarke, England
60 cm x 75 cm
29.176

Beadwork was a popular activity during the seventeenth century. It was undertaken by older girls in wealthy families during the later stages of their education or as a suitable leisure activity in the years before marriage. The tiny glass beads were probably imported from Venice and have retained their bright colours. This basket was made by Elizabeth Clarke (1655–99) when she was about 20 years old. In the centre are a fashionably dressed courting couple who may represent Elizabeth and Samuel Greene, whom she married in 1676. They are surrounded by three-dimensional flowers and fruit, including daffodils, tulips, pansies, acorns and oranges.

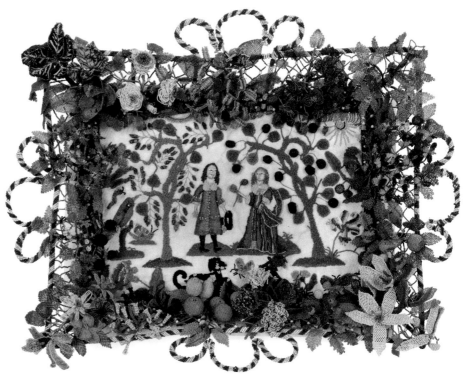

**Prayer rug, 1700–1800** ◄ ►
Ottoman Period
Wool
Made in Ladik, central Anatolia,
Turkey
203.2 cm x 109.3 cm
9.55

There are three crescent moons
crowning the arches above the
central niche on this prayer rug.
They resemble the gilt brass finials
that crown mosque minarets
across the Middle East – a symbol
of the Islamic lunar calendar,
and a sign that the building is for
worship. On this prayer rug the
crescents indicate that the head
of the worshipper should rest in
prostration at this end. The water
vessels are a symbol of cleanliness
and purity, both physical and
spiritual. The tulips below the blue
niche were the favourite flowers of
Anatolia and during the Ottoman
period the tulip became a symbol
for God.

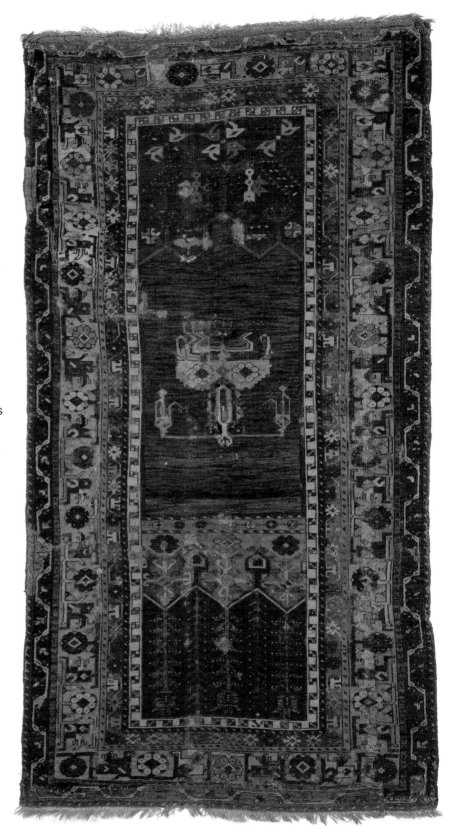

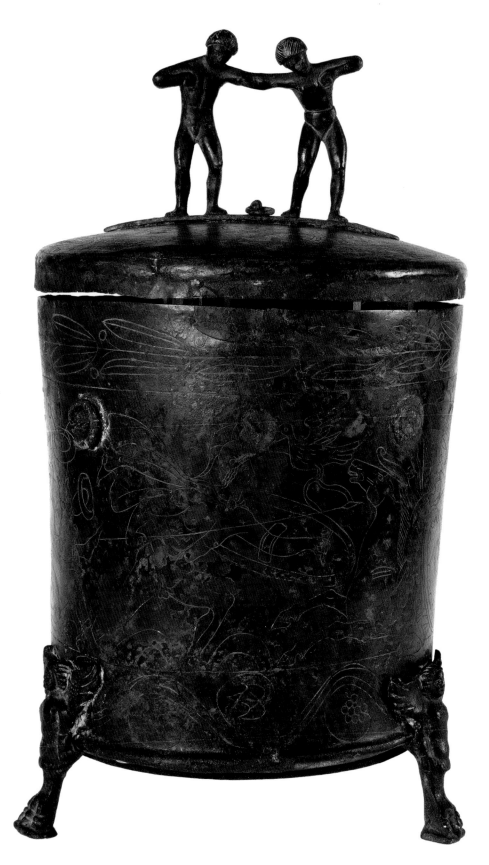

▲
***Cista* cylindrical box and lid, 400–300 BC**
Hammered bronze
Etruscan, probably made in Praeneste,
Palestrina, Italy
33 cm x 20.3 cm x 20.3 cm
19.32

Over 100 of these cylindrical lidded bronze
boxes or *cistae* have been found buried
in tombs in the ancient Etruscan town of
Praeneste, now Palestrina, near Rome. Some
seem to have been used as containers for
women's toiletries, as they were found to
contain mirrors, *strigils*, combs, hairpins and
cosmetic pots.

The box stands on three feet in the shape
of winged figures above lions' claws. It is
finely engraved with a battle scene showing
three naked heroes defeating four clothed
warriors. The lid is engraved with a frieze of
animals and the handle is in the form of a
bronze figurine of two wrestlers or boxers.

**Longsword, about 1250**
Steel
Made in France or Germany
123.8 cm x 17.8 cm
2.74

When wielded with practised skill
the longsword is deadly. It is a tool
specially designed to kill and maim
humans. By expertly combining iron
and steel, swordmakers crafted
blades that were both flexible and
tough. They bend without breaking
and slice with razor-sharp edges.

Chronicler Jehan Froissart (about
1306–56) described an expert
swordsman attacked by a mob in
1381: 'whosoever came near received
such a blow that with each stroke
dealt he cut off a foot, or head, or arm,
or leg!' The excavated remains of
men and boys slain in brutal medieval
battles bear grim witness to the
longsword's lethal efficacy.

The detail below shows inlaid marks
on the sword.

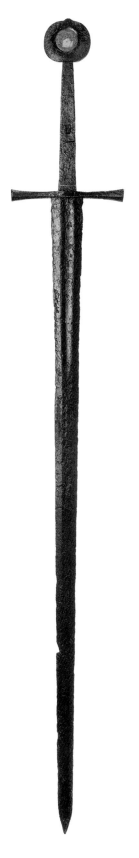

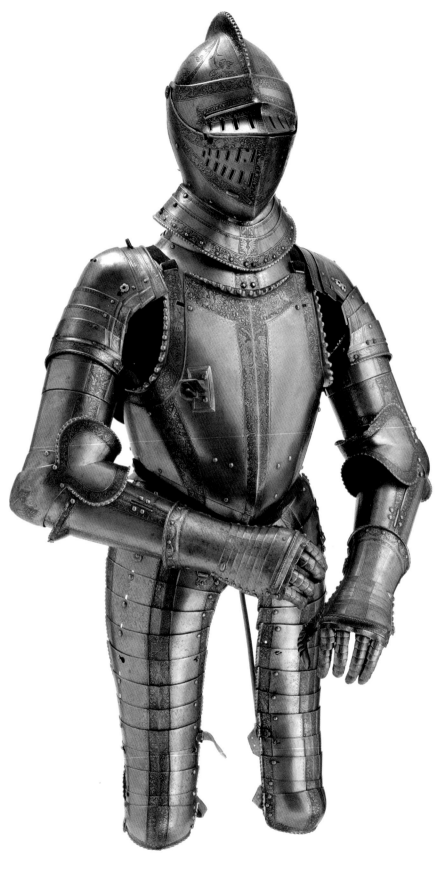

**Three-quarter light field armour, about 1540**
Steel, leather
Made in South Germany
125 cm x 76 cm
2.3

This fine armour played a key role in the international resurgence of interest in the knight in shining armour. It was once the treasured possession of Sir Samuel Rush Meyrick (1783–1848), one of the leading lights in the study of arms and armour. Sir Samuel built Goodrich Court, a neo-Gothic castle in Herefordshire. There he displayed his fine collection in the armoury in the great hall. Many artists and writers visited. The influential Romantic artists Richard Parkes Bonington (1802–28) and Eugène Delacroix (1798–1863) studied this armour in great detail as inspiration for their work.

## Pair of salt dishes, 1726

Silver
Made by Anne Tanqueray, London, England
4.9 cm x 8.9 cm x 8.9 cm
43.148, 43.149

These salts are stamped with the mark of silversmith Anne Tanqueray (1691–1733), the eldest daughter of the Huguenot silversmith David Willaume (1658–1741). During the seventeenth century French Protestants – Huguenots – settled in London seeking religious freedom and security. Some Huguenot craftsmen brought with them skills in modelling, casting and engraving silverware in the 'International' or 'French' style. By the early eighteenth century high demand for this fashionable French silverware in England allowed Huguenot silversmiths to gain commissions from wealthy patrons. They became freemen of the Goldsmiths Company, establishing workshops and taking on apprentices.

Anne married her father's apprentice David Tanqueray (d. 1724) in 1717 and then worked in her husband's workshop making silverware. After her husband's death, Anne took over the running of the workshop, registering her own mark with the Goldsmiths Company in 1724. Under Anne's leadership the workshop established a successful reputation and she became Subordinate Goldsmith to the king in 1729.

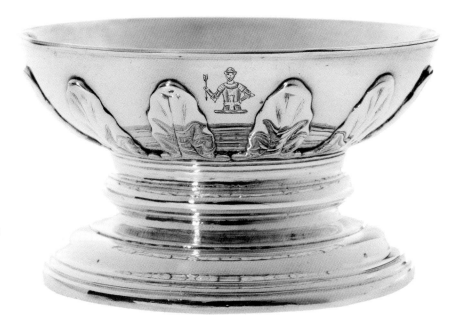

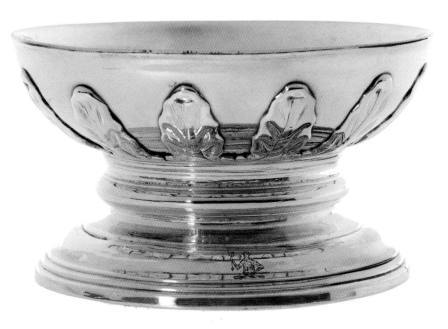

**Janiform double-headed flask,
100–300**
Roman
Moulded glass
Made in Eastern Mediterranean,
Roman Empire
7.4 cm x 4.8 cm x 4.6 cm
17.40

Roman glass-making became a
major industry in the first century
AD. By the second century AD glass
head flasks like this were popular
across the Roman world, with
significant manufacturing centres
in modern-day Syria and Palestine.
The vase was shaped by blowing
molten glass into a specially made
two-part mould.

   The heads represent a wide
variety of individuals – both
gods and humans – with Medusa
and Bacchus being particularly
popular. In this case, the globular
areas surrounding the faces may
represent grapes and this vase is
likely to show Bacchus, the Roman
god of wine.

**Beatrix of Valkenburg,** ▶
**about 1293**
White, coloured, stained and painted
glass, lead
Made in Norwich, England, from the
Church of the Greyfriars, Norwich
59.5 cm x 26 cm x 1 cm
45.2

Beatrix of Valkenburg (1254–77)
was born into an aristocratic
European family. She became the
third wife of the much older Richard
of Cornwall, King of the Romans
(1209–72), who was the brother of
King Henry III of England (1207–72).
She was buried in the Church of
the Minorites in Oxford, where it
was thought this panel came from.
It is now believed to have come
from the Franciscan Church in
Norwich and to have been paid
for by her nephew, King Edward I
(1239–1307). Wealthy people in
the medieval period could pay for
windows depicting their relatives to
decorate churches. They believed
their generosity would be rewarded
in heaven.

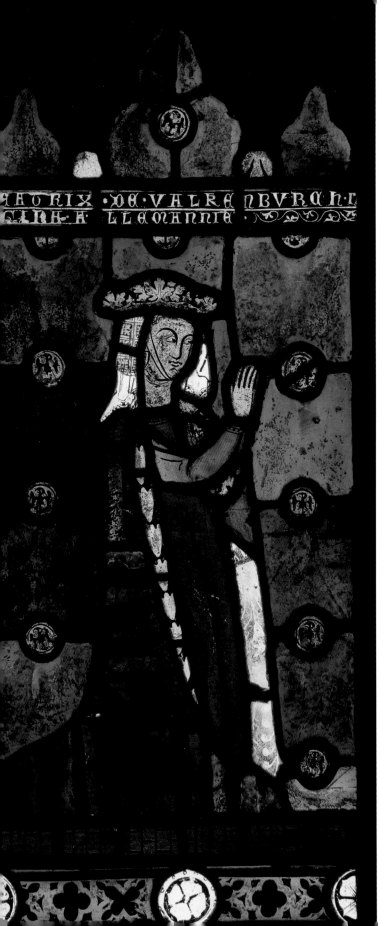

**Angel and architectural ornament, about 1340–50**
White, coloured and painted glass, lead
Made in Austria
110.5 cm x 62 cm x 1 cm
45.481

This kaleidoscopic bust of a praying angel surrounded by Gothic architecture shows the range of colours that glassmakers were able to produce. When Sir William Burrell bought this panel in 1939 it was believed to be German. It was later traced to the abbey of Stift Neukloster in the Austrian city of Wiener Neustadt. Founded as a Dominican monastery in the thirteenth century, it was rebuilt as the Neukloster, after being damaged in a fire, and handed to the Cistercians in 1444. Following a destructive hail storm in 1897, some of the windows were removed for restoration. These were eventually sold, and this panel found its way into the collection of the businessman and publisher William Randolph Hearst (1863–1951).

**St Mary Magdalene, about 1350**
White, coloured and painted glass, lead
Made in Constance, now Switzerland
47.5 cm x 23.5 cm x 1 cm
45.479

Mary Magdelene was one of Jesus'
disciples. She carries a jar for anointing
Jesus' dead body with myrrh, but when
she went to his tomb it was empty with
no body inside. When Sir William Burrell
bought this panel in 1935 it was not
known exactly where it came from but
in recent years it has been possible to
identify its origin. It is one of only three
surviving original windows from the
Liebfrauenkirche (Church of Our Lady)
in Meßkirch, Germany, north of Lake
Constance. This tiny church, dedicated
to Mary and St Martin, was probably
built in the mid-fourteenth century.
The figure's clothing can be related to
costume worn around 1350, placing
the panel in the church from its very
beginnings.

## King David and Zacharias, about 1470

White, coloured, stained and painted glass, lead
Probably made by the St Cecilia Workshop, Cologne, Germany
35.8 cm x 30 cm x 1 cm
34 cm x 29 cm x 1 cm
45.385, 45.386

These portraits were inspired by images in the *Biblia Pauperum* (Pauper's Bibles) which were picture books with short pieces of text. They juxtaposed scenes from the Old and New Testaments and were used to teach Bible stories. They often had portraits with quotations on scrolls, similar to the speech bubbles in a comic strip. Both of these figures are from the Old Testament. David was the shepherd boy who slew Goliath and became the King of Israel, and Zacharias was a prophet.

These little panels were likely to have been inset in the small openings in the upper traceried parts of a window, perhaps around a cloister. They were probably made by the prolific St Cecilia Workshop in Cologne, Germany. To meet the demand for the enormous glazing programmes being undertaken in that city around 1450–1525, glass workshops repeated and reused scenes, figures and inscriptions. There are a good number of other surviving pieces from Cologne, in the same style and of the same size. There are clear similarities between some of them, as they appear to share a cartoon, or preparatory drawing, but to have been executed by different craftspeople.

## Princess Cecily, about 1482–87 ▶

White, coloured, stained and painted glass, lead
Made in England
40 cm x 30.5 cm x 1 cm
45.75

Princess Cecily of York (1469–1507) was the third daughter of King Edward IV of England (1442–83). She was born during the Wars of the Roses, one of the most turbulent periods in English history. This panel was originally part of the Royal Window in Canterbury Cathedral. It showed the royal family kneeling in prayer. Commissioned by the king, it was probably made by one of his artists. In 1643 the window was mostly destroyed by the fanatical Puritan clergyman Richard Culmer (1597–1662), wielding a pike 'on the top of the citie ladder, near sixty steps high'. Cecily's portrait survived and was removed in 1789. The window has since been restored and reconstructed.

## Quarry bearing the device of John Islip, Abbot of Westminster, about 1500–30

Stained and painted white glass, lead
Made in England
31 cm x 24.5 cm x 1 cm
45.223

Diamond-shaped glass panels are called quarries. This one depicts a visual pun on the name of John Islip (1464–1532), who was the Abbot of Westminster Abbey in the early sixteenth century. As well as an eye and the word 'SLIP', the man in the tree is slipping down the trunk. The slim branch he has cut from the tree is known by gardeners as a slip. A puzzle which uses pictures and letters to represent words is called a rebus. These were popular in the medieval period and several versions of the Islip rebus are known to exist.

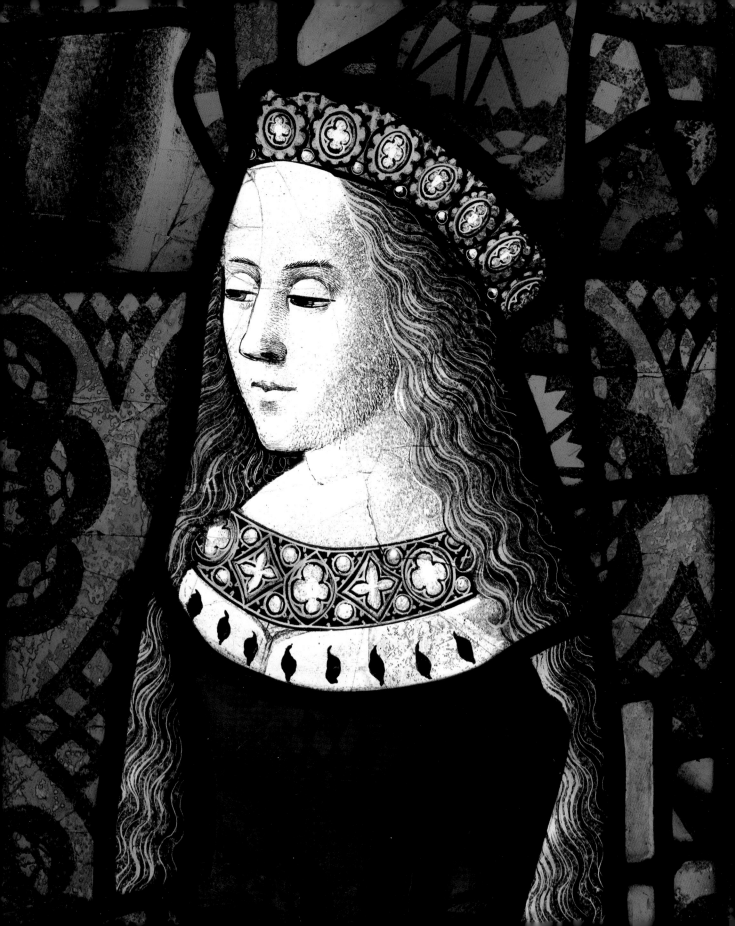

## Goblet with Bible inscriptions, about 1688
Engraved by Willem Jacobsz. van Heemskerk
Glass with diamond point engraving
Made in Leiden, Dutch Republic, now the
Netherlands
20 cm x 10.1 cm x 10.1 cm
16.98

Highly skilled amateurs carried out diamond-point engraving on glass vessels in the Netherlands during the seventeenth century. The fluid lettering and calligraphic flourishes covered the surface of the goblets, bottles and bowls.

This goblet is engraved with a Biblical quotation in Latin which translates as 'We are not born for ourselves', after St Paul's letter to the Romans. A signature on the base reveals that it is the work of one of the most prolific and well-known calligraphic engravers, cloth merchant Willem van Heemskerk (1613–92). Alongside the date, 1688, he has also added his age, so we know he was 75 when he engraved it.

## Battle for the Trousers, 1600–1700
Stained and enamelled white glass, lead
Made in the Dutch Republic, now the
Netherlands, or Northern Germany
19.4 cm x 14 cm x 1 cm
45.613

The seven women in this panel are fighting over a pair of trousers, or breeches. This traditional scene dates back to at least the mid-fifteenth century. It might represent women who embarrass themselves by lusting after the contents of the breeches. Alternatively, the breeches are a symbol of domestic power, as in the phrase 'she wears the trousers'. There was a tradition, especially in northern Germany, of giving decorative panels to celebrate the building of a new house. The name 'Jochim Moritz', indicates German or Dutch origin. 'Muttel' could be a family name or can mean 'mother', and '16' is the first part of the year.

# Index

**Items in bold are objects**

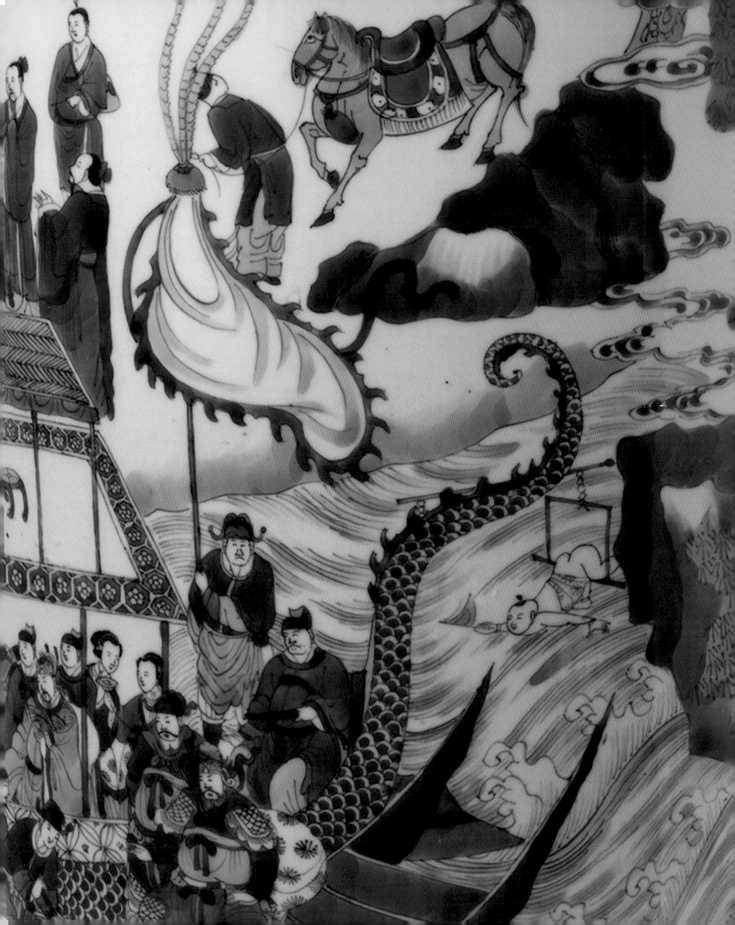